Artists of Wyeth Country

Also by W. Barksdale Maynard

Architecture in the United States, 1800–1850 (2002)

Walden Pond: A History (2004)

Buildings of Delaware, Buildings of the United States series (2008)

Woodrow Wilson: Princeton to the Presidency (2008)

Princeton: America's Campus (2012)

The Talent Mandate (2013)

The Brandywine: An Intimate Portrait (2014)

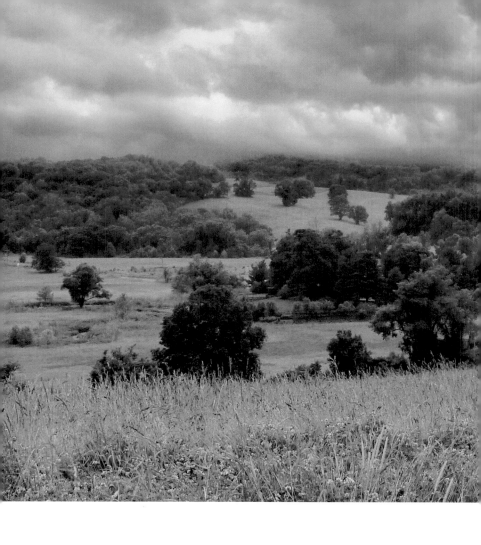

TEMPLE UNIVERSITY PRESS

Philadelphia | *Rome* | *Tokyo*

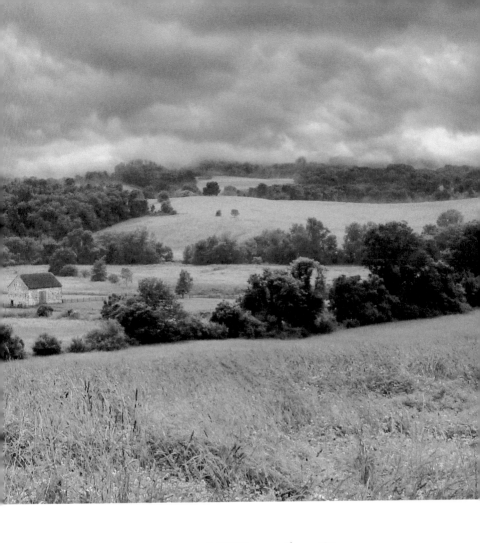

Artists of Wyeth Country

Howard Pyle, N. C. Wyeth, and Andrew Wyeth

W. BARKSDALE MAYNARD

TEMPLE UNIVERSITY PRESS
Philadelphia, Pennsylvania 19122
tupress.temple.edu

Text design by Kate Nichols

Library of Congress Cataloging-in-Publication Data

Names: Maynard, W. Barksdale (William Barksdale), author.
Title: Artists of Wyeth country : Howard Pyle, N. C. Wyeth, and Andrew
 Wyeth / W. Barksdale Maynard.
Description: Philadelphia : Temple University Press, 2021. | Includes
 bibliographical references and index. | Summary: "A history of the Wyeth
 family artists, those who influenced them, and the environs in which
 they worked, combined with six walking and driving tours that allow
 readers to visit the places that the Wyeths painted in Chadds Ford,
 Pennsylvania"—Provided by publisher.
Identifiers: LCCN 2020027484 | ISBN 9781439920701 (paperback)
Subjects: LCSH: Wyeth, Andrew, 1917–2009—Homes and haunts. |
 Pyle, Howard, 1853–1911—Homes and haunts. | Wyeth, N. C. (Newell Convers),
 1882–1945—Homes and haunts. | Artists—Brandywine Creek Valley
 (Pa. and Del.) | Chadds Ford (Pa.)—Guidebooks. | Brandywine Creek Valley
 (Pa. and Del.)—Guidebooks. | LCGFT: Guidebooks.
Classification: LCC ND237.W93 M39 2021 | DDC 759.13—dc23
LC record available at https://lccn.loc.gov/2020027484

Printed in the United States of America

9 8 7 6 5 4 3 2 1

To Susan, Alexander, Spencer, and Elisabeth

Contents

Maps appear on pages 18 and 56–57

Preface

O N A COLD MARCH NIGHT IN 1935, the lights of the Hotel du Pont glittered above the dark treetops of Rodney Square in downtown Wilmington, Delaware. Erected on a hill overlooking Brandywine Creek, the hotel symbolized the prestige of the DuPont company, founded by French émigrés in the early days of the American nation as a gunpowder factory along that historic waterway. It had grown to be the largest explosives manufacturer in the country and, with an expansion into chemicals, was on its way to becoming extraordinarily powerful among corporations. Just weeks before, a DuPont chemist had discovered nylon—eventually helping the firm break the top ten of the first Fortune 500 list postwar, with revenues of $1.7 billion.

Civic-minded, the du Pont family had sought to give Delaware valuable amenities, from the beautiful theater built into the hotel to parks and libraries. Especially luxurious was the du Barry Room of the hotel, suitably French in its sumptuous decorations and ornate plaster ceiling. That room had seen many splendid society functions and august gatherings of engineers, bankers, and lawyers. But tonight, the crowd was different: these were the former students of the famous illustrator Howard Pyle, gathered to celebrate his memory twenty-four years after his premature death on a trip abroad at age fifty-eight.

Speeches were given in honor of this illustrious native son, glasses clinked amid the candlelight, and old friends reminisced about youthful summer days along the Brandywine with the Howard Pyle School of Art, back when President William McKinley was in the White House. To those who love American illustration, this crowd was filled with legendary figures, because the charismatic Pyle had singlehandedly reshaped the illustrator's art and launched the careers of a whole generation of pupils, producing what we now call the golden age of this evocative craft before photography finally supplanted it. These illustrators considered themselves artists of high caliber, even if their approach seemed increasingly old-fashioned amid the innovations flowing in from Europe: in 1935, Pablo Picasso and Salvador Dalí were ascendant.

Among all the illustrious artists in the room that night, one was the undisputed master of them all, universally admired and emulated. All voices were hushed when N. C. Wyeth rose to speak. Pyle had changed N. C.'s life from the moment the younger man stepped off the train in Wilmington, a big-boned farm boy from Massachusetts with an uncanny gift for drawing. Pyle had offered N. C. praise and encouragement, watching as his pupil's confidence grew during sessions in the city as well as during summer school at Chadds Ford, on the Brandywine in Pennsylvania, nine miles north. N. C. went on to marry a Wilmingtonian and settle down at bucolic Chadds Ford, where he would attain fame for painting the illustrations for *Treasure Island*, a worthy sequel to Pyle's own masterpiece, *King Arthur*, likewise done at Chadds Ford.

A return to the artistic traditions of Howard Pyle would refute the "modernism that has swept the world," N. C. declared to the crowd, condemning the avant-garde trend of "art as sensationalism." Then everyone went across the street to the downtown library, a virtual shrine to Pyle: by 1923, former students and prominent citizens of Wilmington had arranged for the permanent exhibition of 267 of his works in special galleries, including a loving reassembly of his entire living room and its colorful murals. N. C. was closely involved and would remain on the board of the Wilmington Society of the Fine Arts when it opened the new Delaware Art Museum in 1938.

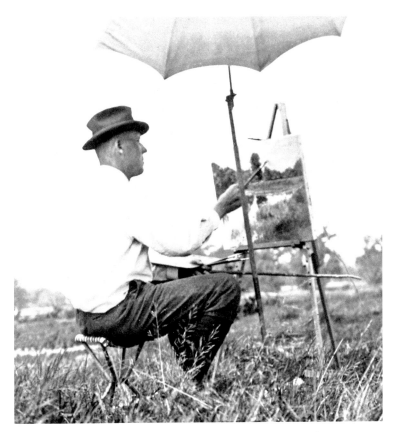

Howard Pyle paints the Brandywine. One of America's foremost experts on the colonial period, Pyle spent summers in historic Chadds Ford, depicting the bucolic local scene.

That cold March night marked a milestone for the famous school of illustration we call the Brandywine Tradition, founded by Howard Pyle and carried on by N. C. Wyeth and others: superb draftsmanship, sumptuous handling of oil paint, gripping storylines, and every detail rooted in extremely close visual observation—if not exhaustive historical research. But even as the artists looked back that night, recalling how far they had come, the occasion contained the seeds of the future. For sitting at his father's side in the du Barry Room was a seventeen-year-old boy with tousled blond hair: Andrew Wyeth.

Icon of the Brandywine School. Howard Pyle's classic pirate picture *Marooned* (1909) at the Delaware Art Museum, Wilmington. Young Andrew Wyeth learned lessons from this picture's sober simplicity.

Already a painter himself, studying with his father in the Chadds Ford studio, Andrew listened to the speakers who lauded Pyle so highly. "He opened our eyes to the drama of the commonplace," one said—in what almost became Andrew's lifelong personal manifesto. And then at the library, he studied once again the fabled paintings in the galleries he knew so well: when he was fifteen, his own artwork had appeared in public for the first time in these rooms where the Pyles were displayed (November 1932).

The Brandywine Tradition, so vigorous and admired, was about to go in a new direction in the hands of this talented young practitioner. For many of the artists that night, the crowning achievement among all the Pyle pictures was the desolate pirate scene *Marooned* (1909). A newspaperman noted with admiration its "effect of vast loneliness. In the midst of the large canvas is a single

figure crouched. Against the yellow sand his cloak of red is predominant." Thirteen years later, Andrew Wyeth would paint a pink dress against a lonely yellow hillside and call it *Christina's World*.[1]

The Artists at Chadds Ford

I wrote this book because I believe that the art of the Brandywine painters cannot be understood apart from the real places they depicted and drew inspiration from, with three hundred years of cultural heritage behind them. Those places are centered on Chadds Ford, where Pyle's school met in a series of historic colonial buildings. N. C. lived at "the Ford," painted there, raised his family of five children, three of whom became artists—to the American public in the middle of the twentieth century, the Wyeths were about the most famous artistic clan the nation had produced since the Peales. N. C.'s tragic death in an automobile accident at Chadds Ford in 1945 made national headlines; Andrew's rise to great fame almost immediately followed. As is legendary, he made Chadds Ford his own by depicting it again and again during an artistic career that extended into our own times.

Today, Chadds Ford Township (population 3,640) is a leafy, upscale commuter suburb, proud of having preserved 1,660 acres of land from development pressures that ceaselessly grow in the greater Philadelphia outskirts. But for most of its long history, going back to Quaker settlement in the 1680s, it was a village of just a few hundred near the edge of Brandywine "crik," known for the major road that crossed the river here (originally at John Chads's ford) as well as a series of productive mills. All around were farms. Except for occasional rampaging floods, this was an exceedingly quiet rural locale where cowbells tinkled in the meadows and sycamore leaves drifted down to the steadily gliding river. Today, the pace has quickened.

Surprisingly, a guidebook has never been written for what has long been called "Wyeth Country," although the art of this revered family cannot be understood apart from its microregional context. ("Wyeth Country" has been standard nomenclature since at least 1971, when a *New York Times* article popularized the term.) The six

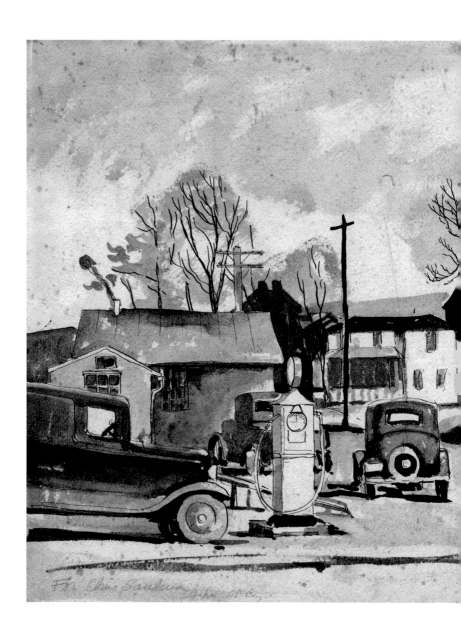

For Chris Sanders
John McCoy

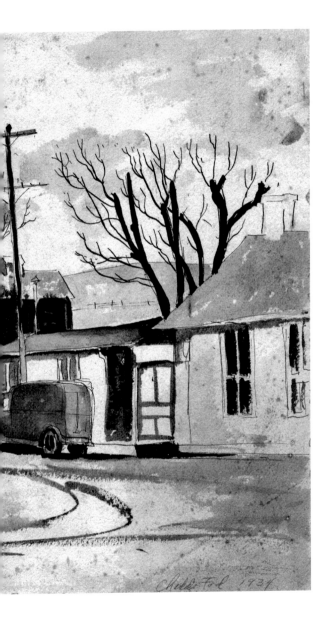

Rural crossroads. Village of Chadds Ford, 1934, looking north up Creek Road from Brittingham's garage in an ink rendering by N. C. Wyeth's son-in-law, John McCoy. (Photo courtesy of the Christian C. Sanderson Museum, Chadds Ford, PA © 2020.)

tours in this book take you throughout modern Chadds Ford, some by foot and some by automobile—use caution on these busy roads, which unfortunately preclude taking the tours by bicycle. Please note: some of the places that I point out from the road are privately owned, with no public access. At times, the settings seem little-changed from the nineteenth century, but more often, the differences are striking. To a degree that might have been unimaginable to N. C., agriculture has sputtered out, wooded thickets have reclaimed the fields, and developments have proliferated: the mere 400 local housing units in 1970 had swelled to 1,300 by 1990. Even some trails that Andrew Wyeth walked in the 1980s are now indistinguishable amid torrid growths of invasive shrubs. "Back then, you'd see hot-air balloons land in the fields on a Saturday, and everybody would have champagne," one local recalls. "Today the feel of 'country' is really gone." Much more would have been lost, except that the Brandy-wine Conservancy was founded in 1967 by friends of the Wyeths and has preserved more than sixty-three thousand acres up and down the valley, even as it partners with the Brandywine River Museum of Art, home to the premier collection of Wyeth paintings.[2]

In this book, I mention scores of artworks by the Wyeths, indicating exactly where each was drawn or painted. To stand in the footsteps of the painters can reveal much about their processes and intentions; indeed, one can play detective with Andrew Wyeth, that notoriously furtive artist who wouldn't tell his wife, Betsy, where he went each day and sought to keep even his lunch engagements secret from her (the complexities of their married life are extensively documented in his 1996 authorized biography by LIFE magazine reporter Richard Meryman). Again and again, one notices how accurately the Wyeths depicted what they saw, with one notable exception: Andrew's work habitually omits intrusions of modernity, from automobiles to tractors to the hideous electric towers that marched across Kuerner Farm in the 1950s (in *Pennsylvania Landscape* of 1942, the concrete U.S. 1 is replaced with the Brandywine!). He loved the land, but he is certainly not an accurate chronicler of contemporary agricultural practices; such was never his intent, and he admitted, ironically, that he didn't partic-

Peripatetic painter. Uphill from his parents' Homestead, Andrew Wyeth surveys his beloved Chadds Ford landscape, about the same time that he chose this same location for the 1957 watercolor *Above the Orchard*. (Photo courtesy of the Christian C. Sanderson Museum, Chadds Ford, PA © 2020.)

ularly like farming. When depicting a building, he allowed himself to omit certain windows for artistic effect. But in general, as this book demonstrates, he is almost uncannily beholden to what he called the "literal truth." Not that his work is unimaginative; but it features imagination, as Pyle decreed, that springs from a basis of fact. Pyle "told his students to go to life to discover truth"—so Andrew Wyeth summarized the wisdom of his master.[3]

I have tried to paint a vivid picture of Andrew Wyeth at work, whenever possible giving fresh anecdotes from interviews I conducted—my attempt to peek around the edges of the imposing authorized biography to see him, in Boswell's words, *as he really was*, without "panegyrick, which must be all praise." Many locals were generous in helping me, even if sometimes hesitant to talk about the artist. This is old habit, born of intense loyalty to a beloved local hero. More than thirty years ago, the nation was transfixed by the Helga pictures, a secret cache of more than two hundred

paintings and drawings that Wyeth had done of an attractive female neighbor, often posing her nude. When reporters swarmed the village, seeking salacious details, longtime residents patiently explained that they had never heard of Helga Testorf or even Andrew Wyeth. Stung by countless critics, the artist himself grew adept at evasion: he denied one author's well-meaning interview request for *thirty-five years*, and I have heard of admirers who secured a coveted invitation to his home at Brinton's Mill, only to watch in astonishment as the great man, hearing them coming, darted out the back door and went scurrying across a cornfield.

Even a decade after he died, the researcher may encounter headwinds in Chadds Ford: this work of scholarship was approaching publication when I was forbidden by the Wyeth Office, after they read my draft, to reproduce any of his artwork whatsoever. This requires the reader to look online, where nearly all the pictures I mention can be readily found. Also online, every N. C. Wyeth painting can be looked up in the artist's catalogue raisonné at the Brandywine River Museum of Art website, an invaluable resource. No such publicly available catalogue yet exists for Andrew Wyeth, and I have only mentioned paintings of his that happen to have been published. This is just a sample of his prodigious total; he painted locally from the time of the Herbert Hoover administration to that of George W. Bush.

It has puzzled some observers that an artist of his caliber didn't focus his energies on "major works" instead of innumerable landscape watercolors. In his lifetime, he produced an estimated 250 major temperas but tens of thousands of watercolors and drawings—the exact number is incalculable. "You're wasting your time in watercolor," a friend warned him. "It's a light medium." But Wyeth kept on with his daily exploration of the details of nature, much like his father's idol Henry David Thoreau, born a century to the day before he was. It is to the historian's benefit: he created an exceedingly full visual record of twentieth-century Chadds Ford, that richly historic place that continues inexorably to grow and change.[4]

PART I

Artists of the
Brandywine Tradition

Celebrating the Colonial Brandywine

Howard Pyle to N. C. Wyeth

THE WYETHS, FATHER AND SON, painted the Chadds Ford scene continuously from 1902 to 2008, producing an extraordinarily bountiful body of work that has hardly been matched by any other painters-of-place anywhere in the country—except, perhaps, by their own depictions of coastal Maine. (This book deals *exclusively* with the Brandywine, considering Maine a separate story, 450 miles removed.) A renowned grandson, Jamie Wyeth, lives and paints along the Brandywine as well, his complex career of more than a half century lying beyond the scope of my research. But the art tradition here did not begin with Wyeths: poets, writers, and artists had flocked to Chadds Ford throughout the nineteenth century.

What Walden Pond was to intellectual Boston, fifteen miles east, so was the Brandywine Valley to intellectual Philadelphia, twenty-three miles east: a place to escape the evils of urbanism and modernity and plunge back into nature and the unspoiled countryside. In the case of Chadds Ford, its special appeal was its colonial heritage. As the nation relentlessly urbanized, early America seemed to survive here in this unaltered place, famed for the 1777 Battle of the Brandywine, the largest land battle of the American Revolution. From the 1850s, Chadds Ford was linked to Philadelphia by easy railroad connection, making it a weekend destination

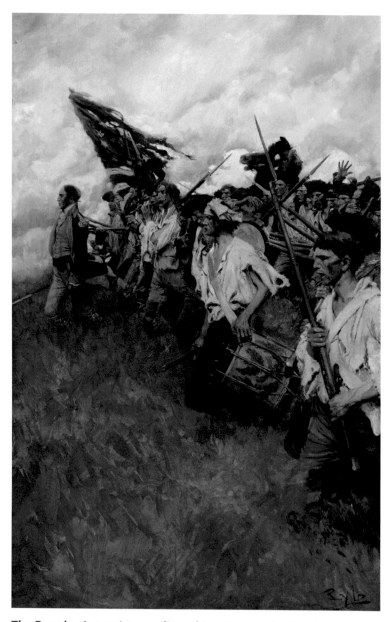

The Brandywine artist as military historian. Inspired by the historic battlefield all around him, Howard Pyle painted *The Nation Makers* during a summer session at Chadds Ford, 125 years after the fight. (Howard Pyle [1853–1911], *The Nation Makers*, ca. 1902, oil on canvas, 40¼ × 26". Brandywine River Museum of Art, Purchased through a grant from the Mabel Pew Myrin Trust, 1984.)

of choice for countless artists in America's second-largest city. They set up easels beneath the ash trees along the river, draped picnic blankets across the grass, and searched freshly plowed fields for the cannonballs and bayonets that farmers routinely unearthed.

Historian with a Brush

In 1898, the famed illustrator Howard Pyle founded his summer art school at Chadds Ford, eager to spring his Drexel Institute students free from hot, jam-packed Philadelphia. Year-round instruction would keep their skills sharp, plus "my young people might be taught to breathe in the open air and to hear the song of birds, to know how nature looked and to drink in the sunshine." He emphasized that "the students shall go out and paint landscapes from nature in full color" and on Saturdays "take a holiday, in which they may ride their bicycles through the country . . . to photograph and to sketch, to observe beautiful nooks of nature and to talk about them." Pyle ran this delightful school during the summers of 1898 and 1899 under Drexel auspices and then from 1900 to 1903 after he had founded his own art school in his native Wilmington, Delaware, nine miles south and likewise on the Brandywine.[1]

One of his 1902 students was a big, bright farm boy from Massachusetts named Newell Convers Wyeth, who instantly fell in love with the rural Brandywine landscape. "We spent days with him rummaging around old furniture shops, hunting for seasoned mahogany for panels to paint upon," N. C. fondly recalled of his master, Pyle. "And we spent very much more time with him roaming the gorgeous hills and woods of the Brandywine valley at Chadds Ford." No student seemed more receptive to Pyle's thrilling Revolutionary War stories than N. C. In July 1903, Pyle had N. C. drive him on a twenty-five-mile carriage tour of the battlefield. That evening, master treated student to a vivid discourse on the bloody events of September 11, 1777. Awed by this lesson in history, N. C. later searched for earthworks and relics on the creek banks.[2]

Between 1877 and 1909, Pyle illustrated no fewer than eighty-seven magazine articles on colonial and Revolutionary War sub-

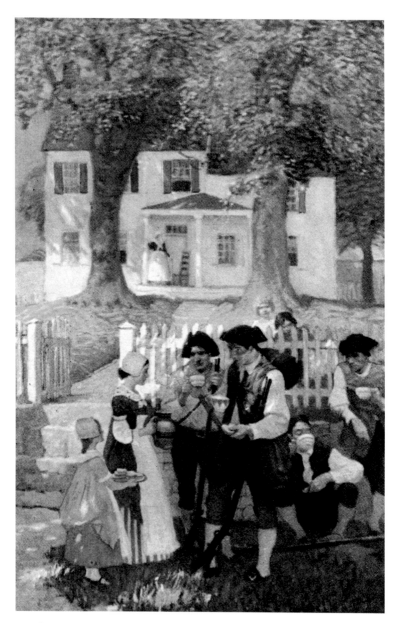

Washington's Headquarters inspires the Brandywine illustrators.
Local scenes found their way into magazine art by Howard Pyle and his
talented students. (N. C. Wyeth, *On the Way to the Front in '76* [1918]. Photo
courtesy of the Christian C. Sanderson Museum, Chadds Ford, PA © 2020.)

jects, playing a significant role in that bourgeoning cultural move-
ment of the day, the colonial revival, and attracting an international
audience that even included Vincent van Gogh. He was "a historian
with a brush," Norman Rockwell later said admiringly. "His draw-
ings of Colonial days, of the Revolution, of pirates, were authentic
re-creations, backed by years of study and research."[3]

In his rural school, Pyle stressed artistic *imagination* with a kind
of burning spiritual intensity, but imagination fed by the authentic
facts about colonial society and culture. He was accurate down to
"the number of buttons on the tunic of a British subaltern," his sec-
retary recalled, and is said to have modified the moon in a picture
of the death of General Edward Braddock so that it was astronom-
ically accurate for that very date. The Howard Pyle School of Art
was no ordinary educational establishment but his deeply personal
effort to found a movement as influential as the Barbizon School in
France: he would, at last, produce "painters of true American Art."[4]

Inculcating patriotic stories of the American Revolution was
crucial to this process, so Pyle sat on the porch of his Chadds Ford
rented mansion, Painter's Folly, telling spellbinding stories, some
passed down from his great-grandmother who, growing up just east
at Painter's Crossroads, had witnessed the aftermath of the 1777
fight. She had watched the beaten Continentals retreating past the
family farm, "trailing their muskets over the dry fields of Septem-
ber, their shoeless feet wrapped in gunnysack, and bleeding." The
influence of the master was lasting, N. C. recalled: "Thus to know
Howard Pyle—in this country of all countries, where Washington
had fought, where from the spacious veranda we looked across the
meadows upon Rocky Hill, the very location of the deciding con-
flict that sent Washington and his men to their memorable winter
at Valley Forge—to know Pyle here was a profound privilege."[5]

Pyle little realized what he had set in motion with the Wyeth
family—N. C.'s lifelong devotion to the Battle of the Brandywine,
which he depicted as literally coming to life in his studio in the fas-
cinating *In a Dream I Meet General Washington* (1930). Andrew, still
a boy, appears in that painting as an avid sketch artist. Growing up,
he was deeply influenced by his surroundings at the very heart of the

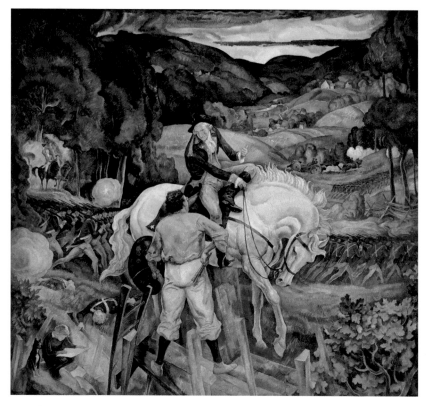

The Brandywine Battlefield comes to life. Engaged in the largest land battle of the Revolutionary War, George Washington narrates the stirring scene to an awestruck N. C. as little Andrew sketches at lower left. A vivid dream inspired N. C. to drop everything and create this painting. (N. C. Wyeth [1882–1945], *In a Dream I Meet General Washington*, 1930, oil on canvas, 72⅜ × 79". Brandywine River Museum of Art, Purchased with funds given in memory of George T. Weymouth, 1991.)

largest of the 1,546 battlefields of the American Revolution, where, he thought, bullet holes scarred the rocks just uphill from his dad's studio. Introducing himself to the public for his major appearance at the Museum of Modern Art in 1943, he rooted himself in the past and the milieu of the battle: he had grown up in a village "snug against the historic Brandywine River, which waters a beautiful valley of farms and grazing lands. The memory of early days still clings

to these hills and valleys where Washington and Lafayette fought their losing battle with General Howe." This description sounds more like the calling card of an antiquarian than of a young man trying to break into the ultrasophisticated milieu of modern art in Manhattan![6]

To an extraordinary degree, Andrew Wyeth's artistic output in Chadds Ford was *determined by the historic architecture* that he portrayed again and again across many decades, including those revered colonial landmarks that had witnessed the conflict of 1777, from Kuerner Farm to the Barns-Brinton House. Over time, Andrew and Betsy became as deeply knowledgeable about local history as any trained expert. In the 1950s, they bought and restored as their home Brinton's Mill, where redcoats had waded across the creek; it appears in *Battleground* (1981), and the depredations of the King's Troops there are literally illustrated in *Plundered* (1996). Late in life, he spoke of "my strong feelings for the American Revolutionary War, the aura of which surrounds me here and which I feel from my constant wandering around these hills in the Brandywine Valley." Truly, the colonial heritage of Chadds Ford as revealed by Howard Pyle had become central to the artistic vision of both Wyeths, as did Pyle's insistence on the balance between *imagination* and *fact*—the key tension in the paintings of Andrew Wyeth.[7]

Howard Pyle died while on an artistic pilgrimage to Italy six years before Andrew Wyeth's birth, but his influence on the younger man was enormous—in fact, a refuge to which Andrew fled to escape N. C.'s epic painting style (at age fourteen, he watched his dad paint a mural that measured sixty feet across). His teenage forays into art began with copying Pyle's ultraprecise *King Arthur* ink illustrations. A creepy-crawly ink-pen phase followed, with his subjects rendered almost too exactly. Summer-school student Frank Schoonover recalled how nature was "divided and subdivided by Mr. Pyle into the most minute detail. Nothing seemed to be too small for careful consideration"—the same can also be said of Andrew Wyeth throughout his career.

Long walks were likewise a Pyle obsession: "Upon these gentle voyages through field and woodland, there was a subtle pointing

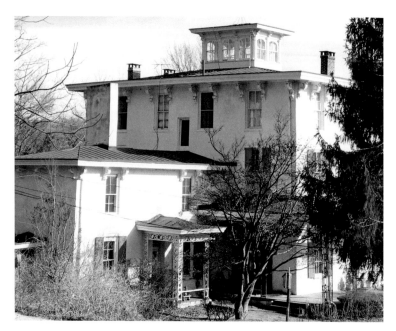

Home to Howard Pyle. The rented Italianate mansion Painter's Folly (ca. 1857) became the beloved family residence during summers on the battlefield at Chadds Ford. A century later, the elderly Andrew Wyeth began visiting the place constantly.

out of a purple, of broken color in a whitewashed wall"—just such walls as Andrew Wyeth became famous for depicting. He abolished the bravura brushstrokes ("swish and swash") of the typical "Pennsylvania impressionist" in favor of a dry and superaccurate literalism: had not Pyle cautioned his pupils "not to be led astray by fancies and trickery, but to hold up always the mirror of nature as a supreme guide"? Finally, in the 1940s, Wyeth purged color in favor of sepia effects: had not Pyle been celebrated as "the greatest illustrator in black and white the world has ever seen"? All his days, Andrew Wyeth would hang the art of Pyle on his studio walls, encourage others to start Pyle collections rivaling his own, don quaint historical costumes of the kind Pyle amassed, and even go walking the Brandywine hills in Pyle's own boots (*Trodden Weed*, 1951).[8]

Howard Pyle's Wilmington

Urban renewal has claimed the 1853 birthplace of the legendary illustrator (on Market Street, two houses north of Grand Opera House), but **Goodstay** on Delaware Avenue survives, the quaint colonial estate that made a powerful impression on his historical and aesthetic sensibility during early childhood. Still extant is the "storybook" rose garden he recalled so fondly and the ivy-covered boulder where he first wrote poetry. At "the quaintest, dearest old place you can imagine," young Howard pored over picture books while lying on a rug in the library by the fire, rolled down the "terraced bank" in front of the house, and watched Conestoga wagons rumble by on the turnpike.[9]

As he avidly explored "old-time life in a Quaker town," Pyle sought out colonial landmarks, including **Old Swedes Church** (1698–99), complaining when it was modernized in a restoration. Splendidly preserved is his picturesque, Queen Anne–style **Studio** on Franklin Street (1883, student section 1900), a noted landmark still used by artists today. Here N. C. studied, always recalling the faint sound of Pyle's footsteps coming up the brick walk. Digni-

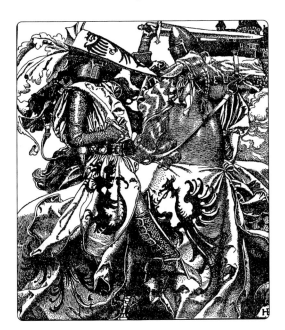

Champion illustrator. The extraordinary pen-and-ink skills of Howard Pyle were at their height with *Sir Kay Breaketh His Sword*, from his iconic book *King Arthur* (1903), drawn at Chadds Ford. Studying these pictures obsessively, young Andrew Wyeth adopted a hyperfocused style full of telling details, an eye for history—and even a predilection for forms sharp and menacing.

taries visited, including Woodrow Wilson in 1900. In 1896, Pyle moved nearby to **1601 Broom Street**. His final residence on the east side of Delaware Avenue lay where southbound Interstate 95 cuts through the city.

Art collector William Bancroft, whose Pre-Raphaelite masterpieces joined Pyle works to form the core of the **Delaware Art Museum**, built a complex for young illustrators at Rodney Street, now the **Frank Schoonover Studios**, with N. C. one of the first users (1906–08). At that time, the newlywed N. C. lived down the brick sidewalk at **1331 Shallcross**. Pyle and pupils found inspiration in the Brandywine countryside, taking "sketching rambles" down **Montchanin Road**, where one can still see carved mile-markers, stone walls, and other venerable traces of the once-rural scene (as celebrated in Pyle's *Good for the Soul*, 1898).

N. C. Wyeth Paints Outdoors

The eager farm boy N. C. came to Chadds Ford to study with Pyle in October 1902. After marrying the young Wilmingtonian Carolyn Bockius, he settled here permanently in 1907. The following year, he rented the Harvey Homestead overlooking the village; by 1911, he had earned enough from illustration that he could build his nearby home and studio on Rocky Hill, which are National Historic Landmarks today. From the day N. C. arrived, old-timey Chadds Ford resonated deeply with this descendant of Nicholas Wyeth, who had helped settle Massachusetts in 1645. Raised on a farm along a river not far from Walden Pond, N. C. delighted in the sinuous Brandywine and the countless farmsteads that made it one of the most famous agricultural regions of the American colonies and later. He never tired of lauding its hay-scented barnyards, fields of waving grain, old-fashioned zig-zag "worm" fences, and piles of corn in the autumn with scattered pumpkins—quaint agricultural scenes fast disappearing in many places, as the nation rapidly urbanized and farming grew mechanical.

Even as N. C. achieved fame as an illustrator, the Brandywine landscape fueled his desire to cut himself free from commercial art

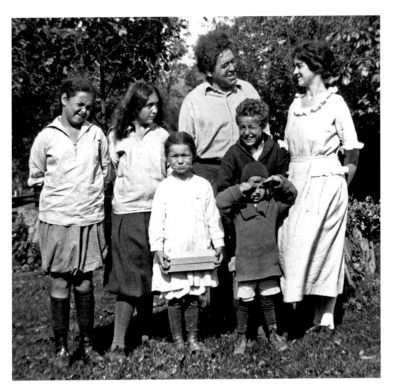

America's artistic clan. N. C. and Carolyn Wyeth and their family at the Homestead, about 1920, as his illustration career flourished. Children (left to right): Carolyn, Henriette, Ann, Nat, Andy. (Photo courtesy of the Christian C. Sanderson Museum, Chadds Ford, PA © 2020.)

and become a rural landscape painter in the Barbizon tradition. A series of farm scenes for *Scribner's Magazine* in 1908, painted amid the grain fields of Chadds Ford and including the iconic *Mowing*, won high praise from Pyle as the best work any student of his had done and fed Wyeth's urge to portray such bucolic scenes exclusively—to *"paint, not* for ammunition companies, but for *myself!"*[10]

As he plunged into landscape painting, N. C. Wyeth joined the prestigious Philadelphia Sketch Club, which gave him his first solo show in November 1912, including several farm landscapes painted near the Harvey Homestead. Starting at this same time, Thoreau became the great influence on N. C., whose horticulturist

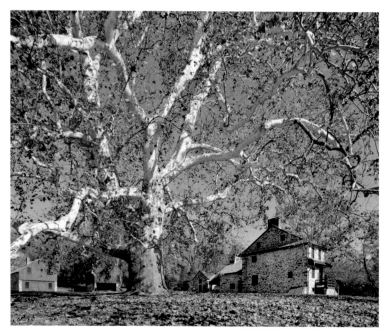

Three-hundred-year-old sentinel. The giant buttonwood at Lafayette Headquarters, witness to the American Revolution and painted reverentially by both N. C. and Andrew Wyeth.

grandfather had known the Concord writer. N. C. later owned a deluxe set of Thoreau's journals, in which the transcendentalist urges the close observation of nature through daily walking. N. C. was deeply moved. His own walks had long been frequent, including a memorable one in September 1910 throughout the Chadds Ford countryside that he carefully recorded on a hand-drawn map.[11]

For the studio-bound illustrator, to escape outdoors and set up an easel amid cornfields and meadows was a relief, as was to paint earthy reality instead of imaginary scenes. "Pa very definitely rejuvenated himself by doing landscapes," Andrew recalled. As a boy, he was struck by how his father's magazine illustrations regularly borrowed from Brandywine scenery. Pyle had shown knights in fanciful medieval settings derived from the English Pre-Raphaelite

painters he so admired, but N. C. had them fight among the very boulders and trees where young Andy played, just above the Rocky Hill studio.[12]

A proud Andrew Wyeth thought his father was America's best illustrator—*and* its best contemporary landscape painter. Although he urged his dad to take pride in illustration, he sensed that N. C. would have eventually switched to landscape painting entirely had he not died suddenly in an automobile accident in 1945. As a sensitive interpreter of landscapes, N. C. had an enormous influence on young Andrew, who later confirmed that father and son "believed absolutely the same things." It has seldom been noticed, but N. C.'s *Dying Winter* (1934), painted during the period when the elder man was training his son in the studio, establishes the exact, melancholy themes that Andrew would eventually become famous for: faded grass with "patches of snow, dying winter" (as the younger artist later enthused about on Kuerner's Hill in 1946), and black crows ominous against a barren slope. And the little girl looking wistfully back to her house in N. C.'s nearly final painting *Nightfall* (1945) is echoed in Andrew's breakout success, the Maine picture *Christina's World* (1948). Andrew chose *Dying Winter* and *Nightfall* to hang in his father's memorial exhibition in Wilmington, in which we see the artistic baton being passed from father to son.[13]

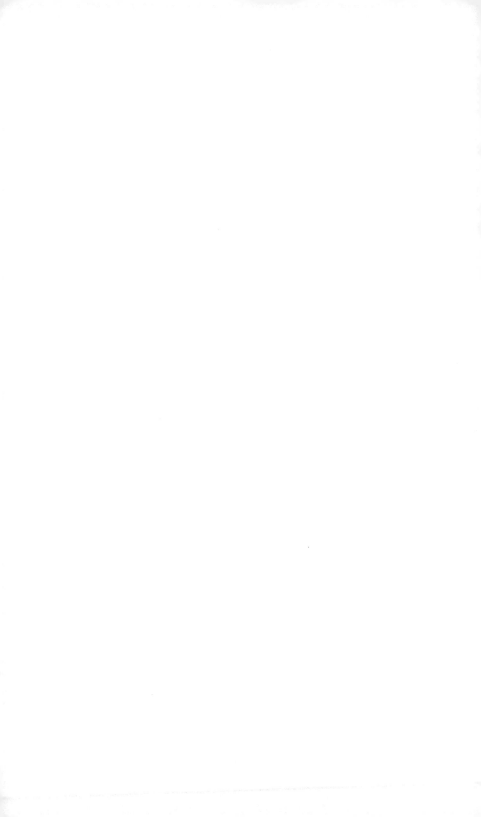

Chapter 2

The Walking Painter

LOOKING DOWNSTREAM near Chadds Ford on a May morning, the artist finds a dozen subjects for a painting: the green and undulating floodplain of the Brandywine River carpeted with flowers; contorted black boxelder trees, half-horizontal over the water; red canoes in a swale; the shimmering reflections of forest and sky as the river, high from spring rains, courses down toward Twin Bridges and the rolling du Pont estates. The easel sinks in the brown mud, the canvas shakes in the wind, but the artist perseveres, hoping to win a place in the grand tradition of the Brandywine painters. And the man to emulate, of course, is Andrew Wyeth.

We are standing in the heart of Wyeth Country, the great American place made famous by the landscape paintings of Andrew Wyeth and his father. It exists in our mind's eye as a quasi-mythical realm: weathered colonial farmhouses, barren pastures, somber treeless hilltops familiar from such blockbuster books as *Wyeth at Kuerners* (1976). Yet the place is not mythical but real, and this guidebook makes it possible for you to stand exactly where these famous artists once stood and to see what they saw. To visit places the Wyeths knew is to deepen our understanding of their artistic

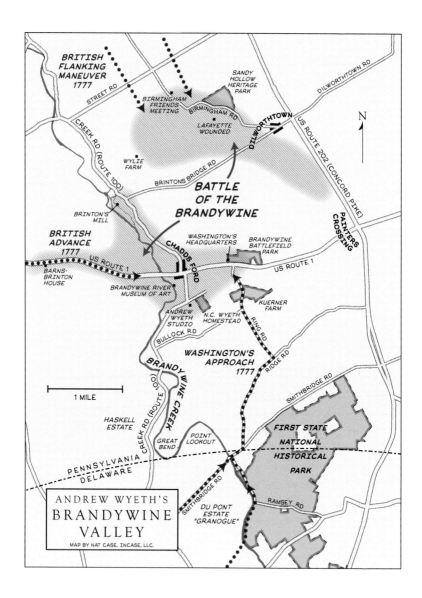

methods: did they paint only what is actually there, or did they move things around, editing reality for their own purposes? And it allows us to see in detail how the landscape has changed along the Brandywine in Pennsylvania in the more than one hundred years since N. C. first depicted it.

In the case of Andrew, in particular, to walk in his footsteps is to gain a richer comprehension of his whole artistic purpose. Art

critics have often assailed him for painting such ordinary subjects and restricting himself to a single, tiny corner of the world—he virtually painted *only* in close vicinity to his home in Chadds Ford from the beginning of his career in the early 1930s until the day he died in 2009 (except, of course, for summers in Maine). "A strangely circumscribed life has produced a sadly circumscribed art," one critic wrote.[1]

Is there a more positive explanation for his strict, self-imposed focus? One answer, I believe, lies in his habit of daily *walking*, around which he built his artistic approach. Like Henry David Thoreau, the peripatetic writer with whom he shared a birthday, exactly a century apart, Wyeth was a peripatetic painter: he *walked*, he *observed*, and then he *painted* what he had seen. Nature itself steered his course as he abandoned himself entirely to its direction. His narrow artistic range, in the end, was the range that a daily walk afforded, and no more—a fact that largely held true even in later years, when lameness compelled him to drive his Chevy Suburban or Jeep Wagoneer instead—often going off-road, careening through fields and woodlots.

He achieved extraordinary popular acclaim in his lifetime: the cover of *American Artist* at age twenty-five, the sensation of *Christina's World* at thirty-one, the cover of TIME at forty-six, an unprecedented one-man show at the White House at fifty-two, the first exhibition by a living artist at the Metropolitan Museum of Art at fifty-nine, the media frenzy surrounding the Helga pictures at sixty-nine. . . . More than a decade after his death, he still exerts a powerful hold over much of the American public, and abroad. Visitors to his retrospective at the Philadelphia Museum of Art were frequently seen weeping, so moving did they find his art. Even academics and art critics, long his implacable foes, are now praising him. The first of its kind, this guidebook sends you out walking in his footsteps (and tire tracks) and those of his father, N. C., allowing you get inside their minds as they explored these verdant Pennsylvania hills and valleys. It is an excursion not only into geography and landscape history but also into the working methods of two of America's most enduring artists.

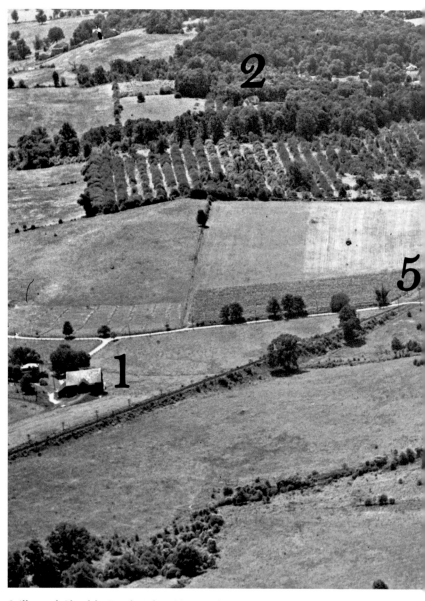

Still-rural Chadds Ford, July 1939. Looking west along newly widened Baltimore Pike during the dozen years when N. C. and Andrew Wyeth were simultaneously painting the local landscape. Agriculture was limitless then, before suburbanization. 1: Kuerner barn

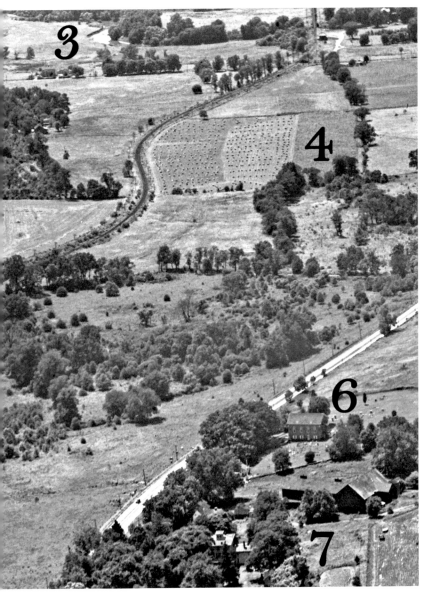

and house. 2: N. C. Wyeth Studio. 3: Brandywine Creek (Chadds Ford village lies to the right). 4: Harvey Run Valley. 5: Fatal railroad crossing of N. C. Wyeth. 6: Baptist Church. 7: Painter's Folly, where Howard Pyle had lived.

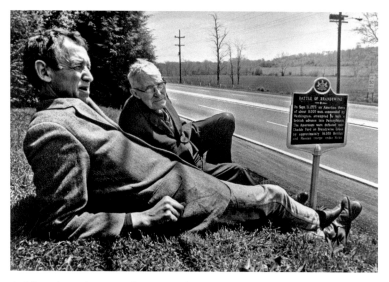

Avid antiquarians. Andrew Wyeth and his elderly historian friend Christian Sanderson at Washington's Headquarters along Baltimore Pike, May 1966, during the campaign to prevent industrial development of the distant meadows. The historical marker commemorates the Battle of the Brandywine. (Photo courtesy of the Christian C. Sanderson Museum, Chadds Ford, PA © 2020.)

The Paradox of Andrew Wyeth

Don't be fooled by the seemingly straightforward subject matter of farmyards and pastures: it is not easy to grasp Andrew Wyeth's work, although he became the most famous and (to the public) widely beloved American painter of his time. He was highly atypical of artists of his generation, or perhaps any generation.

To see how truly strange he was, perhaps it would be helpful to compare him to another painter. Almost at random, I pick Stephen Greene, because I knew him slightly and because he was Wyeth's exact contemporary. Greene's trajectory was "typical": he went to art school; he interacted closely with fellow artists throughout his life; he prowled the museums of Europe and suddenly changed his painting approach based on exciting encounters with Old Masters; he responded eagerly to contemporary trends and innovations in

New York and abroad; and he used a wide range of brilliant colors in oil paint. During a long career, his style evolved dramatically into something entirely different from how he had begun. Unable to support himself by painting except for two years out of fifty-plus, he instructed at universities, inspiring countless students. He lectured to general audiences on art history. He was lauded by critics and fellow artists, although the public at large had never heard of him.

Those are the facts of a "typical" American master exactly Andrew Wyeth's age, who, by the way, painted in both realist and abstract modes. *Not one of these statements is true for Andrew Wyeth—not one of them. He could hardly have stood farther outside the norm.* No wonder he spoke in 1965 of his alienation from his peers: "Most painters don't care for me. . . . Actually, I don't consider myself an artist in the usual sense."[2]

How to get a handle on someone so exceptional? Having spent a couple of years looking closely at his art and walking in his footsteps along the Brandywine, I find that certain bedrock statements ring true:

- He is a Thoreauvian *arch-individualist*, proud of his rural roots and remoteness from corrupt urban values. Entirely alone, he glided among the rocks and trees with the stealthiness of the solitary animal that looks down from a barren hilltop in N. C.'s *Thoreau and the Fox* (1935).

- Individualism aside, he is allied to those young artists of the 1930s who rejected what he called "Frenchy" painting, colorfully daubed, in favor of a dry and "American" hyperrealist style: thus he was a committed *anti-impressionist*.

- He also belongs to the 1930s regionalist movement in American painting but takes it to such an unheard-of extreme that he could be called a *micro-regionalist*. He demanded that artists should be "ingrown," and truly one cannot overstate his craving for a *narrow horizon*: tiny Chadds Ford being too vast, he burrowed down into even tinier Kuerner Farm for decades. His special emphasis

was the accurate recording of early architecture, in the manner of a historic preservationist; hardly one venerable building around Chadds Ford escaped his brush, which he wielded with what one critic called *exhibitionist virtuosity*, capturing the effects of light on surfaces with jaw-dropping skill and microscopic accuracy.[3]

• In addition to his lifelong adulation, via Pyle, of the German artist Albrecht Dürer (1471–1528), one European movement did inspire him: he was one of many American contemporaries influenced by 1930s *surrealism*, not only in subject matter but in the use of chance and *automatism*, an approach to painting that stresses the play of the Freudian unconscious.

• He had the misfortune of seeing regionalism widely discredited before he turned forty. (Assigned to a class with Grant Wood, the artist known for *American Gothic*, Greene immediately dropped the course, recalling in 1968, "I'd rather stop painting than be in his class. I hated what he did. I hated what he stood for. I thought it was stupid. And I still think it's stupid. I think it's backward painting.") Yet Andrew Wyeth, against all critical fusillades, *persisted in the regionalist mode* into the twenty-first century, backward or not. He enjoyed a key advantage: "He had a huge amount of money around him in the Brandywine Valley," the longtime editor of *American Artist* told me. "He was a Regional painter who happened to live in a region filled with du Ponts." As we saw, the chemical and explosives company of that name had been founded along the Brandywine in 1802 and eventually grew to become one of America's largest corporations; as late as the 1980s, the du Pont family was the richest in the entire nation, worth three times more than the Rockefellers, and many of them lived on rolling estates and horse farms near Chadds Ford. Through helpful du Pont family and corporate connections, *Roasted Chestnuts* hung in the Dwight Eisenhower White House, several Andrew Wyeth watercolors decorated the Hotel du Pont, *Groundhog Day* was displayed in the Philadelphia Museum of Art, and an entire

Wyeth museum was founded in Chadds Ford by a du Pont who married Andrew's niece (another du Pont married Andrew's son). Norman Rockwell was dumbfounded when a du Pont associate wanted to trade away one of her Wyeths: "Gee, she must be crazy. Should I tell her? A Wyeth's worth $50,000."[4]

- "Andy hated change," a friend recalls—and his *anti-modernism* was a fine old Brandywine tradition in art, literature, and thought. An art expert who visited him in Chadds Ford in the 1950s was astounded at how anti-modern he was: "In terms of all the prevailing directions of modern art, he is a reactionary. In terms of the possible ways of twentieth-century American life, he is living in the nineteenth century." In his art, Wyeth scrubs away most references to current technology, turns back to the late medieval practice of tempera painting, quite radically foregoes the camera, and (perhaps most importantly) *relishes the centuries-old art of drawing*—he created sixty drawings for *Groundhog Day* alone! The "unchanging" nature of his painting style, basically established in the 1940s, has been regarded as a plus and a minus, depending on the critic.[5]

Andrew Wyeth and Americana

As I argue in my book *The Brandywine: An Intimate Portrait*, this region was the beating heart of the "Americana" craze that flowered during Andrew Wyeth's youth. The antiques-collecting movement found its perfect milieu along the Brandywine, as today's grand house museums attest—Nemours, Eleutherian Mills at Hagley, and especially Winterthur—and this has become the essential place in the nation for cultural tourism around the theme of early American antiques. When Henry Francis du Pont became the master of Winterthur upon his father's death in 1926—an enormous estate of 2,400 acres, rolling down to the verdant banks of the Brandywine in Delaware—he undertook a multi-million-dollar expansion of the house, building a gigantic addition to showcase his growing col-

lection of classic Americana. The existing thirty-two-room mansion was supplemented by a wing with more than a hundred rooms, designed for good natural light and standing fully nine stories high on the downhill end. Eventually, it would include more than 175 period rooms in all, purchased from historic buildings in the thirteen original colonies. In the 1950s, just as Andrew Wyeth was becoming famous for nostalgic paintings rooted in rural Americana, Winterthur Museum was opened to an admiring public—130,000 tourists would eventually come every year, admiring some ninety thousand decorative objects from the seventeenth century to the early nineteenth, the largest collection of American antiques in the world. Living just five-and-a-half miles apart, du Pont and Wyeth were two facets of the same Americana movement that enjoyed tremendous middlebrow appeal. Eventually, Wyeth would paint du Pont's portrait on the Winterthur stairway, and the magnate would purchase *Groundhog Day* for the Philadelphia Museum of Art.

At ninety, Andrew Wyeth paid one last visit to Winterthur to see a Howard Pyle marine painting in the conservation lab, "setting off a small panic" among the curators when he grabbed the picture off the easel in his excitement. He and Jamie "crowded close to the canvas," a reporter wrote, "practically pressing their eyeballs against this work by their artistic forebear." "Can't you just feel the swell of the sea, Jamie?" the elderly artist cried.[6]

Wandering over the Hills

A closeup of legs and boots, *Trodden Weed* (1951) shows Andrew Wyeth stomping down a bleak Chadds Ford hillside while wearing his favorite footgear for walking—vintage French cavalier boots once used as a studio costume by Pyle and later one of his students. It perfectly captures the idea of the *walking painter*, steeped in a sense of historic place and love for the early American scene. The experience of walking was fundamental to Andrew Wyeth's art: as a little boy, he recalled, "I played alone, and wandered a great deal over the hills, painting watercolors." Another time he said, "When I was a kid and the rest were going to school, I was getting educated wandering through cornfields and the woods."[7]

Suffering from sinus and respiratory problems as a child, he never finished first grade and was subsequently educated at home, especially by his father, who thought the classroom blunted an artist's innate genius. He started training him in his studio when Andrew was fifteen. N. C. encouraged Andrew's delight in close, almost microscopic study of natural phenomena, emphasizing the importance of telling the exact visual truth as well as capturing a kind of spiritual essence in the object. In this approach, he was strongly influenced by Thoreau—as Andrew recalled, "He talked often about Thoreau to me," and he enlisted his teenage son to help illustrate a book that he had long dreamed of writing as a Thoreau tribute, *Men of Concord* (1936). Like the Concord transcendentalist, Andrew would always cherish the earliest winter months ("This is my time of year," he exulted in chilly January 1957) and make the most of this seemingly barren season. In addition, the dictum of close observation came from Pyle, that disciple of nature-worshiping English Pre-Raphaelites, who took his students daily into the Brandywine landscape and said, "Look on this, study it, absorb it. Never again will it be the same. If you see it tomorrow the light will be different and you will be different. This moment is unique."[8]

Throughout his career, Andrew Wyeth stressed his identity as a painter-of-places who depicted what he had *actually seen*, out walking. When displayed in museum exhibitions, even the lowliest cornstalk might carry (almost needlessly) the ultraprecise caption, "Painted in the field above the Chads House." Likewise consistent was his refusal to use photography as a tool, as artists had done since Edgar Degas; instead, he sketched constantly. Just as Thoreau ("I have traveled widely in Concord") found everything he needed for his craft within walking distance of home (Walden Pond was a mile-and-a-half away), so did Wyeth at Chadds Ford: the vast majority of his outdoor artistic production was done somewhere between Brinton's Mill and Archie's Corner, within a span of just 2.2 miles. Truly he was a micro-regionalist, traversing just two miles in seventy-five years and even lamenting at times that he had ever branched out to include Maine!

Under the spell of Dürer (likewise Pyle's master) and the Northern Renaissance artists famed for their microscopic vision of nature, young Andrew had taken up the ancient technique of tempera painting by 1936, the year he told a journalist, "I spend much of my time drawing and painting directly from nature . . . in this rather remote Brandywine Valley which still remains much as it was fifty

Patron saint of nature worship.
Henry David Thoreau was a key influence on the thinking of N. C. Wyeth, a fellow Massachusetts native who paid tribute to his idol in an evocative painting. His son Andrew absorbed these ideas too.
(N. C. Wyeth [1882–1945], *Walden Pond Revisited*, 1932 / 1933, oil on canvas, 58⅛ × 70". Brandywine River Museum of Art, Bequest of Carolyn Wyeth, 1996.)

years ago." Tempera does not lend itself to outdoor work, so he wasn't routinely seen in Brandywine fields while standing at an easel, like his oil-painting father—a stance the younger man regarded as entirely too static. Watercolor became his preferred plein-air medium: Andy charged briskly out the door with a cheap store-bought pencil, watercolor tubes in a metal box, and a sheet of paper supported by a slab of cardboard. When asked to paint a self-portrait (1945) for his National Academy of Design membership, he tellingly showed himself out walking the fields with a black pad tucked under his arm (and with ominous birds flapping in from a Pyle illustration). As often, he owed a debt to the Victorian Pre-Raphaelites in England: John Ruskin had advised fellow painter D. G. Rossetti not to sit outdoors and paint nature but to "merely look at the place; make memoranda fast, work at home at the inn, and *walk* among the hills. . . . A bit of paper fastened on a board is all you can possibly want." Unencumbered with an easel, Wyeth was free to draw anything and everything, and from multiple angles, even lying down in the stubble; leaves can still be found stuck in the dried paint of his pictures. "The winter has been

Artistic locus. The colonial John Chads House just before its 1960s restoration, a vicinity where the Brandywine illustrators—and, later, Andrew Wyeth—often sketched and painted.

cold and with plenty of ice and snow and the country looks the way I like it," he wrote to a friend in February 1944. "I have taken many walks over the hills [with] my watercolors under my arm as usual in case something hits me."[9]

In time, their beloved local landscape became a point of division for father and son, as Andrew began painting temperas of winter hills almost devoid of color (as in *Soaring*, begun in 1942). N. C. strongly argued against this approach—it was unsellable, and

Glimpse of the artist at work? This seemed to be a very rare photograph of Andrew Wyeth painting outdoors—but in fact is his young disciple Rea Redifer reenacting the 1964 creation of *The Bachelor*, sitting in a Chadds Ford side yard just where Wyeth did. (Photo courtesy of the Christian C. Sanderson Museum, Chadds Ford, PA © 2020.)

besides, the Chadds Ford landscape was full of color, even in the colder months. "I don't see this country in the winter that way," Andrew decisively replied as he courageously forged his own way—a direction encouraged by his forceful young bride, Betsy, who found N. C. overbearing and who, like Andrew, associated bright colors with the crass demands of advertisers and portrait commissioners. She knew how important his walks were: in publishing *Wyeth at Kuerners*, she organized the pictures as a stroll around the farm

acreage, calling this "a walk that took Andrew Wyeth 44 years to complete."[10]

She would tirelessly manage her husband's artistic career for decades, to the point of naming all his paintings (often with novelistic flair), insisting that he be called "Andrew Wyeth" and not "Andrew" (or the "Andy" that locals prefer), attiring him in oddly unconventional clothes, and making him ubiquitous through those coffee-table books and posters that virtually defined middlebrow American culture starting in the 1960s. One day in 1970, she explored the basement of the Chadds Ford Inn with her husband, studying historic architecture, as they loved to do. A preservation architect had joined them. Andrew casually doodled what he thought might have been the original circa-1810 layout. Before the architect could absent-mindedly put an original Wyeth artwork in his pocket, Betsy's hand shot out: "I'll take that." She maintained such eagle-eyed management of America's beloved artist all her married life.[11]

"Do Whatever Works"

In the 1970s, representational painting was at a low ebb as modernism triumphed. The young Florida artist Les Linton dreamed of meeting Wyeth just to ask him about traditional art techniques, which nobody had taught him in college. In March 1976, he secured a meeting with his idol, visiting the artist's studio, as few outsiders ever did. He asked so many questions about paints and papers that Wyeth laughed and said, "Materials don't matter. Do whatever works." Linton was astonished to find that America's most famous watercolorist broke the rules by frequently using opaque paints, as commercial illustrators did (his watercolor and gouache paints were mostly Winsor & Newton, but he used other brands as well). He was also amazed to see thumbprints in the shadows of the paintings (to lift the wet paint and show the paper) and half-finished pictures carelessly strewn underfoot in the studio. Wyeth pulled a print of Dürer's *Young Hare* (1502) from a drawer and explained that this masterwork had inspired his

"drybrush" technique, using tiny brushes; the term was an invention to justify his dealers' charging extra for these paintings that took several times longer than watercolors. Linton saw Whatman watercolor paper from England, bound into pads by a Wilmington bookbinder, but was shocked that Wyeth also used a slick, plate-finished Bristol paper, anathema to most watercolorists but good for showing minute brushstrokes. For this Southerner who regularly "stayed up at night with a magnifying glass" to study Wyeth reproductions, the visit to the studio sent him in a new, more experimental path in art: "It changed the entire direction of my life." And it is a reminder of the titanic stature of Wyeth among young artists—not a few were Southerners—who responded to his anti-modern themes in the back-to-nature seventies and desperately longed for a return to realism.[12]

Rainy afternoon along the Brandywine. Visitors to the historic valley in summer are often surprised at its lush greenness, so different from Andrew Wyeth's muted wintertime palette.

Flash Impressions

As we have seen, Andrew Wyeth's creative process strongly resembled that of Thoreau. The writer or artist goes out into nature *alone*—this was critically important to both men, to be undisturbed—wandering wherever his feet carry him, without much preconception. (Wyeth was often seen out walking, his peculiar clothing and elfin, ducklike stride making him immediately recognizable, but I have found almost nobody who actually looked over his shoulder as he painted.) He observes nature closely, almost obsessively; he sprawls on the ground, gets dirty; he stoically endures any kind of weather: "Sitting on a snowbank, lying in a marsh," as Wyeth wryly put it. Nature, in turn, rewards him with a sudden flash of inspiration. Rapid artistic notes are taken. Later, back at home, the artist begins to paint. Through this Thoreauvian process, the man disappears, becomes the "transparent eyeball" of transcendentalist lore, and nature shines right through.[13]

Accordingly, Andrew Wyeth did not plan his painting day: "I just walk a great deal over the countryside," he said in 1965. "I try to leave myself very blank—a kind of sounding board." While walking, he might glimpse "out of the corner of my eye . . . a flash impression of something—a spark of excitement." He would then reach for his watercolor block "as a notation—as one would write in a diary." Nature would take over entirely: "Sometimes, wandering—sometimes I don't even know I'm walking; don't even know I'm there." As so often, he followed the artistic dictates of Pyle, who similarly called for "the elimination of one's self." One had to work in isolation: as Howard Pyle School of Art students were taught, "You can't do it mechanically. You can't just say to yourself, 'I'll paint that.' First you must project your mind. And to do that you have to live very much alone."[14]

A well-documented example of Andrew's method is the painting of the famous *Brown Swiss*, a long, horizontal portrait of the Kuerner farmhouse and pond, which began with one or more *flash impressions*. "I have been taking long walks over the winter hills," he wrote to a friend in early 1957, "and just this morning

I went over to Karl Kuerner's house," appending a sketch: "The house looked like this in the morning light." Another time, he was motoring his Jeep home and stopped to watch Kuerner drive his Brown Swiss cattle across the road to the barn—noticing with a thrill the brilliant reflection of the farmhouse in the pond. His stories varied with every telling; a different version is that he was walking over Kuerner's Hill late one afternoon when he saw that reflection: "It got me. I went into my studio. A bottle of Higgins ink was on my desk. I grabbed it. . . ." Thus began a long series of studio and outdoor studies and finally the landmark painting.[15]

"It is very odd," he said in 1961, "but I find myself going back to the same places I have walked all my life and getting more and more excited." With the passing years, he suffered from a bad hip that made it increasingly difficult to walk. Often he preferred to drive his Jeep to favorite locales and, pushing his dogs aside, to sketch or paint while looking out the window or perched on the hood (the engine idling to keep him warm), but they were still the places that he had walked to as a younger man. The experience of walking defined his work right to the end. He described, for example, the streamlet and fence in *Run Off* (1991) as "based on many, many walks all my life long."[16]

Andrew Wyeth

A New Interpretation

VOLUMES HAVE BEEN WRITTEN about Andrew Wyeth, yet still he eludes our full understanding. I was granted no access to the four hundred hours of tape-recorded interviews the artist provided to his very patient biographer, but I gather that Andrew in conversation was not tethered by strict factual accuracy, often weaving mythologies-of-self. Subsequent writers have repeated these mythologies endlessly—how many times must we be reminded that he loved Halloween? We hardly get a glimpse of his true relationship to the history of art, and we come no closer to solving the conundrum of this man who was so extravagantly loved *and* hated by the world, which could never quite decide whether he were a profound poet of the human condition or a vulgar, sentimentalizing imposter; a modern Old Master or an illustrator of cornpone Americana suitable for framing; a firmly rooted man admirably loyal to his artistic convictions or a narrow-minded man too incurious to range widely in a career of seventy years. We are left to ponder, *Did he make the most of the unparalleled advantages he was afforded in life? Was his art a high quest or, to some extent, a kind of crowd-pleasing performance based on virtuoso skills in imitating reality?*

Promisingly, a good 2018 show at the Delaware Art Museum paired Wyeth's work with that of John Ruskin, a Victorian wor-

shiper of nature, a step toward placing him in a true, larger context, looking *back into the past* as we need to do for this most anti-modern of artists, whom the *New York Times* called "one of the last survivors of a very endangered nineteenth-century species." Like his father's hero Henry David Thoreau, he found electric inspiration in the lowliest products of the natural world: "My God, when you really begin to peer into something, a simple object, and realize the profound meaning of that thing—if you have an emotion about it, there's no end." So he brought a frozen crow to his studio and lay on the ground, drawing grass, all in preparation for the dead-bird picture *Winter Fields* (1942), a turning point in his closely observed art: "Without seeing this crow I would never have done *Christina's World*." Andrew Wyeth habitually lay on the ground—here again, following his father's predilection for visceral nineteenth-century romanticism in the vein of Wordsworth. N. C. wrote in 1907, "I feel so moved sometimes toward nature that I could almost throw myself face down into a ploughed furrow . . . I love it so." Just like Ruskin, Andrew Wyeth was profoundly devoted to art but arguably *even more devoted to nature*, with art a *tool for understanding* rather than an *end*. To twentieth-century modernists, this was a slippery slope on the way to "imitation," illustration, and mass-appeal kitsch; but to Wyeth fans, here his genius lay. As his protégé Bo Bartlett observed, "When he saw something that excited him he would reach for pencil and paper. . . . It wasn't about 'making Art,' he was just painting his life, recording his world. . . . Andrew Wyeth taught me what art is all about." Looking back at his career, the master explained to Bartlett, "I was really illustrating my life."[1]

The insistence on microscopic observation obeyed Howard Pyle's fervent dictum of "*real* things, *real* surroundings, *real* backgrounds." This mantra was a constant throughout the life of Andrew Wyeth: the totemic "real object itself" captured by the artist in a quasi-mystical endeavor through "absolutely accurate drawings." He followed an "ideal," said fellow artist Charles Burchfield, which was to "paint every straw in a haymow or every grass blade in a meadow and not lose the big pattern." Like Pyle, Wyeth had a strongly antiquarian emphasis, the preservation of the past: when

a reporter asked Pyle "what kind of shoe buckles were fashionable in 1764," he replied "with sentences precise and strong," for he was "an accurate historian. As regards manners, costumes, house furnishings, the accoutrements of war—everything, indeed, that was visible to the eye in the past—he is admitted to be the foremost American authority for the Colonial and Revolutionary periods." So too did impassioned references to history constantly spring up in the art of Andrew Wyeth, who cherished an oil sketch by Pyle that shows almost microscopically precise details of a fire crackling in a colonial fireplace, complete with real eighteenth-century andirons and tongs—extraordinarily intensive groundwork for an illustration.[2]

Artist of the Absolutely Accurate

Museum crowds are awed by Andrew Wyeth's endlessly patient verisimilitude (a friend called him "surgically observant"); some art critics condemn it as a kind of trompe-l'oeil cheap trick likely to inspire a slack-jawed, "Gee whiz, how'd he *do* that?" response. When I think of his work, I recall *Adam* (1963), with its loving and almost microscopic depiction of the wood grain in, of all trivial things, a *broomstick*. Going to such extremes is not to everyone's liking: "In the end his art seems the product not so much of inner vision as of an empty if superficially brilliant observation," said a critic in 1967, typified by a "conspicuous and perhaps even exhibitionist virtuosity" that gave the public such delight but was ultimately as shallow as an illustration. Not only the reigning abstractionists strongly recoiled from this approach ("like a vampire from a cross," one artist told me); representational artist Fairfield Porter disparaged "Wyeth's black virtuosity." "I don't like Andrew Wyeth's paintings," he told an interviewer. "I get something from him which I dislike." Was it in the antiquated subject matter or the lack of color? No, said Porter: "In him."[3]

The critics be damned: the microscopic eye was fundamental to Andrew Wyeth. "When painting people, Wyeth often seems at pains to describe the particulars and individual features," ad-

The artist going afield. Andrew Wyeth emerges from his station wagon on Creek Road, perhaps with sketchbook in hand, ready for a day of wandering the hills seeking "flash impressions." (Photo courtesy of the Christian C. Sanderson Museum, Chadds Ford, PA © 2020.)

mirer Wanda Corn wrote in 1973. "He is freer and less tied to such physical fact in his approach to non-figural works." I disagree: his "pains" extend to the smallest details of the landscapes of Chadds Ford, where "physical fact" is his constant striving. By revisiting the places where he stood, I have often been surprised to discover ever-more-extreme examples of his fidelity to exactly literal truth, even when there seemed to be no need for it: for example, the precision with which he depicts the mundane subject of a local car repair shop on the west bank of the Brandywine (*Retread Fred's*, 1982), for which he asked the mechanics to rearrange the piles of tires into a more pleasing pattern before he began—he would not

deign to "imagine" the piles but had to have them actually before him. Fifty years into a celebrated career, he could still find interest in the utterly ordinary and almost seemed to flee to it in lieu of making a grand statement (Pablo Picasso after fifty years gave us *Guernica*).[4]

Today's visitor to Kuerner Farm can confirm the exact configuration of nail holes in his *Easter Sunday* (1975), showing Anna on the porch; the exact pattern of the cheap wallpaper in *Groundhog Day* (1959); and even the exact same arrangement of colored knobs on the stove in *Home Comfort* (1976). Looking at his Chadds Ford work, I conclude that, to an extent unusual in the history of major artists since 1850, he fundamentally *avoids imagining things that are not there*, nor does he *much alter things that are*, except for selective omissions to give a "spare" effect. We think of him as a great traditionalist, but Jean-Baptiste-Camille Corot or Edgar Degas would have scratched their heads at this constrained approach to picture making.

He seems to have regarded his paintings as accurate stage sets preserving forever Chadds Ford as he knew it, after deleting certain unwelcome intrusions of modernity. Unless he gets the details exactly right, it won't truly be his Chadds Ford. Summoning a world with uncanny exactitude contains a kind of magic, as if he has captured something for all time, saved it, and kept it for his own delight and even the edification of the historic preservationist. (It anguished him whenever an old building was altered or demolished before he'd had a chance to portray it, making a "monument" in its memory—again, perhaps, art as a *tool for understanding* rather than an *end*.) On these stage sets would perform the actors of his rich imagination. He constantly referred to his own work as "emotional," but this term did not refer to the fevered artistic distortion of reality, as one might expect from a more typical twentieth-century master; instead, he meant the patient delineation of ultrareality, forming a factual framework in which his emotions could then play out. Sometimes these stage sets are peopled, and sometimes they are hauntingly empty; on occasion, the actors are almost-too-theatrically acting (*Snow Hill*, 1989).[5]

So he was the Artist of the Absolutely Accurate. Kuerner knew this well: upon being shown *Groundhog Day* at the painter's studio, he hurried home to fix the cracked windowpane in his kitchen, which he had never noticed before! Instinctively, he knew that Wyeth would never insert something imaginary. Whether such a fealty to "truth" and so passive an approach to what nature sends you (within the confines of two miles of countryside, for seventy years) makes for good paintings will always be subject to debate. He himself worried that his art hinged too much upon accuracy, as when he discussed his pictures candidly with a journalist in 1961: "I'm afraid that's why they have appeal, of course . . . to those many people who have no understanding of painting at all and enjoy seeing objects that look like real objects." Still, he was not dissuaded by the warnings of his detractors that great artists (especially after the invention of the camera) are not much interested in reiterating surface appearances with virtuosity.⁶

Certainly, he has not experienced the epiphany of Paul Gauguin, who declared to artist friends as long ago as 1888, "Some advice: do not paint too much after nature. . . . Think more of the creation which will result than of nature." Like his illustrator father, Andrew Wyeth revels in the chance effects of sunlight and shadows (*Young Bull*, 1960; *Big Room*, 1988), but Gauguin regarded such trivia as unworthy: "I will get as far away as possible from that which gives the illusion of a thing, and since shadows are the *trompe l'oeil* of the sun I am inclined to do away with them. . . . [Don't be] a slave to shadow." Wyeth's admirers often decry the abstractionists who attacked him, but it occurs to me how little he was beholden to the dictates of great *representational* artists, the postimpressionist Gauguin among them. Like Thoreau, he marched to the beat of his own drummer.⁷

But even Thoreau was shaped by his times. So it was with Wyeth: he came of age in the 1930s, when hyperrealism enjoyed a sudden vogue. "*Sharp focus and precise representation*" was the theme of *American Realists and Magic Realists*, curator Alfred Barr's 1943 show at the Museum of Modern Art, in which Andrew was invited to display several works, a crucial breakthrough for the young artist. Hyperrealism popularized by the English Pre-Raphaelites in

Sunlit studio at Rocky Hill. Andrew and Betsy Wyeth lived here in the 1940s and 1950s as his career blossomed. He continued to use the studio room (left) until his death.

the 1850s had proven a persistent American (and Philadelphian) approach well after photography became widespread and, indeed, made good use of the camera; the uncannily lifelike trees of Thomas Eakins's *Max Schmitt in a Single Scull* (1871), sunlit and reflected, are certainly ancestral to those in Wyeth's *Brown Swiss*. But this mode died out by 1900, except among illustrator-painters such as Maxfield Parrish, who briefly studied with Pyle in Philadelphia. In touch with European avant-garde trends of the 1920s, the Pennsylvania artist Charles Sheeler revived the hyperrealistic mode as *precisionism*, condemning the "slashing brush stroke" so popular since impressionism. Within fifteen years, numerous young American artists were painting in this anti-impressionist way, Andrew Wyeth included.

The public responded gratefully to the at-least-temporary rout of the forces of abstraction. Many artists chose subjects that celebrat-

ed Americana, that huge contemporary vogue; many of the works in the 1943 Museum of Modern Art show made reference to the American scene, either nostalgically or tinged with gentle irony. Often, the artists' statements referred to childhood memories and a strong sense of regional identity. This fertile ground was where Wyeth was lucky to land. As his statement said, he sought (like Sheeler) to abolish "so-called free and accidental brush handling" and thereby achieve "beauty, power and emotional content."[8]

The Robin Hood of Painters

I might suggest another source for his preference for the hyper-real—the curious circumstances of his upbringing. Upon visiting the two great art studios in Chadds Ford, the tourist comes away with a sense of how *neo-medieval* his childhood was, growing up as he did among the props and costumes of his illustrator father famed for *Robin Hood*, who himself was the disciple of the Pre-Raphaelite-inspired Pyle, who gave us the immortal *King Arthur*. N. C. designed a model castle for the boy, who even as an adult kept it in his studio. We see Andy playing Robin Hood among the rocks, wearing the hand-painted quiver of arrows that lies on a studio windowsill today (even as an old man, he would playfully sign his name "Robin Hood" and sometimes dress much like him). "To young Andrew, the hills and woods of Chadds Ford were Sherwood Forest," Corn wrote, "possessed of medieval castles, knights-in-armor." He and his gang would swoop down on the hapless grocery boy, plundering his sacks and then enjoying a repast in the forest.[9]

At age nine, Andrew used watercolors to illustrate his favorite themes in a little book, *The Clang of Steel*. When he eventually set aside his tin soldiers (or did he ever?—he collected them all his life), there came his ambition to be a painter. What kind? Surely a *medieval painter* in the spirit of the Pre-Raphaelites. He underwent a very old-fashioned apprenticeship with a master, N. C., who "ran his household like a medieval craft guild," one observer wrote. He cut his teeth by copying the medieval illustrations of Pyle and produced a stunning ink picture of the siege of a castle. The talent-

ed fencer handled watercolor in Maine with a swordlike, slashing stroke (he often equated painting with fencing) and posed in his studio for LIFE magazine in May 1948 with his sword stabbed into the floorboards. In the room next door stands a film projector, and he would screen such Hollywood epics as Charlton Heston's *The War Lord* (1965) over and over, which he called the perfect portrayal of the Middle Ages on screen.

And ultimately he revived tempera, that medieval painting medium. Like artists pre-Raphael, he raises the horizon line and flattens space (*Winter 1946*); he flattens skies as well and, to a degree exceptional for any modern landscape painter, ignores the transient effects of clouds or fog (nearly every day is "dull overcast," not his dad's "cumulus clouds and romantic feeling"). Moreover, he indulges in the so-called microscopic-telescopic vision of the early Northern artists whereby everything near and far is in hyperfocus. He omits mechanical modernity, unless it has a vaguely medieval flavor: rusted chains, iron barrels, sharp scythes, helmets (he said the barrel in *Roasted Chestnuts* recalled his father's tales of medieval armorers and that the whole scene "belonged as easily to the Middle Ages as to Pennsylvania Route 202").[10]

Moreover, he rejects entirely that modern apparatus, the camera, although artists had found it useful ever since a painter came up with it in the 1830s. Here he diverged sharply from most realist artists, including his own masters: Pyle had his students photograph colonial buildings and amass collections of reference prints, and the camera-loving N. C., late in his career, projected photographs with a lantern slide to draw them (*Portrait of a Farmer*, 1943), to Andrew's disgust. "I despise cameras," he told a reporter in 1961. "I can't run one." Five years earlier, he had said to a visitor, "When an artist starts using photographs, God help him! Then his imagination has *no* chance."[11]

But even more anachronistically than this, Wyeth reverts back to a *late-medieval conception of what painting is*: the almost mystical re-creation of nature on a flat surface through the use of illusionistic techniques. Truly his career arc seems to have been determined by an almost idolatrous admiration for Albrecht Dürer's *Great Piece*

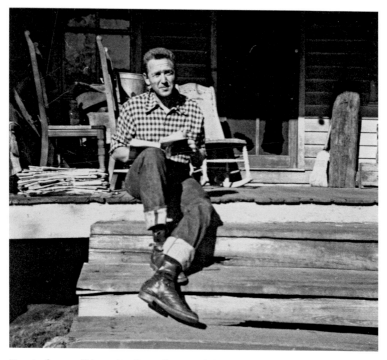

Boots for walking the Brandywine hills. Andrew Wyeth relaxes on Sanderson's side porch, a quiet retreat in the village. (Photo courtesy of the Christian C. Sanderson Museum, Chadds Ford, PA © 2020.)

of Turf and *Young Hare*, from the grass of *Christina's World* to the astonishing dog fur of *Ides of March* (1974). "My God that damned German could paint!" he once shouted to a startled young admirer. He believed that his father had been corrupted by the lush blandishments of French impressionist painting; by deliberate contrast, Andrew was an austerely *primitive* painter (as his austere wife encouraged, one might add).[12]

So primitive is his style that his works almost go back to the dawn of art: are not his numerous tempera-on-thick-masonite portraits with figures starkly outlined against putty-colored walls (*Buzzard's Glory, Maga's Daughter*) similar to Pliny the Elder's account of the birth of picture-making in antiquity, with the potter Butades's daughter outlining the shadow of her lover's face on a Grecian wall

to keep him forever? Note how he described the profile-view *Nicholas* (1955), which President Dwight Eisenhower admired so much that he borrowed it for the White House: "There was the eternal spirit of youth, seated against the bare wall of my studio—stone which dates back hundreds of years. The contrast of childhood against antiquity." Little Nicky, Andrew's elder son, was made to pose an hour a day for seven months for this picture, which revives the profile-portrait formulated by Pisanello in the 1400s but seldom used in modern centuries. A further Wyeth touchstone is that other ancient legend, much admired by pre-Renaissance artists, of Zeuxis painting the grapes so realistically that birds came and pecked at them. Surely he matched Zeuxis: as a child in the 1970s, I was mesmerized by the miraculously lifelike effect of the splintered log in *Groundhog Day*—who wasn't?[13]

American Surrealist

To try to tackle another fundamental problem that commentators have usually skimmed over: Why are his landscapes so "noncolor," as he once described them? We cannot fully accept the artist's explanation that the shock of N. C.'s death made him change his palette to brown; the transformation happened about three years before that. Surely the answer lies in his larger effort to establish himself as an artist independent of his awe-inspiring father, whose color shimmered and whose virtuoso handling of oil paint, he believed, could never be surpassed. And the anti-impressionist was determined to avoid the sentimentalism that stereotypically went with "Pennsylvania landscapes," red barns and brown cows, what he called a mere "pleasant picture." Moreover, his sober style developed around 1942, in the midst of a global war that claimed the lives, among countless others, of thirty-three thousand Pennsylvanians just his age.[14]

But in a more positive vein, the scrappy young man sought to forge, in the spirit of Pyle, an entirely American approach to art, with nothing owed to French impressionism. Note how Pyle's credo, expounded to a journalist in 1910, exactly matches that

Surrealist roots of Andrew Wyeth's haunting style. Decades later, he had not forgotten the impact of first seeing the mysterious *Paranoiac-astral Image* by Dalí in the thirties.

of Wyeth years later: "That art should represent what the people want, what they love; that the artist should base his work on simple statement of natural and psychological fact; that Americans should study at home in their own country, instead of flocking to France, where art [is] decadent." Deliberately, Wyeth cut himself free from what he regarded as the corrupting oversophistication of Paris and sought a uniquely nativist approach, finding hints in austere early Americana: ironwork, cabinetry, wagon building. Thereby he shook off, he recalled, "the colorful 'impressionism' of my earlier works" (such as the 1937 Maine watercolors that first gained him critical attention). His own, increasingly earth-brown paintings became expressions of American *craft*—not his father's bravura plein-air oils dashed off in an afternoon but old-fashioned temperas that might take a year to finish. Tempera perfectly suited his desire to

achieve that "dry quality" in art that he found peculiarly pragmatic and American.[15]

And yet Paris did influence Andrew Wyeth, although critics have largely overlooked it. Surrealism was all the rage there when he was a boy. Salvador Dalí made a sensation with an exhibition in New York in 1934 (those melting pocket watches) when young Andrew was first painting in his father's studio. In a revealing interview late in life, he could still remember the first time he saw Dalí's *Paranoiac-astral Image* (1934) in New York, a surrealist landscape that combines hyperreal observation with swaths of lonesome void—not unlike Pyle's *Marooned*, actually, and an approach that he would come to embrace in his own art. Already he was primed to appreciate surrealism: Pyle's art was rooted in intuition and deep feeling (touched with Swedenborgian mysticism), and Andrew recalled of N. C. at work, "My father used his subconscious mind heavily."[16]

Commenting on his own painting, Andrew Wyeth frequently mentioned Freudian psychological themes and a fixation on dreams and memories, sex, and dying, the roots of surrealist thought about art (see, for example, the glowing corpse of *Christmas Morning*, 1944, or his weird horse-skeleton picture, *Night Mare*, 1973). He said that a deathlike Dürer himself had summoned him once in a frightening dream. In a typical statement, one critic finds him obsessed with "illness, putrefaction, and death." His landscapes often highlight surrealist tropes: sharp-beaked birds, dead and alive (*Winter Fields*, *Woodshed*) and sharp, menacing objects (blackberry thorns, the ceiling hooks in *Karl*, the jagged log standing in for a dog's fangs in *Groundhog Day*, the rifle pointed at the hapless wife in *The Kuerners*).[17]

Throughout his work, ordinary places assume a surreal psychological intensity by being portrayed a little too microscopically; hills become the rounded forms of human bodies, with tire tracks as scars; the model Helga Testorf's curvaceous body is equated with Kuerner's Hill (*Overflow*, version of 1973). In *Groundhog Day*, the knife "becomes" Kuerner by mysterious means of the surrealist "significant object." Readers of Wyeth's sometimes-shocking authorized

Wyeths on exhibition. Jamie, Betsy, and Andrew Wyeth at the artist's Delaware Art Museum show, January 1957. Ever since the time of N. C., the family had many connections to Wilmington, where du Ponts proved influential friends. Jamie had posed for *Faraway*.

biography will recognize numerous, faintly unsettling psychological themes that find resonance in Dalí's work, from the sexual right down to the scatological. Likewise unsettling was the frankness of certain of the Helga nudes and, I am told, some of the artist's own uninhibited conversation: like the surrealists, he did not hesitate to shock the straight-laced. The painting process itself was like the "urge for sex," he said. Americans needed no deep reading to absorb Freudian and surrealist ideas: Alfred Hitchcock's *Spellbound* was a smash hit in theaters at Christmas 1945, with a disturbingly psychological dream sequence designed by Dalí himself—including a lonely man running headlong down a featureless hill, which seems unmistakably to happen again in Wyeth's *Winter 1946*.[18]

Again and again, his painting methods owe much to surrealist thought. A childlike adult who, his biographer makes clear, evaded much real-world responsibility, he consistently sought to tap into childhood memories and dreams, painting the places of his boyish memories again and again—following the surrealist insistence that childhood is the wellspring of our subconscious. In *Faraway*

(1952), he shows his own child, Jamie, daydreaming alone "on a path above the studio" after a typical day "crossing fields" with his dad—engulfed by nature. (Decades later, Jamie's own paintings would grow surrealist too, as in *Pumpkinhead—Self-Portrait* of 1972.) He constantly worried that he was overintellectualizing his art, which he thought should be shaped by hidden forces and chance. For the same reason, he avoided showing unfinished paintings to anyone and, when working outdoors, scurried away when people approached—lest they make a rational comment that would derail the subtle internal process. He largely favored visiting Kuerner Farm because the gruff Germanic owner left him, and his psyche, alone. "He was always wandering around here, busy at painting something," Karl's daughter recalled. "I thought he was so handsome. But my father was very strict about us not bothering him."[19]

In addition, he closely followed the surrealist dictum of "automatic painting," in which chance and accident seize control, overruling the conscious mind: taking artistic walks with no preplanning; grabbing a watercolor tube at random from his messy metal box and using whatever color it happened to be; leaving a splatter caused when his palette was kicked by the frisky heifer of *Young Bull* (1960); or knocking over a bottle of black ink and then turning the drips into the trunks of pine trees in *The German* (1975). Watercolor was good because "you come on something in nature, you're excited, and you can let it out before you begin to think." Perhaps automatism was ideal for a chiefly instinctive artist. One local who knew him for decades laughed when I began to discuss his work in intellectual terms: "No, he was *simple*. Not a deep person. Totally out of the world, never went anywhere. Lived to paint." Any intellectual overlay, this commentator believed, came from Betsy, who was well-read, was uncannily intuitive, and thoroughly "orchestrated" her husband's career. *Never went anywhere*: to understand him we must not forget how truly narrow his horizons were, by choice, and how "ingrown" the Thoreauvian became, alone with his drawing pad all those hundreds of drizzly mornings in Kuerner's cattle yard.[20]

So the Freudian-psychological became central to Wyeth's art, a direction in which N. C. himself was already moving with *Dying*

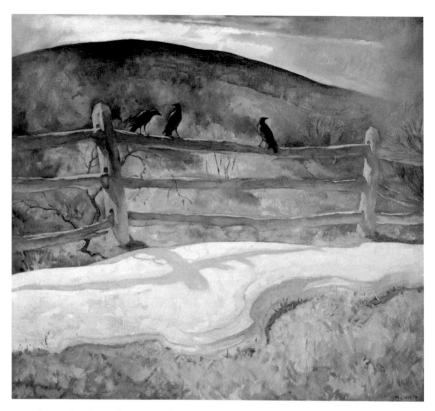

Genesis of a sober mood. During the Depression, N. C. pioneered the wistful approach to landscapes that his son Andrew would later make his own. Here he evokes Kuerner's Hill. (N. C. Wyeth [1882–1945], *Dying Winter*, 1934, oil on canvas, 42¼ × 46⅜". Brandywine River Museum of Art, Purchased with Museum funds, 1982.)

Winter. As has become legendary, Andrew's career was transformed by the psychic shock of his father's sudden death at the railroad crossing alongside Kuerner's Hill in October 1945: "I had always had this great emotion toward the landscape and so, with his death, I seemed to—well—the landscape took on a meaning—the quality of him." Painting *Winter 1946,* in which the barren hill becomes a symbolic portrait of N. C. himself (the late artist somehow still alive and breathing beneath the grassy slope), showed the young artist how he could paint realistic subjects in his cherished local

countryside and, at the same time, supercharge them with personal meaning, emotional depth, and a tinge of surrealist strangeness.[21]

He persevered in this new approach, which found a triumph in *Christina's World* (1948). It earned an immediate home at the Museum of Modern Art for its *en vogue* surrealist qualities: the faceless woman, young/old, crawling hopelessly toward an unattainable goal in a hyperreal yet barren landscape, one that may be just a dream. By then, his rocketlike rise to fame had already begun: earlier that year, LIFE magazine had called him "one of America's most popular artists" and the torchbearer for "a purely American tradition in art." Much preparation had gone into this achievement: it had been exactly fifty years since Howard Pyle had come to Chadds Ford to launch an artistic revolution, forging "painters of true American Art."[22]

PART II

Exploring Wyeth Country

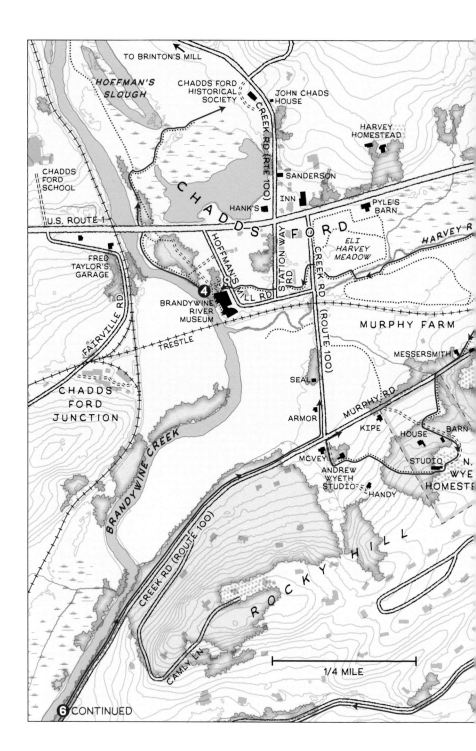

TO BRINTON'S MILL

HOFFMAN'S SLOUGH

CHADDS FORD HISTORICAL SOCIETY

JOHN CHADS HOUSE

HARVEY HOMESTEAD

CHADDS FORD SCHOOL

CREEK RD (RTE 100)

CHADDS FORD

SANDERSON

INN

HANK'S

PYLE'S BARN

U.S. ROUTE 1

HARVEY R

ELI HARVEY MEADOW

STATION WAY RD

HOFFMAN'S MILL RD

FRED TAYLOR'S GARAGE

FAIRVILLE RD

④ BRANDYWINE RIVER MUSEUM

CREEK RD (ROUTE 100)

MURPHY FARM

MESSERSMITH

TRESTLE

CHADDS FORD JUNCTION

SEAL

MURPHY RD

KIPE

HOUSE

BARN

ARMOR

STUDIO

MCVEY

N.

BRANDYWINE CREEK

ANDREW WYETH STUDIO

HANDY

WYE HOMESTE

CREEK RD (ROUTE 100)

ROCKY HILL

CAMLY LN

1/4 MILE

❻ CONTINUED

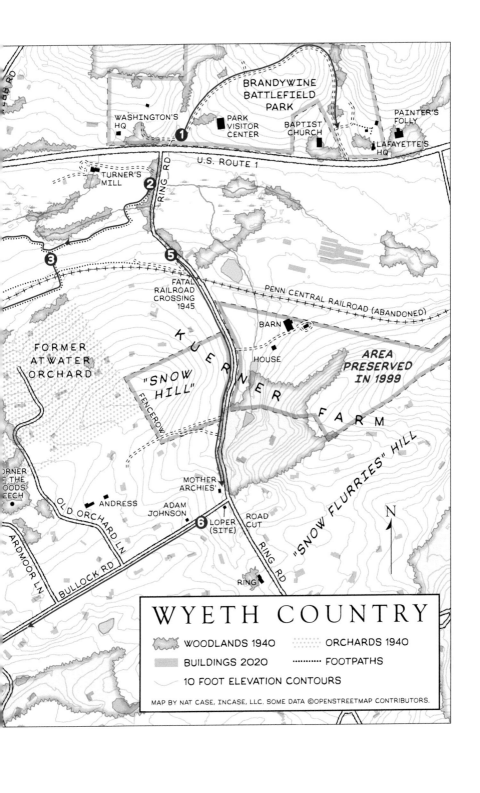

WYETH COUNTRY

WOODLANDS 1940
ORCHARDS 1940
BUILDINGS 2020
FOOTPATHS
10 FOOT ELEVATION CONTOURS

MAP BY NAT CASE, INCASE, LLC. SOME DATA ©OPENSTREETMAP CONTRIBUTORS.

"An Illustrators' Haven"

Brandywine Battlefield Park

T HE BATTLE OF THE BRANDYWINE haunted the imaginations of N. C. and Andrew Wyeth, and together they depicted every major place associated with that epic battle of the American Revolution (September 11, 1777). This tour offers a chance to contemplate what the conflict meant to them as well as to Howard Pyle, who deliberately chose to locate his ten-week summer art school for fifteen gifted students at the headquarters of George Washington and the Marquis de Lafayette. The drive leads through the fifty-two-acre state park that preserves a small fragment of the sprawling battlefield, much of which has been buried under upscale housing developments since 1980.

Not one but two "September 11ths" darken the chronicles of American history. The often-forgotten one happened in 1777, when the trouncing of Washington's army at the Battle of the Brandywine marked the military nadir of the American Revolution. Philadelphia was then the largest city in America, and to defend it seemed imperative. Armies attacking from the south would have to cross the Brandywine, a formidable barrier with steep-sided hills and strong watery currents. And so it was on the banks of the Brandywine that Washington drew his defensive line in September 1777 as a British invasion force approached—having landed at the

Historic hills above Chadds Ford. This hallowed 1777 battleground was a longtime haven for artists. Shortly after the Civil War, the visiting Russell Smith showed fence-diggers unearthing a Revolutionary-era cannon in *Brandywine Battlefield* (1870).

Russel Smith

head of the Chesapeake Bay and marched north. The bucolic countryside settled by peace-loving Quakers was about to witness the largest and longest land battle of the Revolutionary War, with some thirty thousand soldiers engaged as Generals George Washington and William Howe faced off in their only head-to-head matchup.[1]

Jumping ahead more than a century: the so-called Brandywine Tradition of art was founded by that tall, stern, and square-jawed Wilmington native Howard Pyle—the most successful American magazine and book illustrator of the late nineteenth century, legendary for *King Arthur* and other classics. "They call it the Brandywine School," Andrew Wyeth told an interviewer in 1980. "It's actually the Howard Pyle School, really. It was an illustrators' haven here." Through 3,300 illustrations plus the nineteen books he wrote himself, Pyle gave us our modern conception of knights and pirates, vivid images that Hollywood later appropriated, and his reputation continues to grow. As we have seen, he had a passion for Revolutionary War history, as countless paintings and illustrations attest—for example, the stirring depiction of Continental troops advancing in *The Nation Makers* (1902), now at the Brandywine River Museum of Art (see p. 4). In 1898, he brought his summer school to colonial Chadds Ford at the heart of the Brandywine battlefield.[2]

Washington Gets Flanked

The American rout at Brandywine was the result of one of the more ingenious flanking maneuvers in military history—"a capital stratagem," novelist Washington Irving later called it. As Howe's army approached, some eighteen thousand strong, Washington, with about fifteen thousand tattered troops, failed to identify all the Brandywine fords upstream from his position at Chadds Ford. Moreover, someone fed him the false information that there were no fords at all above a certain point. The British took brilliant advantage of his ignorance. The portly, toothless Howe was that day "at his very best," according to British military historian Sir George Otto Trevelyan, not his sometimes sluggish self but "the high-mettled warrior who had stormed the redoubt at Bunker's Hill."[3]

As Howe's massive army neared the Brandywine on the foggy morning of September 11—their ultimate objective being Philadelphia—he sent a small group to strike Washington's center at Chadds Ford, purely as a distraction. American cannons thundered at Rocky Hill (the future site of the N. C. Wyeth Homestead), and redcoats waded across at Brinton's Mill (home of Andrew Wyeth for nearly fifty years). At the same time, the main body of the British army went left by back roads to cross the Brandywine upstream from Washington's army at Jefferis's Ford, a locale the American commanders were unaware of. The Continentals were closely guarding the Brandywine fords they knew about—seven crossings from Pyle's Ford north to Buffington's Ford—but unfortunately not the one higher up. Local Loyalists made the flanking maneuver possible by guiding the British, at whose head rode General Charles Cornwallis, erect in the saddle, an awesome sight to farmers who, forgetting their hay making, stared in astonishment as history passed their door: "His rich scarlet clothing loaded with gold lace, epaulettes &c occasioned him to make a brilliant and martial appearance"—much as suggested in an Andrew Wyeth watercolor, *British General at Brandywine* (1944).[4]

At midday, Washington finally realized that he had a huge enemy force advancing across the hills toward his vulnerable right. He swung his army into action, and fighting was fierce around Birmingham Meetinghouse. But as the hot day ended, his army was fleeing in disarray, in spite of the efforts of the young French officer Lafayette, whose wounding made him a transatlantic hero (Andrew Wyeth showed *Washington and Lafayette* in a 1954 tempera). The defeated Americans would spend the winter camped in near-starvation conditions at Valley Forge, the very trough of the young nation's fortunes.

Two Revolutionary Headquarters

⇢ *Enter Brandywine Battlefield Park at the intersection of U.S. 1 and Ring Road.*

As you look left, the road leads to the Benjamin Ring House, or **Washington's Headquarters** (ca. 1730, burned in September 1931

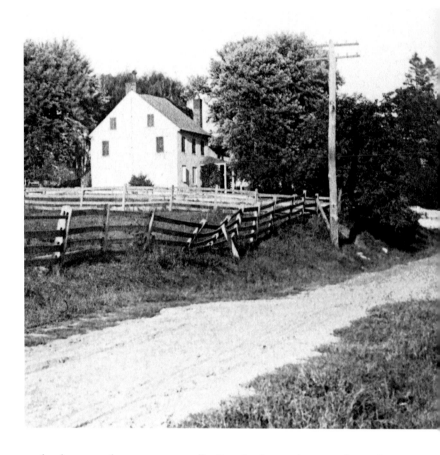

and subsequently reconstructed). Overlooking what was long the main highway from New York to Washington, it has attracted countless tourists since the dawn of the automobile age. Famed for its role in the Revolutionary War battle, this historic stone dwelling was home to the male students of Pyle, who drew lots for the best rooms; losers had to sleep in the sweltering attic. All made do with a primitive outhouse. Pyle took the students "into the fields near Washington's Headquarters" to set up easels and paint a model on June 24, 1898, the very first day of his school.[5]

N. C. had a deep affection for this place, for which he even painted a roadside sign; he showed it for example in *The Pump House* (ca.

Great Road of colonial times.
A rare view of Washington's Headquarters in the 1890s era of the Howard Pyle School of Art, facing dusty Baltimore Pike, which runs north toward Philadelphia—today's congested U.S. 1.

1911, a view from its uphill springhouse), and he tried to remember its prefire appearance in *Nightfall* (1945). He adored the quaint Quaker sisters who lived here as well as the enthusiastic local historian Christian Sanderson, who, with his mother, later rented the place, before the conflagration. Young Andrew became a disciple of the colorful, curmudgeonly "Sandy"—who always called him "boy." The artist showed Washington's Headquarters in the background of his *Portrait of Chris* (1937), now at the Sanderson Museum in the village. Among his first exhibited works (1935) was a watercolor, *Ruins—Washington's Headquarters*.

Far uphill (off Atwater Road) stood the vine-covered, green-serpentine-stone **Windtryst**, a stately Victorian mansion built in Italianate style by the wealthy Philadelphia lawyer Joseph C. Turner in 1867—among the first indicators of the estate-building mania that would eventually transform this valley. Turner had met his poetical wife, Eliza, after the battle of Gettysburg, where both were serving in hospitals. The author of *Out-of-Door Rhymes* (1872), she invited poor city kids to spend weeklong summer vacations with them at

Chadds Ford—her Children's Country Week Association may have planted an educational seed in the mind of Pyle. Turner eventually rented Painter's Folly and the gristmill to the illustrator for his summer school. N. C. lived at Windtryst upon returning to Chadds Ford as a newlywed in 1907 and again in early 1911 after giving up the lease on the Harvey Homestead (although he retained the Harvey studio until the fall, painting *Treasure Island* there).

Windtryst burned in the fall of 1914, putting an end to the famous masquerade dances beneath lantern light amid shocks of corn. Andrew played among the romantic ruins as a child. Some of its stones were hauled to Kuerner Farm by German prisoners of war during World War II. This area, now largely developed into housing lots, was a favorite place for N. C. to go walking: up the hill at Taylor's (formerly Turner's), down the "ravine," up to the still higher hill he adored as **Sugar Loaf** (at the top of today's Atwater Road), from which one could then see across a treeless landscape the du Pont mansion of Granogue on its hilltop in Delaware.

✤ *Drive east through the park.*

The road twists down to **Lafayette's Headquarters**, otherwise known as Gilpin's Tavern. Neither name is historically accurate, some scholars now say, but I believe that they ought to be retained, having been current for centuries—the Revolutionary War historian Benson Lossing called it Lafayette's Headquarters on a tour in the 1840s, and after the Civil War, this site was the prosperous Lafayette Farms, only the second dairy to ship milk to Philadelphia in glass bottles. The stone section is from 1745 (Pyle thought it dated from 1700); various dates have been suggested for the puzzling frame half. Owned by the state of Pennsylvania since 1949, two restorations have tried to return the place to an authentic, if somewhat scrubbed-clean, colonial appearance. Many stories relate to its role in the battle and to the elderly Lafayette's ceremonial visit on July 26, 1825, when he shook hands with the dying Gideon Gilpin here—ample proof of his close connection with the locale.

Lafayette slept here. His famous Revolutionary War headquarters as the students of Howard Pyle knew it, ca. 1903.

Formerly whitewashed, the venerable structure housed the female students of Pyle, who posed for photographs on the stone steps facing the highway. It had once been owned by his grandfather, William Painter. Pyle described it in an 1898 letter: "It is a beautiful little place perched upon the side of a hill, overlooking the stretch of valley to the airy hills beyond, and surrounded by old stone walls with a horse-block and with great buttonwood trees at the sides and sloping fields around." He loved the quaint historic details of this home and used its eastward-facing porch steps to illustrate a *Harper's Monthly* article in 1898—although the text was about another colonial subject entirely![6]

Lafayette's Headquarters was a favorite haunt of the younger Wyeth, who painted the owner and avid local historian Arthur Cleveland in a bedroom here, a picture splashed across a full page in LIFE magazine in May 1948 (and the subject of a controversial sell-off by a strapped Delaware museum in 2015). The bedroom also appears in *Four Poster* (1946), the ceiling plaster cracks *shown identically each time* with his curious precision when it comes to trivial details—most other painters might have used an artistic pre-

Lafayette's Headquarters transmogrified. Its venerable steps were transformed into a magazine picture of an unrelated colonial subject by the imaginative Howard Pyle: *And You Shall Not Hinder Me* in *Harper's Monthly* (December 1898), an early example of the new full-color printing process that proved a boon for illustrators.

rogative to invent them. (A far more "typical" approach was that of Graham Sutherland in England, making wartime art during this same decade: every time he drew a scene, its appearance *changed* under the influence of his imagination, what he called "metamorphosis" through intense feeling; with Wyeth, the scene basically *remains the same* every time.) Andrew deeply sympathized with Cleveland, whose health failed after he lost this building to the state in a bitter court battle—he died of a heart attack in 1950.[7]

A huge barn once stood uphill. Near the parking lot, the **springhouse** that formerly had a giant sycamore behind it was a favorite subject for Pyle's student painters. It resembles the one that N. C. painted in one of his last and most beloved depictions of disappearing rural life, *Springhouse* (1944), which Andrew put in the memorial exhibition that he organized in his father's honor at the Delaware Art Museum in January 1946.

Painted by N. C. as the Pennsylvania impressionist masterpiece *Buttonwood Farm* (1919), the immense **Lafayette Sycamore** on the lawn of Lafayette's Headquarters is one of the nation's finest trees, measuring an extraordinary 23 feet around, 99 feet tall, and 130 feet in magnificent spread. It is considered so valuable that Longwood Gardens has cloned it. Andrew loved retelling the legend that it shaded the injured French officer in 1777 as he stoically poured blood from his boot. Longwood estimates its age as 290 years; certainly, it was already huge when Lossing sketched it in the 1840s, and later Andrew Wyeth would speak of it rapturously as being five hundred years old and epitomizing everything he loved about the local scene.

Shown with Dürer-derived hyperprecision, it played a starring role in his signature early picture, *Pennsylvania Landscape* (1942), in which intrusive U.S. 1 is discreetly replaced by the sinuous Brandywine, and it appears again in *Gilpin's Tavern* (1952). The American public first became aware of him when he painted this tree for the cover of *Saturday Evening Post* as *The Hunter* (1943). Cleveland's son told me how he marveled at the artist perched on a twenty-foot ladder up in the sycamore. He added that Andrew frequently visit-

**Essence of
the pastoral
Brandywine.**
One of N. C. Wyeth's
last, most beloved
paintings, *The
Springhouse* (1944)
took a nostalgic look
back to a vanishing
way of life. Like his
son Andrew, he was
deeply moved by the
historic architecture
of Chadds Ford.

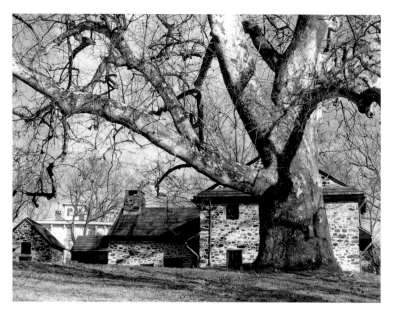

Pennsylvania landscape. The immense Lafayette Sycamore towers over the French general's wartime headquarters. At left rises the white cupola of Painter's Folly. All this was the inspirational summertime campus of the Howard Pyle School of Art.

ed the Gilpin place during wartime, sometimes painting in the back of his Ford station wagon in the rain.[8]

Pennsylvania Landscape was a crucial milestone in Andrew Wyeth's development. The contrast with his father's *Buttonwood Farm* of twenty-three years earlier is telling: the younger man declares himself a committed anti-impressionist by banishing the broad brushstrokes, the gauzy portrayal of lush nature, the atmospheric effects, and the high-key "painterly" purple. Instead, he gives us microscopic details of twigs and trunk and a maplike portrayal of the landscape. He is committing himself to a career of micro-regionalism: he will paint subjects extremely close to home, to which he can easily walk or drive; he will plunge deep into their actual appearances by means of understanding them with Thoreauvian thoroughness; precisely real places will become

the stage set where his rich emotional world of imagination can play out.

West of Lafayette's Headquarters stands **Brandywine Baptist Church** (1869), the only really large public building of old Chadds Ford—one shown in the background of Andrew Wyeth's *Renfield* (1999). A place of worship has stood on this knoll for more than three hundred years—back when this was the westernmost fringe of European settlement in the Mid-Atlantic—and colonial tombstones dot the graveyard. Except for today's trees, the setting has hardly changed since Pyle knew it. Andrew attended the funerals of Karl and Anna Kuerner here. The **sexton's house** by the highway was frequently painted by Pyle's students, a challenge when backlit by the sun (*contre jour*).

Howard Pyle at Painter's Folly

"Within a stone's throw of General Lafayette's Headquarters," as N. C. put it, stands the handsome, ten-bedroom Italianate house **Painter's Folly** (bought in 2018 by Chadds Ford Township in a happy turn of events), which will always be associated with Pyle. Built by Samuel Painter about 1857 on 225 acres, it was long known as Lafayette Hall. Pyle's mother was Samuel's sister, born east of here at Painter's Crossroads, and he knew this house from childhood. The morning after arriving in Chadds Ford, N. C. and the other students boarding at the Harvey Homestead "all went up to Howard Pyle's . . . and attended a composition lecture," the start of a delightful connection with the place.[9]

In establishing his art school, Pyle rented the vacant Painter's Folly from Turner, its owner since 1870, filling it with his family of six children. His pupils never forgot the fun of ping-pong or tennis on the lawn (the site of the court, laid out in August 1902, is visible east of the house), plus all-day fireworks extravaganzas on July 4. Sitting on a kitchen chair before an easel on the lawn as students painted in the meadow across the road, Pyle worked on the marine picture *The Evacuation of Charleston* for *Scribner's* in 1898. He

was shaded by an apple tree from which he had Frank Schoonover break off a switch as a mahlstick.

During the evening, family life routinely shifted to the spacious, 220-foot **porch**, where Pyle drew his now-legendary pen-and-ink pictures for *King Arthur*—an American art triumph never to be forgotten—while his children romped. If he needed more light, he would sit just inside the screen door, under a lamp. (The text was dictated back in Wilmington as he paced the floor in his studio, its jaw-breaking neo-medieval diction driving his young secretary to distraction—a horror she had not forgotten when interviewed in 1966!) Pyle reverently pointed out features of the battlefield from the porch, stressing that fighting took place right before their door. On October 18, 1903, the last day he taught in Chadds Ford, he posed for a photograph with grinning students on the lawn, N. C. among them.[10]

The house is beautifully preserved today, and one can imagine Pyle's students cracking nuts before a roaring fire here and listening to his Revolutionary War tales. One recalled seeing him up on the stair landing with *Travels of the Soul* on his easel (*Century Magazine*, 1902), the model fidgeting in her costume, children caroming underfoot, and Mrs. Pyle reading aloud his proofs from *King Arthur* as he verbally corrected them—all at the same time. N. C. never forgot his very first sight of Pyle in Chadds Ford, glimpsing him through the tall windows from the porch, the great artist reading at a table with the entire family gathered around, some busily drawing—it was a joyous domestic scene that N. C. would later seek to replicate himself as a father.[11]

Andrew Wyeth at Painter's Folly

Some Kuerner Farm paintings of Andrew's show Painter's Folly beyond the train tracks (before the trees grew up), such as *Toward Atwaters* and *Downgrade* (both 1968), and it appears in the background of *The Big Oak* (1978). One day in 1989, he suddenly showed up by the swimming pool, making sketches, to the shock of the owners, George and Helen Sipala; soon he was painting there almost every day, starting an intense twenty-year friendship. (Curiously, he

Legendary porch of Painter's Folly. Here, the Howard Pyle family sat on summer evenings as the great artist drew the immortal ink sketches for *King Arthur*. Photo ca. 1970.

had never been inside the house since coming there for appointments with the ear, nose, and throat doctor Arthur H. Cleveland as a boy.) The decorated interiors (and lavish Christmas displays) reminded him of the Homestead when he was a child, quite unlike Betsy's stern and rather bare aesthetic he had lived with for decades. Helen's delicious cooking and endless patience in listening to his stories (both true and palpably false) gave him a blessed sense of respite during the 1990s, when his unconventional lifestyle led to tensions with the women in his life, Helga Testorf and Betsy. Deliberately, he would park his car behind the house so that nobody could find him.

Helen posed for him throughout the majestic house, as in *Beauty Rest* (1991), often straining her back or suffering from the direct sun that the artist preferred; these were modeling sessions that Andrew came to expect, regardless of whether they suited her personal schedule. Letting watery pigments gush down the paper, he frequently ruined Helen's carpets, bedspreads, and furniture; he was cheerfully indifferent to her property, her time, and his power to disrupt others' lives. Usually the sessions were full of laughter, but sometimes Andrew and Helen quarreled over

the question of whether church or modeling took precedent on a Sunday, with the atheist artist finding her religious observances absurd—the local hills were his God, he explained.

Helen and George are tucked into bed for the strangely moving *Marriage* (1993). Andrew felt right at home, sometimes driving over and sneaking upstairs in the early hours of the morning and watching the Sipalas as they slept. He showed special interest in the glassed-in **cupola**, in which he sat to paint *Glass House* (1991) and the moonlit *Renfield* (1999)—the latter offering a view of Lafayette's Headquarters and the giant sycamore from above, a century after Pyle's students lived here, plus the oddity (for Wyeth) of headlights on the highway; late in life, he somewhat loosened his strictures against depicting modernity. Helen marveled at the frenzied speed at which he painted, and his watercolor-paint splatters are still visible on the walls of the cupola today. In the curious *Widow's Walk* (1990), for which he sat perilously on the porch roof, Painter's Folly appears against a fictional landscape blending Chadds Ford's Sugar Loaf and Delaware Bay (as Betsy suggested, although Helga disapproved). The oceanic horizon was meant to allude to Pyle's sailing for Europe and premature death. Andrew fell in love with this remarkable Victorian house, flooded with light from its huge windows and redolent with associations of Pyle and N. C.; and with typical generosity to friends, he gave the Sipalas the money they needed to replace the stucco and the roof. His last visit came at Christmas just days before he died.[12]

We might consider as well some locales farther east from here. Not far away and very close to the highway stood the rickety-looking **Andy Davis House**, a colonial landmark for Andrew as a boy when his father drove him to Painter's Crossroads (on Concord Pike) for ice cream on Saturdays, where a policeman attired like a Keystone Cop stood in the middle of the highway to turn the traffic signal. Decades later, Wyeth painted a series of pictures of the house and its black inhabitants, including *Oliver's Cap* (1981) and *Painted Post* (1985). The odd *Fast Lane* (1987) shows a dead squirrel splattered on the highway. At one point, it is said, an outraged traffic officer warned him he couldn't stop and paint alongside the busy road:

"Who do you think you are, *Andrew Wyeth?*" Always affectionate toward old houses, he was shocked when the Davis House was suddenly demolished in 1995. "Andy hated change," a friend recalls, perhaps the perfect three-word summation of the man.

Several eateries nearby had Wyeth associations. Tom Drane bought the old, scrappy **Chadds Ford Tavern** on the south side of Baltimore Pike in 1967, long an African American juke joint, and offered live music. To draw customers' attention, he installed the red British phone booth beside the road. Andrew would drop off his dissipated model Willard Snowden with $20; soon, he began staying for a meal himself, with his son Jamie often stopping by, perhaps listening to the likes of the young rocker George Thorogood, who would pass the hat after an acoustic set. "Tommy Drane's" became a favorite eatery of Andrew's, its musical scene contributing to the unforgettably stimulating vibe of seventies Chadds Ford. **Christy's Restaurant** (1929) on the southwest corner of Concord Pike and U.S. 1 (**Painter's Crossroads** or "Christy's Corner," where one caught the regional bus) was once a gaudy attraction; it is said that Andrew took his sons to see the baby alligators in the indoor fountain, only to find them lurking under the booth where they were sitting. On the northwest corner of the Crossroads was **Birmingham Grill** (a New Jersey–built diner from 1948, moved bodily to Truckee, California, in 1995). Just west of Painter's Crossroads still stands the brick **William Painter House** (1820), home of Pyle's grandfather, the local postmaster.

Driving north on U.S. 202 toward the site of *Roasted Chestnuts* (1956; Concord Pike at Brinton's Bridge Road), one passes on the right **Jimmy John's Pipin' Hot Sandwiches**, "Famous for Frankfurters" (1940, rebuilt in 1960 and again after a disastrous fire on the day of its seventieth anniversary in 2010). Owner Roger Steward remembers how Helga would wait outside while Andy in his tweed jacket ordered a box lunch, which they ate in the car: "He always wanted his cheeseburger *rare*. You aren't really supposed to do that, but I wasn't about to tell him no!" Usually nobody recognized the celebrity, but occasionally someone would swoon "as if the pope had walked through the door." In the seventies, Jimmy John and Andy

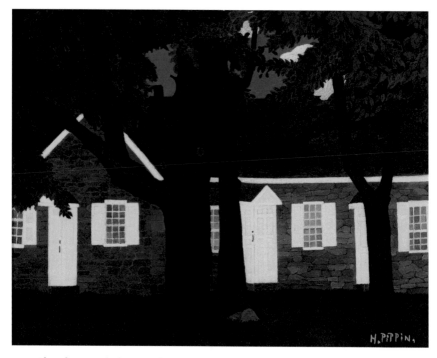

Bloodstained shrine of the Revolutionary War. Self-taught
local artist Horace Pippin depicted *Birmingham Meeting House
in Summertime*, a military hospital both right before and after the
1777 battle. (Horace Pippin [1888–1946], *Birmingham Meeting House in
Summertime*, 1941, oil on fabric board, 16 × 20". Brandywine River Museum of
Art, Purchased with the Museum Volunteers' Fund and other funds, 2011.)

would chat at length, and perhaps *Roasted Chestnuts* is a disguised
homage to this industrious restauranteur who began his career sell-
ing hot chestnuts alongside nearby U.S. 1 in the 1930s.[13]

Farther Afield on the
Brandywine Battleground

Anyone interested in the Battle of the Brandywine will want to
visit other historic sites made famous during that conflict. The
King's Troops surged through the rolling fields shown in Andrew's
Osborne Hill (Crows in a Landscape) of 1943. At various times, he

depicted **Birmingham Friends Meeting** (1763; Birmingham Road at Meetinghouse Road), that critical flashpoint of the battle and grim military hospital (Sir William Howe poses in the doorway in an imaginative 1948 watercolor). N. C. and Christian Sanderson exhibited some of their collection of battlefield relics at Birmingham Meeting in September 1915, when six thousand people gathered for the dedication of historical plaques around the battlefield. The French ambassador spoke—Lafayette's republic was then fighting for its life—and President Woodrow Wilson sent a message saying "how thoroughly worthwhile it seems to me to do things of this sort." (Wilson had known Pyle through a book collaboration when he was a Princeton professor, with the artist often correcting his errors concerning colonial history.) N. C. was awed by the dark bloodstains he was shown on the oaken floor of the meetinghouse, where the operating table had stood. His master Pyle had sometimes worshiped here, likewise pointing out to his students the blood on the benches and bullet holes in the doors.[14]

The 150th anniversary of the Battle of the Brandywine was celebrated in a nearby field on September 11, 1927. A crowd of seventy-five thousand watched five hundred reenactors re-create the conflict as airplanes and the dirigibles *TC-5* and *Los Angeles* droned overhead. An enraptured N. C. had brought along ten-year-old Andy. The next episode here was tragic: in 1945, the bodies of N. C. and his little grandson were brought to Birmingham Meeting after the fatal car accident. The following day, Andrew sat here with them, dry October leaves blowing outside the windows, and pondered his father's face, now a "mask of eternity." That scene finds echo in the Helga picture *Night Shadow* (1978). N. C. is buried near the east end of the **graveyard**, beneath a tiny headstone. For years to come, a grieving Andrew kept N. C.'s shattered eyeglasses in his studio.[15]

East of the meetinghouse, the battle concluded near quaint **Dilworthtown** (*Granddaughter*, 1956), with the new **Sandy Hollow Heritage Park** preserving a sliver of the battlefield near the site of the wounding of Lafayette. Jim Graham was once a young waiter at the **Dilworthtown Inn**, watching as Andrew arrived in his capacious sheepskin coat, accompanied by his sister Carolyn, who

Artist-preservationist of the colonial past. Andrew Wyeth in his studio at the time he skipped the John F. Kennedy inaugural to paint the Barns-Brinton House, 1961. (Photo courtesy of the Christian C. Sanderson Museum, Chadds Ford, PA © 2020.)

filled ashtrays so quickly that one could hardly keep up with emptying them. Graham grew up to become a noted photographer whose work is often compared favorably to Wyeth art, a perennial touchstone of quality in this region. West of the Brandywine on U.S. 1, Wyeth drew **Kennett Meeting** (ca. 1713), where Quakers persevered in their worship even as the battle raged just outside. He was attracted to the primitive brick **Barns-Brinton House** nearby (1714), around which fighting likewise swirled on the morning of the battle. John F. Kennedy invited him to his inaugural, but he had started a picture of the Barns-Brinton House the day he was supposed to leave and telephoned Washington to say that he couldn't attend—the art always came first, even if that meant snubbing the new leader of the free world. (His disappointment that Richard Nixon had lost the election may have been another factor.) "I'm glad you worked on that picture when you did," Kennedy later told him upon seeing *Tenant Farmer* (1961). "The results were worth it."[16]

Painted when he was forty-three, *Tenant Farmer* embodies the artist's suggestive storytelling: what absent person has hung up the deer carcass, leaving one window open so that the curtain flutters? Typical of his style, he shows us every detail about the architecture, so that the picture becomes a valuable record of what the aged house looked like before its 1978 restoration. The Delaware Art Museum visitor leans in close to gaze at the extraordinary minutiae: the stiff, wet fur on the deer and even its whiskers; the rope, precisely delin-

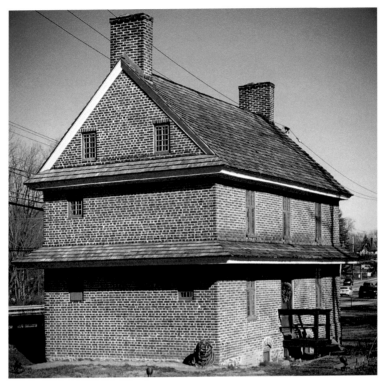

Venerable relic. A three-hundred-year-old survivor from the westernmost fringe of William Penn's colony, the Barns-Brinton House became the subject of Andrew Wyeth's *Tenant Farmer*—with U.S. 1 deliberately omitted.

eated so one can see exactly how it was run up through the branches of the willow tree; even the buds on every wind-tossed stem.

Exhibited in a Pittsburgh show in 1961, it seemed a throwback to a bygone era of American life, surrounded as it was by strange abstract pictures by hip urban artists. Visitors stumbled around "bewildered, almost stunned" by the modernism so symptomatic of "the presently confused world," one fan wrote to Wyeth in a letter that perfectly captured the deep devotion—and anxiety about a fast-changing America—that his admirers routinely showed. She had taken up her pen to thank him "for being true to yourself, your ideals, and your great talent. *Tenant Farmer* was almost the only moment of sanity in the show. . . . We hope, almost pray, you will never change your style."[17]

Andrew Wyeth's Creed of Anti-Modernism

As usual, Wyeth in *Tenant Farmer* gives us an extremely reliable portrayal of what he actually encountered in Chadds Ford. It is exactly the appearance of the Barns-Brinton House, but minus modern intrusions: the highway is cut off to the right, and 1959 photos of the place show that he left out a Champion Spark Plug sign nearby as well as electric wires and meter boxes (one would hardly guess that the house in the painting had modern appliances inside). Everything is *hand-drawn*, not photographic, yielding nervous energy in his lines and quirky little imperfections in the perspective. Hundreds of brown bricks are individually delineated with exhausting precision—each somewhat larger than in real life—and the proportions of the house are a little taller and narrower than is actually the case. Like Albrecht Dürer, he adores the act of drawing, of recording with precise care the realities of his world. With microscopic eye, he portrays everything, clearly delighting in the sport of draftsmanship.

Not only is this house archaic; the artist seems a bit archaic too. In its five-hundred-year-old sensibility of vehement anti-modernism, one can hardly believe that *Tenant Farmer* is contemporaneous with Tom Wesselmann's *Great American Nudes* series and the rise of pop art in 1960s New York. TIME magazine noted in 1966 how Wyeth portrays "a nostalgic world" without "the candy-colored savor of pop culture. . . . There is in it a tragic search for preservation."[18]

The name *Tenant Farmer* belies the fact that this house stands, then as now, inches from a thundering modern highway. The "farmer" reference is significant: much of Wyeth's popular appeal owed to widespread nostalgia for rural life as family farming quickly waned. His career exactly coincided with the steepest decline in farming ever recorded: 30 percent of Americans lived on a farm in the year he was born, but only 2 percent did so by the time of the Helga pictures. At the height of his fame, from 1950 to 1970, half of all farms disappeared. *Tenant Farmer* captures this sense of decline and desolation.

Harvey Run Trail

AFTER TEN DIFFICULT YEARS of planning and obtaining permits, the Harvey Run Trail was opened in 2016 through the heart of Brandywine Conservancy meadowland in Chadds Ford. For the first time, the public could stroll at leisure through landscapes where the Wyeths painted. To *walk* as they did proves to be an entirely different experience than to clutch the steering wheel on today's crowded roads. The trail begins at Chadds Ford Municipal Building, off Ring Road, and allows us to enjoy the surviving rural beauties of the valley. But it also reveals how much the landscape has changed locally with the demise of agriculture since World War II. In a remarkably short period, farming has gone extinct, and fields have reverted to scruffy forest—or are frozen in "preserved" condition, eternally fallow. When Andrew Wyeth was a boy, surely 90 percent was farmland; by his eightieth year, the Chadds Ford vicinity was 32 percent suburbanized, 42 percent wooded, and only 23 percent agricultural.

Harvey Run Trail runs to the Brandywine River Museum of Art, through low terrain and "Pennsylvania dry mud," the color of which fascinated him. These three hundred protected acres form the heart of Wyeth Country, beloved to artists and rich

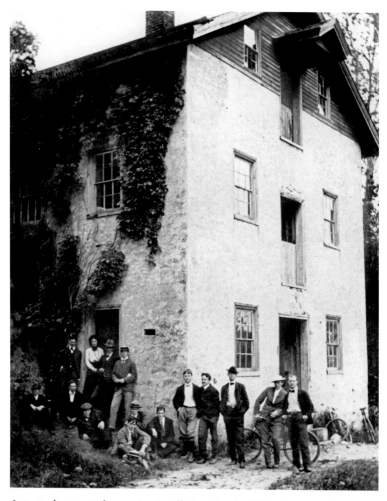

Art students at the ancient mill. Starting in 1898, the venerable walls of Turner's Mill housed the Howard Pyle School, which aimed to produce "painters of true American art."

with associations with Howard Pyle as well. Andrew Wyeth played an important role in the founding of the Brandywine Conservancy in 1967: "It's the last unspoiled section on this side of Philadelphia," he told a reporter. "I'm afraid we're losing the countryside."[1]

Howard Pyle at Turner's Mill

⤷ *Begin at the trail sign beside the parking lot, east of the Municipal Building.*

Chadds Ford Municipal Building incorporates the stone walls of **Turner's Mill**, which burned in January 1953 and, after alarming talk of demolition, was rehabbed in 2006. Built by Joseph C. Turner about 1868 on the site of Benjamin Ring's colonial mill, this was the ivy-draped "Old Mill" so esteemed by Pyle, which served as the studio for his students every summer. Pupils bicycled back and forth to lodgings nearby or at "the Ford" (the village). Pyle had the second floor as his own studio, while the youngsters used the main floor below. To inspire them, Pyle hung his now-priceless pen-and-ink drawings on the rustic mill walls. Here, his disciples worked long days amid the smell of grain and flour dust and the sound of water gurgling over the huge oak wheel beneath the floor; here, they displayed their completed artwork and had a little show at season's end. For a pirate-themed illustration for *Collier's Weekly* (*Flying Dutchman*, 1900), Pyle had them build a tilted platform outdoors like a ship's sloping deck, slosh it with water, and then pose on it in costumes. The end of a long day's work was signaled by the tramp of cattle's homeward-bound feet on the dirt road nearby, little bells tinkling.[2]

Behind this structure, a living but almost-limbless trunk is all that remains of the enormous **sycamore** shown in Andrew Wyeth's watercolor *Turner's Mill* (1973). It shaded Pyle's students as they escaped the sweltering mill by setting up easels outdoors, painting models who posed in historical costumes as the master gave fervent instruction: "That's one thing he stressed tremendously, the *feeling* of the thing," Frank Schoonover recalled—to depict the subject not with dry photographic accuracy but with deep heart. At the sycamore's foot runs the former **millstream**; a huge **swamp white oak** a few yards downstream is the same one beside which Pyle and the rest washed their paintbrushes at the end of each day. Out beyond is the

A master washes his brushes. Howard Pyle and a female student beside Turner's millrace, about 1898, with Harvey's Meadow beyond. The oak still grows there today.

meadow, once open, where students painted, played baseball and even golf, and occasionally fled from ornery bulls. Here, Pyle had them study objects in sunlight, his school emphasizing the mastery of iridescent color effects not obtainable indoors in the city: "Under the sky he could show how light flooded, bounced from, and enfolded every form that it could reach," a young follower recalled. "Look! Look! Look at that tree!" Pyle would exclaim, pointing to an oak lit by the afternoon sun. "It is a tree which has golden plates, pure gold," and one should always paint it that way. Every afternoon was devoted to landscape studies that might be useful in illustrations, with an emphasis on the old-timey agricultural scenes of "worm fences" and corn husking. Students were so engrossed in their de-

pictions of nature that they stood for hours in the summer sun, to the bafflement of local farmers, sure that these artists were mad.[3]

In a way, Turner's Mill introduced Andrew Wyeth to the world: a 1933 drawing of it was his first published artwork, in a *Scribner's* pamphlet promoting the new Brandywine edition of the works of Pyle. Among his subsequent, very early book illustrations were those for Wilmer MacElree's local topographic history *Around the Boundaries of Chester County* (1934) and historical sketches for the novelist Christopher Ward's *Delaware Tercentenary Almanack* (1938). Andrew also did a dozen drawings for Henry Seidel Canby's *The Brandywine* in the Rivers of America Series (1941), earning $350. N. C. was delighted that this last project had gotten his son "all stirred up about the landscape here, which is as it should be"—a vital step on his lifelong artistic journey.[4]

Into Harvey Run Valley

> ⇢ *Proceed east along the trail, turning right by Ring Road.*

Noisy **U.S. 1** was paved in a single lane of concrete in 1916–17 (widened in 1936 and several times subsequently) as part of the Lincoln Highway from Maine to Florida; locally, it was called Baltimore Pike. In Pyle's day, it was a quiet dirt road down which farmers drove placid cattle. Across the road is **Washington's Headquarters** (Tour 1).

Turning right, the trail enters **Harvey Run Valley**, beloved of all Pyle students. In 1907, N. C. extolled this "great peaceful meadow with its winding brook and willows, its cattle and its larks. A gentle and silent valley but at one time the scene of a great and bloody conflict." Here one Friday morning, October 19, 1945, en route to Archie's Corner to pick up the housekeeper, he pulled his car to the side of Ring Road to show his nearly four-year-old grandson Newell a husband-and-wife team bundling shocks of corn. Such shocks had long been one of his favorite features of the Brandywine landscape, among those countless rural folkways fast disappearing as agriculture was mechanized, and he painted them again and again, as in *The Cornhuskers* (ca. 1934). "This is some-

thing you must remember," the laborers heard him tell the child, "because this is something that is passing."[5]

Moments later, grandfather and grandson were killed at the top of the hill, when their car was struck by a locomotive at the **railroad crossing**. It was just a year after N. C. had walked down the track here with Andrew, showing him a spring where Pyle's students once drank. And the older artist had written an uncanny, Thoreauvian letter (July 1944) about hearing "the distant sound of a Reading train whistle . . . an especially eerie and poignant voice—a call from great distances, in space *and* time." He died in the same mellow October season in which he had first arrived to study with Pyle at Turner's Mill, in sight of the railroad crossing, and perhaps nostalgic musings had made him inattentive.[6]

The accident baffled police. The engineer saw the car sitting motionless on the tracks; maybe it had stalled as N. C., always a nervous driver, crept up the hill, extra-cautious because of the glare of the morning sun. The corpulent artist suffered from cardiovascular disease and was carrying pills with him; his son Nat (who lost a parent and a child that awful morning) was sure that his dad suffered a second heart attack when he saw the train coming. It ran this line daily but at no scheduled time; being nearly deaf at age sixty-two, N. C. may not have heard the whistle, which Karl Kuerner's son recalled as having failed to blow in any case. A recent biographer implies, I think improbably, that it was murder/suicide owing to the fact that N. C. suffered from wartime depression and loneliness and had grown romantically fond of his own daughter-in-law. Don Altmaier babysat for another Wyeth grandchild and was frequently in N. C.'s car, driving to Concord Pike for ice cream. Today, he recalls N. C. as a doting grandfather who never would have harmed his little namesake.[7]

Altmaier stood by the crumpled wreckage that day and marveled at how "it was totally demolished—you thought, no one could have survived that." The tragedy remains a mystery that long disturbed the Wyeth family. Today, its powerful impact on Andrew Wyeth is told and retold to rapt tourists by museum docents. Perhaps the story needs to be retired, for there is a risk of portraying him as a

death-haunted, brooding artist. In fact, his life strikes me as singularly untroubled: unlike many of his generation, he felt no hunger in the Depression, fought in no war, suffered no financial setbacks, was indulged by everyone around him, and was given no chores except to paint—I am told that he never carried a checkbook or a wristwatch. No less fortuitous was his attractiveness to all kinds of people: to men who consistently found him earthy and great fun and to women who, far into his old age, jockeyed for his attention, dreaming of fame as a model and melting at his heartfelt, eloquent conversation and soulful blue eyes. The loss of his dad when he was nearly thirty, although painful, was one cloud in an exceptionally sunny sky.

The Death of N. C. and the Rise of Andrew Wyeth

It has seldom been noted, but Andrew Wyeth's rise to fame may have owed something to his father's much-publicized death. Until then, he had been, essentially, a kind of village craftsman ("village idiot" was his self-effacing term), quite happy in his snug studio while mostly producing magazine illustrations and little nature studies. His 1930s Maine watercolors were admired by many, but he was far from a household name. He was resolutely simple: a visiting newspaper reporter found him to be "an ordinary guy" who "dressed as a working man" and acted "just as any other craftsman." Then two things intervened: Betsy's tremendous ambitions for him and the widespread media coverage of the sudden passing of a beloved American illustrator and patriarch of an artistic clan. Suddenly, and almost accidentally, the village craftsman was thrust into the role of the Great American Painter, which he never really found congenial. The arrival of fame with *Christina's World* came just three years after the car crash, with its purchase by the Museum of Modern Art in 1948. "N. C.'s memory rests on the quiet countryside," a visiting journalist reported a year later. "His spirit, simplicity, and courage lives on in his children." Having interviewed the younger artist, he concluded that "there is no doubt that Andy's father's name helped to open the door in the art world." "I was given every chance possible," Wyeth himself later confirmed, "and no one knows it more than I do."[8]

With all the national attention to N. C.'s death, a Park Avenue gallery in New York held a "Wyeth Family" show (including Andrew) in the fall of 1946. Already LIFE magazine had eulogized N. C. with an extraordinary four pages in full color in June 1946 (mentioning Andrew as one of the fascinating Great Family of painters—his sisters Henriette and Carolyn were also artistic); the publication then gave Andrew four similar pages in May 1948, an incalculable boost for anyone—and a boon it would repeat in 1953, 1965, and 1971. Andrew's boundless facility in storytelling, delivered with a twinkling eye and breathy meaningfulness that recalled the poetical sensibility of his comrade-at-arms Robert Frost, made him utterly alluring to journalists. If TIME made Thomas Hart Benton, then LIFE made Andrew Wyeth.

The Wyeths had to hide from gawking tourists in Chadds Ford as early as the thirties. Would Andrew have become a superstar if he hadn't been part of this larger clan marked by tragedy and triumph? Perhaps not: the field of ambitious young representational painters was exceedingly crowded (see the droves of now-forgotten names in American Artist magazine). Certainly the family-of-artists narrative was irresistible to the media, to the point of saturation: eventually, an article even appeared on the scientist brother Nat, calling him "The Wyeth Who Doesn't Paint"![9]

⇢ *Cross the footbridge over the run.*

This pretty stream appeared on the Holme Map of Pennsylvania in 1687, when this was the western, wilderness edge of William Penn's colony. Now called **Harvey Run**, it delighted N. C., who

Facing page, top: Favorite artistic subject. N. C. Wyeth stood in Eli Harvey's Meadow to paint Pyle's Barn. In the distance across Baltimore Pike can be glimpsed his former studio at the Harvey Homestead. (N. C. Wyeth [1882–1945], *Pyle's Barn*, ca. 1917–1921, oil on canvas, 32¼ × 39¾". Brandywine River Museum of Art, Gift of Amanda K. Berls, 1980.)

Facing page, bottom: With palette and easel. N. C. Wyeth painting *en plein air* at Pyle's Barn. (Photo courtesy of the Christian C. Sanderson Museum, Chadds Ford, PA © 2020.)

nicknamed it "Heifer Run" for its many cattle and often walked along its crumbling banks or even (August 1909) in the creek itself, although he was hesitant to roil its crystalline waters. In the 1890s, Pyle had waded in with his students to gather floating chestnuts in the chilly autumn, shouting, "Boys, this is the way those poor devils felt at Valley Forge!"—he wanted them to remember that visceral sensation when painting a Revolutionary War subject. Numerous paintings from around 1910—including *The Meadow*—when N. C. was living at the Harvey Homestead attest to its artistic appeal to him as he sought to reinvent himself as a landscape artist. What the fields of Barbizon were to Jean-François Millet, so was Harvey Run to N. C., a disciple of Pyle's efforts to spark a revolution in "true American Art" at Chadds Ford. The valley is more wooded now (and a recent campaign has added 1,500 more trees); almost completely gone are the agricultural folkways that so charmed the Wyeths along the Brandywine, including fields of waving grain, piles of corn, and cattle lowing everywhere.[10]

N. C. Wyeth at the Harvey Homestead

⤳ *Follow the trail west, going right toward another footbridge (the trail at left is covered in Tour 3). Once across, take the trail on the right that circles through the meadow.*

N. C. rented and farmed the **Eli Harvey Meadow** as his "lower pasture" during the time when he lived across the highway at the Harvey Homestead. Long the favorite baseball field for the village, it remains a beloved feature of Chadds Ford today, narrowly rescued from destruction in the 1960s when a factory was proposed; the Brandywine Conservancy was founded to save it. Today's **barn** beside U.S. 1, which for a time housed the post office, replaced, in 1938, the colonial **Pyle's Barn** (no relation to the artist). Here, we can imagine Howard Pyle at work, as a student said, "with easel and canvas within the shadow of a barn." The original barn was a favorite artistic subject of N. C., a sturdy mass of stone with a cow stable on the meadow side. As one of Pyle's students, he milked

cows here morning and evening to pay for his board. As an adult seeking to make his mark as a landscape painter, he often stood with his easel in the meadow to record the light and shadows on that evocative old place. He was particularly proud of *Newborn Calf* (1917), showing the barn by moonlight as glimpsed during one of his "familiar walks along the broad stretches of the Brandywine Meadows"—"my best work"—and was dismayed by the indifferent reception it received at a show in Wilmington. At Christmas 1918, he built a miniature replica of Pyle's Barn for his daughter Carolyn. Post-demolition, he recalled the place from memory in *Portrait of a Farmer* (1943). Andrew's later fascination with Kuerner Farm was presaged by these similar loving efforts of his father.[11]

⇢ *Look north across U.S. 1.*

The large brick house on a hilltop is the little-changed **Harvey Homestead** (1735 and 1801), where a group of Pyle's male students lived; it was the first destination of N. C. on the day he arrived by foot in Chadds Ford from Wilmington, in October 1902. He described it as the **Gen. Greene Headquarters** of 1777, surrounded by tall trees and with valuable Pyle paintings on display for the pupils. On "one of the richest autumn days I ever remember," he reached the farm in midafternoon, met the dozen students, and then took an evening ramble "up through the vast cornfields back of the place. . . . It was all magic to me and tremendously romantic." Convivial life here included harmony singing on the two big benches on the porch, fireflies spangling the fields.[12]

Following his marriage, N. C. rented the big brick house from April 1908 to March 1911, enjoying the rural life here and the orchard of apples, grapes, and peaches. He drew a map showing pastures that extended south to the railroad tracks. From the west lawn, he observed Halley's Comet. He converted the square stone **carriage house**, still extant, into a studio by adding a north-facing skylight next to the cupola. The studio is legendary as the place where he achieved his greatest triumph, the illustrations for *Treasure Island* in the spring of 1911 (he retained this studio although his family had

Afternoon glow. As he sought to establish himself as an American impressionist, N. C. Wyeth depicted the view west from his Harvey Homestead studio in a steamy July, looking down on the rural village.
(N. C. Wyeth [1882–1945], *Chadds Ford Landscape—July 1909*, 1909, oil on canvas, 25 × 30¼". Brandywine River Museum of Art, Gift of Mr. and Mrs. Andrew Wyeth, 1970.)

recently moved from the house to nearby Windtryst). With the proceeds from this commission, he funded the simultaneous construction of his own house directly across the valley on Rocky Hill.

While living at the Harvey Homestead, N. C. plunged into landscape painting, determined to follow Pyle's teachings about sensitive observation of nature. Numerous pictures show the studio amid summertime trees (*The Converted Barn*, ca. 1908) or the view west toward the village, sometimes including the **windmill** (reconstructed ca. 1980), as in *Chadds Ford Landscape—July 1909*. In *Sultry Day* (ca. 1909), the hotel's red roof appears. Houses of the picturesque town were painted yellow, red, white, green, orange, and blue, surrounded by rich fields where cattle and horses grazed.

✧ *Look to the right of the barn.*

In the raggedy woods, an old **sycamore** overhangs a dried-up streambed, rerouted by highway widening, that constant of Chadds Ford. More than a century ago, this area was a favorite **picnic spot** for the Wyeth family. *Harvey's Run* (ca. 1909) shows the highway (then dirt), the stream alongside it, and Pyle's Barn behind it. One

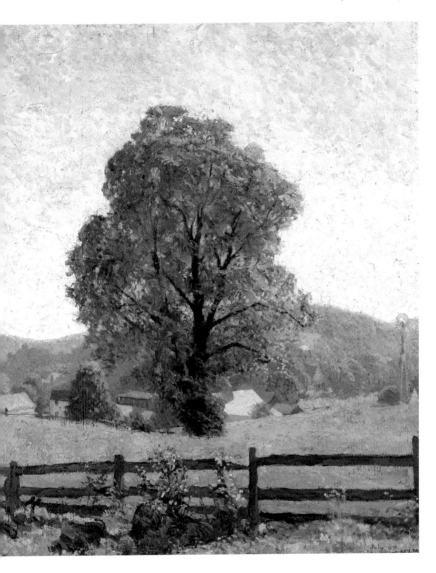

can tease out several other paintings that N. C. did here, often including the former **little island** where he built a stone fireplace, right where the stream bent southward, having flowed down out of farmer John Sheatz's pasture. The island and fireplace are featured variously in *The Brook* (ca. 1909), looking west, with Harvey's Meadow behind; *Woodland Scene with Brook and Fence* (ca. 1909),

looking south to the extant sycamore, a painting he gave to Sheatz; and *Chadds Ford Landscape with Brook* (1910), looking north, which the artist proudly hung on his living room wall. This locale was a major center of his efforts as he tried to become, foremost, a landscape painter. Jumping ahead, the preservation of these acres, and indeed much of Chadds Ford, owed everything to the great prestige of Andrew Wyeth, who in 1966 campaigned against the construction of the Fibre-Metal Products factory on this site. "I'm ready for a fight," he told a reporter. "This would be the beginning of the end. To me, Chadds Ford is a very important place historically. Many artists have worked here. And the meadow now has beautiful trees and a lovely stream." That it still does, a half century later, is another great legacy of this preservation-minded painter.[13]

The mansion east of the Harvey Homestead is **Stonebridge** (ca. 1914), built by the Philadelphia brewer John D. Scheidt and typifying the transformation of the area into estates for the wealthy. Ever the follower of Henry David Thoreau, N. C. decried the "flood of money . . . inundating us" and the "great palatial residences topping every sacred hill—like Babylonian brothels!"[14]

A Glimpse of Chadds Ford Village

✢ *Follow the trail around to the west side
of Eli Harvey Meadow.*

The view of **Chadds Ford village** has changed surprisingly little since N. C. moved to the town of seven hundred in 1902. One recalls Betsy Wyeth's description of the place as she found it as a homesick newlywed in October 1940: there was only "a crossroad with Gallagher's General Store on one corner, a gas station on the other, Willard Sharpless's blacksmith shop on the third, and a marsh on the fourth." Andrew never reconciled himself to the changes over time, telling his authorized biographer in 1968 that with the general store gone, the highway widened, and the covered bridge demolished, the town he knew had "died."[15]

Across U.S. 1 is the former Chadds Ford Hotel (ca. 1810), long called the **Chadds Ford Inn** and now a restaurant (Andrew's reserved table was at the southeast corner). Interior renovations have lately altered the historical flavor, but its distinctive pinkish-red Victorian mansard roof would have been familiar to N. C. Here, Pyle's male students boarded in 1899; here, N. C. relaxed with his visiting parents on the little-changed porch in photographs of 1905; and here, he roomed briefly (on the second floor, in the southeast corner) in 1908, looking out at the broad sweep of the valley. It was long popular with landscape painters: "Chadds Ford hotel is filled to its utmost capacity, the majority of the visitors being artists from New York and Brooklyn, who may be seen sketching along the Brandywine during all hours of the day," a newspaper reported in June 1898. The illustrator Ernest Peixotto, later a teacher of Thomas Hart Benton, spent a season here alongside New York artists "out for their summer sketching." Pyle would come by: "In his buggy he used to stop for me at the inn and we went sketching together up the valley of the Brandywine or over the hill toward the Birmingham Meeting House," with the history fanatic Pyle wont to burst into "martial ballads," such as "The British Grenadier."[16]

A heyday came during the John F. Kennedy years, when Andrew and Betsy could be found dining at the bar—the room thick with cigarette smoke, music playing on the jukebox, and original Andrew Wyeth paintings looking down from the walls. Joining them might be some of the Inn's young, bohemian residents, such as the future sculptor André Harvey, the painter Woody Gwyn, or the filmmaker Denys McCoy. Gwyn has never forgotten the day when Betsy, driving Jamie's green Corvette, pulled to the side of the road to tell him that Kennedy had been shot. The late president's family would invite Jamie to paint his posthumous portrait. "Man, Chadds Ford was a cool place," recalls the artist Terry Newitt, who gaped at Ted Kennedy and Andy Warhol at the Inn, legendary friends of Jamie. At the height of 1970s Andrew Wyeth mania, devotees stayed at Chadds Ford Inn and dreamed of sighting the artist. Locals genially pointed them in the wrong direction. Over

at the Homestead, the offbeat and increasingly reclusive Carolyn Wyeth would call the Inn to order seven filet mignon meals to be delivered: supper for her dogs.[17]

The gabled building west of the hotel was **Baldwin's Store and Battle Field Tea Room**, where Pyle's students bought equipment and got their mail. On the southwest corner of the intersection were stables for the hotel and, later, the Ceresota Flour storage barn, with a colonial soldier painted in the gable. The current 1980s structure formerly housed the **Wawa convenience store** where Andrew stopped for coffee or bought his favorite white extra-large eggs

Haunt of the artists. Baldwin's Store and Battle Field Tea Room, where illustrators bought their art supplies, seen circa 1920. Visiting painters seeking inspiration from the scenic Brandywine stayed at Chadds Ford Hotel, right. (Photo courtesy of the Christian C. Sanderson Museum, Chadds Ford, PA © 2020.)

for tempera painting, mixing the yolks into paint and feeding the egg whites to the hound. The Pre-Raphaelite followers who revived tempera in England (Society of Painters in Tempera, 1901) had hit upon a different solution: they raised their own chickens. East of the hotel stands a red-brick house that was, starting in 1969, the **Chadds Ford Gallery**. Here, Betsy would broker Andrew's autographed prints for sale, part of her extremely lucrative business that art historians have hardly considered: how the master gradually became a beloved printmaker for a national audience (not studio-art prints such as etchings or lithographs, mind you, but "reproductions" produced on paper photomechanically), spreading art widely but perhaps settling for small victories in lieu of a career-crowning masterpiece. Millions more people encountered his artwork on *paper*—in coffee-table books or as posters—than they did hanging on the walls of a museum, so perhaps he was an "illustrator" after all? For decades, the gallery and its successor have been a hub for Wyeth-inspired painters purveying what one insider calls "buckets, barns, and daisies"—no abstraction allowed. Beyond the confines of any gallery, Andrew privately engaged local friends, including the impecunious, to broker his art,

generously providing income for Helga Testorf and others—efforts he is said to have kept secret from Betsy, who oversaw all finances. She remained for many an aloof, almost mythical figure; more than one person has told me, "I've lived in Chadds Ford for forty years, and I've never seen Betsy once."

Heart of Chadds Ford

> *Go across Creek Road and follow the trail*
> *toward the art museum.*

The village retains its small-scale Victorian charm despite the ever-intrusive highway, recurrent floods, and a disastrous fire in May 1915 that N. C. helped fight. A view right up **Station Way Road** shows houses that N. C. saw from his front porch, including Number 9, once home to Andrew's high-spirited model Jimmy Lynch, who liked to drive his pickup onto the train tracks, let some air out of the tires, and then race for miles (*Jimmy's Porch*, 1991, shows his motorcycle on the lawn). This street saw the costume parade for the first Chadds Ford Day on September 11, 1958, led by the local historian Christian Sanderson. Such an event was needed to knit the village together: it had suburbanized rapidly, becoming a bedroom community full of strangers who worked elsewhere. "It felt dispersed," recalled a former resident whose father built a ranch house in the 1950s. The Wyeths were themselves remote, he remembered, "local legends" seldom participating in the social scene "except with the gentry and du Pont relatives. We were proud of him" yet felt some jealousy of "his privileged status." The conviviality of Chadds Ford Day may have helped forge closer ties: nearly all the locals I interviewed revere the Wyeths to this day.

The **crossroads** of Chadds Ford is still small scale, although traffic is vastly increased (there was no need for a stoplight until 1979—worry that a certain famous artist would be killed was a spur to its being installed). Gone is the barbershop for which N. C. painted a sign with the inscription, "This is the Place Where Washington & Lafayette Had a Very Close Shave." Andrew's fa-

Among friends. Betsy and Andrew Wyeth enjoying the festivities of colonial-themed Chadds Ford Day, July 1964. Jamie Wyeth is in the foreground.

vorite place for lunch was Hank Shupe's diner, founded in 1960 on the site of Brittingham's Garage and still in operation as **Hank's**, where devotees from out of town still come, seeking a glimpse of the legend, quite unaware that he has died. Back in the 1960s, he could be found at the counter, eating his favorite cheeseburger with coffee or a western omelet; in later years, he sat with Helga at a

table at the west end. Both attracted attention in restaurants with their unconventional attire and quirky, sometimes boisterous table manners: dining out offered a chance for playful spontaneity for these two celebrities. In the middle of pouring the coffee, a young waitress might find herself invited to become Andrew Wyeth's next model, standing there wide-eyed with astonishment in front of the maestro who had once put a Chadds Ford housewife on the cover of TIME magazine.

In far-off Hawaii in 1989, young watercolor artist Eddie Flotte chanced upon a copy of *Wyeth at Kuerners* and "was instantly obsessed." Making a pilgrimage to Chadds Ford, he ate breakfast at Hank's one winter morning and was astounded when the great man happened to sit down beside him at the counter. "He was wearing a big green parka and looked like he had just finished raking leaves," Flotte recalls. "I noticed his fingers were covered in dark green paint." Soon they were talking about art: "Don't let anybody box you in," Wyeth advised as he ordered two fried-egg sandwiches to go. "Make quick decisions and put them on paper as fast as you can." The Hawaii artist marveled at how anyone could paint outdoors in such weather. "I've done three paintings already this morning," Wyeth laughed. "I keep the engine running and sit on the hood. It keeps my buns warm."[18]

Across the street from Hank's at **Pete's Sunoco**, occupying the site of the former Gallagher's Store, Andy had his many vehicles serviced, including flashy Stutz replicas (on Pontiac chassis). For years, he visited almost daily for gasoline and a newspaper and enjoyed the station's Christmas Eve parties. West of Pete's once stood the village post office, where locals daily converged. One former resident remembers his childhood during World War II: N. C. was a familiar sight, picking up his and Andrew's mail there each morning before driving to the railroad station for a newspaper.[19]

Along the railroad embankment west of the foot of Station Way Road was **Chadds Ford Station**, where artists arrived each summer from Philadelphia. Locals stared at the sight of N. C. clambering aboard, lugging huge oil paintings that, once delivered to the city, would become magazine illustrations. The trail concludes at the

Brandywine River Museum of Art, which opened in June 1971, with Andrew and his mother in attendance (see Tour 4). The du Pont heir George "Frolic" Weymouth spearheaded the museum project as part of his tireless efforts to establish the Brandywine Conservancy. In the early years, crowds proved far larger than expected, so great was Andrew's fame, and celebrity visitors included Gregory Peck, Andy Warhol, and Lady Bird Johnson (who dedicated the attractive garden of native plants). The idea for a museum in the old-fashioned **Hoffman's Mill**, where N. C. had brought wheat to be ground, had been Betsy's, whose wealthy du Pont friends helped put up the money to make Frolic's dreams come true. "Frolic took me by this little gristmill they'd just bought," the architect Jim Grieves remembers. "A millrace ran through what became the parking lot. Frolic wanted to keep the *look* of the mill. Andrew Wyeth had to approve everything—I built a cardboard model that stood on Frolic's dining table. Andrew was supportive all the way." In the earliest years, one might have encountered Frank Schoonover here, an elderly alumnus of Pyle's school of art at Turner's Mill and an eventual pallbearer for his friend N. C., loudly commenting on the paintings from his wheelchair as his nurse tried in vain to quiet him. "Those paintings excited me almost out of my mind" was the response of Karl Kuerner's twelve-year-old grandson, Karl J., who resolved to abandon farm chores—no more flinging hay bales up to Karl's fast-rumbling tractor—and become a professional painter himself. Betsy visited the museum often to plan exhibitions and publications. Andrew showed up occasionally—for example, to critique the lighting of the galleries or to watch stonemasons lay the intricate cobblestones in the courtyard, the museum aiming for a quaint and rustic aesthetic redolent of Wyeth art.[20]

Trail to the Wyeth Studios
at Rocky Hill

P ERFECT FOR THE LOVER OF AMERICAN ART, not one but two superb studios are preserved for public view: N. C. Wyeth's and Andrew Wyeth's. This recently opened trail through Brandywine Conservancy land makes it convenient, for the first time, to visit them on foot.

⇒ *Follow the Harvey Run Trail as in Tour 2, but at the T intersection in the big field bisected by the power line, go left and up the hill.*

The ugly Philadelphia Electric Company **power line** was cut through Chadds Ford in the late 1950s after vehement public objection delayed it five years. We are crossing the abandoned tracks of the **Penn Central Railroad**. As previously discussed, N. C. died when a locomotive struck his car at the Ring Road crossing in October 1945, pushing it off the north side of the tracks, coming to rest about where the rusted semaphore signal-tower now stands. East of Ring Road is the **Dr. George Truitt House** (1940), which overlooked the crash scene. Truitt practiced medicine out of this home for many decades but did not witness the wreck, being then stationed with the Army Air Corps in South Carolina. As for the

cause of the disaster, he supposed N. C. had a heart attack. His daughter Sarah grew up here, a happy rural childhood: running errands to Chadds Ford village ("down in the Ford") and picking up the hitchhiking Christian Sanderson on the way; playing at Kuerner Farm, where Karl was terrifyingly "Prussian" and Anna talked to herself incessantly while spreading manure with a pitchfork. But in all those years, she never once saw Andrew Wyeth out painting.[1]

A Train Ride from Philadelphia

Opened in 1859 as a conduit for hay, grain, and potatoes, the Penn Central Railroad (originally the Philadelphia & Baltimore Central, often called Baltimore Central) allowed rapid access to Philadelphia, the second-largest city in the hemisphere, just twenty-three miles away. Rail technology played a critical role in opening the Brandywine to artists—not only this line but trolleys that linked West Chester to Philadelphia (by 1898, they ran every fifteen minutes). Even before the railroad, painters made their way here or drew inspiration from stirring events of local history. The Battle of the Brandywine was depicted in historical canvases by several nineteenth-century painters, including Alonzo Chappel and John Vanderlyn (who showed George Washington and the Marquis de Lafayette riding spirited horses). Charles Willson Peale, Thomas Doughty, and Bass Otis sketched or painted along the creek, concentrating on early American industry amid nature's romantic splendor. Thomas Birch produced a print of the Brandywine as early as 1805. The portraitist John Neagle depicted a local farming village "on the spot" in 1839. Thomas Anshutz painted here, as did Edward Moran; apparently, so did the leading Hudson River School painter Jasper Cropsey. No wonder Howard Pyle situated his school here; a newspaper reported in June 1898 that students "will be given opportunities to sketch the beautiful scenery along the Brandywine." Ultimately, the Wyeths became the most famous artists the Philadelphia area ever produced—and extraordinary ambassadors too, with *Philadelphia* magazine noting that "they have introduced more of the world to this region than anyone but Rocky Balboa."[2]

Andrew Wyeth's Jeep Trail to Kuerner Farm

⇢ *Over the former railroad, the trail turns sharply right.*

We are following, in reverse, the Jeep trail that Wyeth frequently took from his studio to Kuerner Farm: "When I walked across the railroad tracks where the train hit Pa, I came to Karl Kuerner's house," he recalled of outings around 1946. This way of going remained a longtime favorite, as confirmed to me by the artist Bo Bartlett, who spent much time with the Wyeths in the early 1990s on the way to becoming famous himself: Murphy Road past Messersmith's, along the road under the power lines, and past the fatal railroad crossing. But then again, he frequently varied his direction: "Andy would just drive anywhere in his Eddie Bauer Jeep. Right through properties and across fields—it was all his yard as far as he was concerned. It was his stomping ground, literally, and he was free to go anywhere and do anything. Andy never grew up; he was still twelve until the day he died."[3]

Murphy Farm, south of the railroad and extending west to Creek Road, belonged to William Murphy; on the hillside to the left was the huge Atwater orchard, now a wooded subdivision. Presumably this was "Spud" Murphy, whose sheep Andrew spent weeks painting at age fifteen, until he had his first artistic "flash impression" of the farmer walking among pigpens and apple trees, the kind of visual thunderclap that fired him up to paint. At the east end of Murphy Road stands **Alan Messersmith's house**. The lanky son of a tinsmith who made Andrew's aluminum palettes for tempera painting, Messersmith stood at twilight beside the concrete highway (Concord Pike at Brinton's Bridge Road) in Wyeth's *Roasted Chestnuts* (1956), a favorite painting of President Dwight Eisenhower and one of Andrew's few temperas actually painted outdoors. No fan of modernism, Ike proclaimed Andrew's art to be "what America likes." The house appears in a watercolor, *Messersmith's* (1994). Late in life, the artist began depicting the mentally troubled Messersmith again, drawing him on Murphy Road west

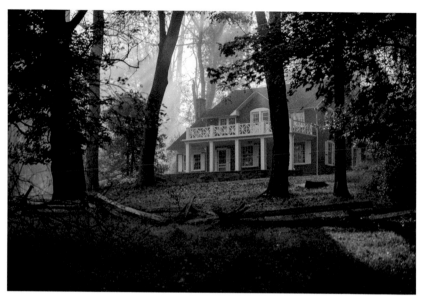

Artist's cottage on Rocky Hill. The sun dawns above the N. C. Wyeth Homestead on the slopes of Rocky Hill.

of the house in *Neighbor* (2003), showing precisely the woodland trees and even the telephone pole with his usual fidelity to truth.[4]

On the left is a majestic **beech** of the type that Wyeth called "formidable" and loved to paint—this being a rare old forest in Chadds Ford, that preeminently agricultural district (another such forest lies south of Kuerner's). A turning point in his development as an artist was *Spring Beauty* (1943), when he lay on the ground to paint the roots of a beech tree, an exhaustive study in Higgins ink and watercolor that confirmed in him the idea of a meticulously observed approach to nature, in the manner of Albrecht Dürer's famous wildflower studies. The *Spring Beauty* beech tree was **uphill from here** in the same forest, along his "favorite walk" to Adam Johnson's (see Tour 6). Later, he painted Betsy Wyeth in *Corner of the Woods* (1954) in that same uphill location, an old beech wood of the kind portrayed in N. C.'s *Their Arrows Flew Together* (1917) from *Robin Hood*.[5]

Spring Beauty awed the famous American painter Charles Burchfield: "The flower nestling among the roots of an ancient

beech tree (the texture of which was accomplished by a miracle of technique)—dried leaves beautifully rendered." As we saw, he admired the Chadds Ford artist as "a man who can paint every straw in a haymow or every grass blade in a meadow and not lose the big pattern." Interestingly, this rural artist who always abstracted nature faulted Wyeth whenever he strayed from "carefully drawn" pictures to use "spatter by toothbrush to achieve snow-flakes" or indulged in any "meaningless lines or scratches": he worried that these were evidence of a "faltering ideal" for the committed hyper-realist at mid-career.[6]

N. C. Wyeth at the Homestead

Strolling down the sun-dappled woods road, we enter the N. C. Wyeth property where what he called a "musical rock-bound **brook**" crosses Murphy Road. This streamlet was a major impetus for his purchase of land here: "Oh, he loved brooks," Andrew recalled. N. C. painted "our brook in the woods" frequently, often showing the **big boulder** just upstream (as in *The Brook—Summer* and *Brook in Winter*, both ca. 1916). His children ran "down into the woods" to play, fashioning little boats out of leaves; sometimes, N. C. theatrically marched the whole family out to find spring beauties, excursions that find echo in Andrew's paintings of Brandywine wildflowers (*May Day*, 1960).[7]

⇢ *Follow the trail left, up the hill (the "lower field")
 toward the N. C. Wyeth House.*

Here are the eighteen acres bought by N. C. in 1911 as "the Homestead," the heart of his personal world. The slope, boulders, and rocky brook reminded him of his native Massachusetts, and he was thrilled to be able to buy the property with the proceeds from his *Treasure Island* illustrations. A series of N. C. paintings shows the hillside—historic **Rocky Hill**, defended by American troops against British assault in 1777—and its extensive views even before he built the house. There were already some chestnut and locust

trees, but he had holes dynamited to plant others, including the plane tree still growing west of his studio. When all the chestnut trees died suddenly in the blight—in spite of N. C.'s spraying his own in 1912 with a defensive chemical used at nearby Longwood Gardens—farmers built miles of fences with the split wood, as seen in *Last of the Chestnuts* (ca. 1916). Skeletal giants with peeling bark appear in the *King Arthur* illustration *They Fought with Him on Foot More Than Three Hours* (1917), a picture that made an electrifying impression on Andrew as a boy.

The Brandywine River Museum of Art gives tours of the fascinating **N. C. Wyeth House**, a National Historic Landmark. Only twenty-eight years old, the precocious artist built the home and adjacent studio in 1911 as a consummate expression of his romantic and historical worldview, its interior a custom-designed, theater-set environment of ye olde colonial chairs and spinning wheels and candles; the **breakfast room** (originally the kitchen) was as deliciously snug and wood-paneled as Captain Kidd's ship cabin, as N. C. must have delighted to ponder as he downed his breakfast of lamb chops at a table he designed himself. Modern comforts were few: there was a telephone (one of the first calls received conveyed the news that Howard Pyle, then in Italy, had died), but for years there were no electric lights; all five Wyeth children huddled around a lamp at night in the **Big Room** to draw. Its walls came to be lined with a virtual museum of family artwork.

Here at the Homestead, N. C. lived and worked for thirty-four years, until his sudden death; here, amid evocative reminders of the American past, Andrew was born in rainy July 1917. On the **circular driveway** were greeted many dignitaries who came to visit America's preeminent illustrator, including F. Scott and Zelda Fitzgerald, H. L. Mencken, Hugh Walpole, Hervey Allen, Sinclair Lewis, Norman Rockwell, and Lillian Gish (the actress admired the children's big dollhouse).

As seen from the driveway, the house consists of the original 1911 block, with a rear kitchen addition built in 1926 (in its basement was the playroom where Andrew spent creative hours as a boy). Between the house and the barn stands a **pump house** (1923)

meant to imitate an old-timey springhouse. The Homestead was designed by the Wilmington architect William Draper Brinckle in a red-brick colonial aesthetic, its handsome **porch** offering a sweeping view up the Brandywine Valley, now much more thickly wooded. Here, N. C. would sit and read the books and articles he was required to illustrate, puffing his pipe (the night before his death, it was *The Robe*); before bed, he would stand and look out to pretty Sugar Loaf across Harvey Run Valley; from here, his children would wave to him whenever he took the train to Philadelphia; and here, young Andrew would take sword in hand and practice fencing techniques. N. C. never tired of lauding this view of "the old valley" and painted it frequently, as in the classic *The Fence Builders* (1915), in which he set his imaginative labors as an illustrator aside and worked as a true painter, "going directly to Nature for my inspiration and details." In that picture—a hymn to winter sunlight—one can make out the Harvey Homestead across the valley, individual buildings in the village, and the covered bridge over the Brandywine.[8]

West of the house (where the chimney has a 1911 concrete datestone hand-inscribed by N. C.), faint traces of the clay **tennis court** survive in the now-engulfing forest, installed by the artist in 1926 after his doctor ordered him to lose weight. It formed a locus for increasingly lavish society parties, which young Andrew deplored as evidence of his father's growing worldliness, eroding his Thoreauvian principles. Andrew's own austere style of painting seems to reject his father's embrace of art-world sophisticates and fashionable Parisian approaches to using prismatic oil color: in 1965, he told LIFE magazine how he abhorred the "Renoiresque or Frenchy—which is what a lot of people want today."[9]

The Homestead remained in the Wyeth family for decades, Mrs. N. C. Wyeth not dying until 1973. She and their art-teacher daughter Carolyn "were obsessed with N. C. Wyeth," a student of the early 1960s told me, in spite of the art world's having completely forgotten him: "All was kept exactly as he had left it. They spoke of him as if he were still alive." When he once commented that his fellow students in Carolyn's class were awfully noisy and

high-spirited amid the shrinelike atmosphere of the place, "Both women burst into tears and said, 'How do you think *we* feel?'" The eccentric and occasionally alarming Carolyn lived and painted here amid bottles, cigarette smoke, and baying dogs long after her mother passed away (and was herself painted by her adoring brother Andrew in the lonely portrait *Up in the Studio*, 1965). Gradually, the place grew rather run-down, with N. C.'s dusty, unfashionable pictures shoved into corners and splattered with dog urine. Fortunately, the property eventually went to the Brandywine Conservancy, with Carolyn continuing to live here until her death in 1994, and everything has subsequently been restored. In the years since, N. C.'s fame has enjoyed a great resurgence. "God, his paintings, I try to bid on some of them," says his grandson Jamie Wyeth, "and I'm always outbid by Steven Spielberg and George Lucas. They'll buy anything, particularly to do with pirates. They'll pay anything."[10]

N. C. Wyeth's Barn and Orchard

⤳ *Continue up the driveway, passing the barn and (left) a huge pecan tree.*

Nearly eighty years after N. C. died, his **barn** (1912) is still crammed with mementos of his life here, from old sleighs to license plates of the 1920s to wooden crates hand-labeled "Macbeth Gallery New York." Built for three carriages, it later housed a series of automobiles; the staunch traditionalist N. C. had a curious weakness for these icons of modernity, as his son later would. At first snowfall, young Andy would rush to get his sled from the hay loft. In a series of paintings, N. C. depicted the barn affectionately, with its green doors and embowering trees. In 1918, he added an attached henhouse south of the wagon shed for Carolyn's chickens. A granddaughter told me of her delight in riding on the dirt road from here up to the studio, sitting on the back hatch of N. C.'s "woody" station wagon as her four-year-old feet nearly bumped the ground.[11]

In the orchard. Always a New Englander at heart, N. C. Wyeth was serious about his apple harvest. The orchard became one of Andrew Wyeth's most persistent painting locales from youth to old age.

The **orchard** of apples, pears, and peaches, now largely replanted, featured prominently in the lives of the Wyeths, a New England clan who took their fruit harvest seriously. In 1908, N. C. made an artistic breakthrough by minutely observing a Chadds Ford apple tree, and here into the orchard he sent Andy, as a boy, to paint his first watercolor, completing the sky himself with bravura brush-strokes. Late in life, Andrew told an interviewer, "I had made a very careful drawing and I was just filling in the lines," at which his father remonstrated, "'Andy, you've got to free yourself.' Then he took a brush and filled it with paint and made this sweeping brushstroke. I learned more from a few minutes of watching what he did than I've ever learned from anything since."[12]

In the fall of 1942, Andrew made further studies of the orchard trees in fruit and actually counted every apple (*Before Picking*). Not all of N. C.'s tutorials of his son were "sweeping": the boy groaned when made to draw cubes for three hours a day, and a childhood friend of Andrew's recalls how the drill-sergeant N. C. made his son "paint an apple for a year. I can remember how that was ridiculous." Such an exercise recalls the advice of the Victorian John Ruskin in *The Elements of Drawing*: "Go out into your garden, or into the road" and pick up the first stone you can find; "If you can draw that stone, you can draw anything." Cultural heroes to their respec-

tive countries, Ruskin and Andrew Wyeth ran in parallel, by the way: often-solitary child prodigies at drawing who were applauded by their parents, they grew up to be nature-adoring anti-modernists who found their muses in much younger women whom they associated with "rocks & woods & clouds & air" and with whom they were ultimately ensnared in celebrated love triangles. Andrew continued to return to the orchard for decades, for example in *Half Bushel* (1959) and *Sunday Times* (1987), and, on milder winter days, Helga posed for him in her loden coat amid the gnarled old trees in nature-worshiping scenes reminiscent of the Pre-Raphaelites. "The orchard is his soul," she once explained.[13]

Great Studio of an Illustrator

Beyond the orchard lies one of the best-preserved and most evocative studios of any American artist. The original section of **N. C. Wyeth's Studio** was built in 1911 in a neo-colonial aesthetic with a splendid window in Palladian style, shown in Andrew's *North Light* (1984), which he painted from his car window during a snowstorm. The eighteenth-century flavor of the Homestead extended to the uphill studio, with its capacious **fireplace** originally fitted with a spinning wheel, tin lantern, musket, and powder horn. Once the studio's inside walls were painted "gray pearl," N. C. would never paint them again, preferring to watch as they gradually became mellow and antiqued with time.[14]

Designed by N. C. himself, a **mural studio** addition to the east (1923) allowed for the painting of gigantic pictures for the phenomenally productive illustrator—*Apotheosis of the Family* (1931) for a Wilmington bank is longer than a tractor-trailer truck. He also added a **storage wing** running up the hill, crammed with historical props and stacks of paintings that kindled young Andrew's imagination. A second eastern addition came in 1930, **Carolyn's studio.** N. C. enjoyed painting landscapes that included the picturesque building, showing, for example, the "winding stone steps" leading down to the house (which he stealthily descended each

Path to his studio. N. C. Wyeth climbed the hill daily to his magnificent art studio (1911) with its huge north-light window overlooking the rural sweep of the Brandywine Valley.

Christmas as "Old Kris" before risking his neck up on the roof). In his later years, he suffered from depression and could sometimes be found in the darkened rooms, sitting with his head in his hands, his son Nat recalled—as if contemplating his failure to become a "real" painter.

After his sudden death, much was piously kept the way he had left it, including his brushes and palette. Appropriate for this lover of colonial heritage and rural life, the unfinished painting that

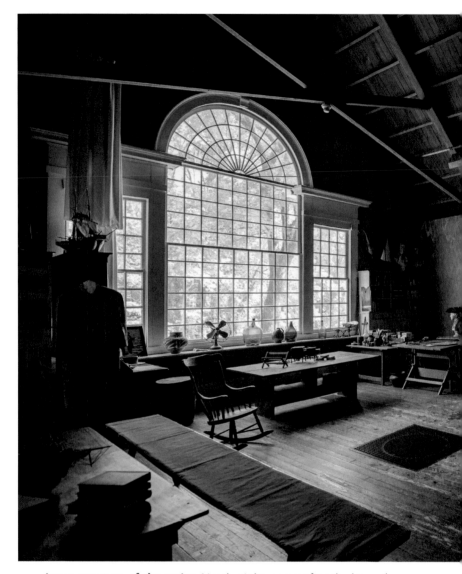

Inner sanctum of the artist. Nearly eighty years after the legendary illustrator's death, the N. C. Wyeth Studio is preserved today with his last picture on the easel, as if he had just stepped away. The mural studio lies beyond.

stood on his easel the day he died was of George Washington gazing out at golden fields of grain: *First Farmer of the Land* (1945). Andrew first received art lessons in the studio in 1932. Some Helga paintings were done in the secrecy of Carolyn's studio, including the much-reproduced, very voluptuous nude *Lovers* (1981), with a sycamore leaf blowing in from outside the window, where the orchard climbs the hillside. The leaf seems to allude to his romantic view of Testorf as a fleet-footed child of the woods. Stool and window, I would note, make reference to Howard Pyle's classic *In the Woodcarver's Shop* (1895). As for the picture's startling title by Betsy, she initially confessed to a journalist that the Helga pictures were about "love"; she quickly thought better of this and improvised that she meant his "love for hills, the love for breathing, the love for storms and snows." TIME magazine and every other outlet reiterated such high-minded explanations (repeated in books for another thirty years), although some readers were rightly skeptical. Also painted here was the sensuous reclining nude of Helga, *Black Velvet* (1972). Demonstrating his typical disinterest in French art, he denied any debt to Édouard Manet's *Olympia*.[15]

Three Generations at N. C.'s Studio

Visiting his studio today, one is struck by the boundless genius of N. C. Wyeth, whose illustrations galloped across the whole terrain of human experience, from the Middle Ages to World War I to sea voyages to Indians chasing buffalo; furiously, he thumbed through his copies of *National Geographic* (still on the shelves) for inspiration in those pre-Internet days. In the course of creating 1,940 paintings of everything conceivable, this man who never once went abroad may have achieved the greatest visual range of any American artist, ever—a true *ars universalis*. Then we contemplate the little boy growing up here, who in reaction chose the opposite approach, an *ars insularis*. If N. C. strode the world like a colossus, Andy recoiled from this notion and instead inhabited a two-mile stretch of wintertime valley like a cozy mouse in a teacup.

Decades later, N. C. would have the greatest influence on Andrew's son Jamie Wyeth, whose mother, it is said, discovered she was pregnant with him the very day N. C. died. Starting at age twelve, he studied with Carolyn for two years. Like his dad before him, Jamie pored over the old paintings stored in the storage wing: "[As a child,] I would spend hours going through all of these. I was absolutely fascinated. And then, I'd go back to our own house," he added with a chuckle, "and there would be my father painting some dead crow or something." The rebellion was real: as a teenager, he proclaimed that he was going to find his own direction in art and not merely roam the windswept fields like his dad. Soon he was off to New York and Andy Warhol.[16]

True, Andrew renounced much of N. C.'s grand and colorful painting style, but he took away one crucial lesson from his years of tutelage in the studio: the Henry David Thoreau–inspired (as well as Pre-Raphaelite) intensive study of tiny details. "Memorize everything!" N. C. would declare. Carolyn recalled her father's heated reaction when she, age fourteen, removed the manila-paper backdrop from a still life she was working on: "That sheet, Carolyn, will never again in your lifetime have exactly those same folds again. You could try and try to thumbtack it up, but the creases would never crack that way. *Remember that.*" In other words, the job of the artist is to depict reality with a near-religious reverence, never merely imagining the creases but instead delineating them with patient exactitude—the *object itself* containing some mystic spark of truth for this disciple of the great transcendentalist. Three years later, he said exactly the same thing to Andrew, who took it to heart. That still life, by the way, took Carolyn *three months* to complete, so intensive was N. C.'s pedagogy of fact.[17]

All this advice is a bit ironic, given that N. C. didn't paint this way himself: he boasted that his bravura *Dusty Bottle* (1924), with its almost trompe-l'oeil effect beloved of museum visitors today, took him only three hours to knock out! Surely in N. C.'s stern teaching (so divorced from his own habits), we can find the roots of Andrew's hypermethodical approach to transcribing the precise cracks in a plaster ceiling, the wood grain in a broomstick.

Through the Woods
to Andrew Wyeth's Studio

✧ *Follow the trail west from the N. C. Wyeth Studio.*

N. C. shows this area as treeless and sunny in *The Studio* (ca. 1912), and views up the Brandywine Valley were extensive. A few forest trees shaded a big **pile of rocks** uphill, which he painted as *The Rocks Above My Studio* and *Boulders* (both ca. 1911) and *The Rock* (ca. 1912, depicted again ca. 1916). These are dark crystalline boulders called amphibolite, some six hundred million years old, part of a single mass that forms both Rocky Hill and Kuerner's Hill within the larger Piedmont geologic province. A favorite picnic spot—almost uniquely wooded amid the region's once immense farm fields—these stones seem to find echo in the *Robin Hood* pictures, substituting for those European landscapes that N. C. never once saw. As charming home movies record, young Andrew loved to play Robin Hood himself here. Building a campfire between the outcrops, he would imagine the British scrambling up Rocky Hill amid musket smoke from Chads's Lower Ford in 1777—reenacting the battle was a favorite pastime of his gang. (One can still find the "bullet hole" in a boulder that thrilled him.) Here, he successfully courted the visiting Betsy James as a teenager; in later years, he posed his model Helga (*Big Rocks*, 1974). Easter picnics were a constant here until the early 1970s, with Andrew baking delicious potatoes. Just uphill lay a mysterious world for the impressionable child, who was allowed to wander anywhere so long as he never crossed a road: "I was about eight years old when I began slipping away up through the woods behind my father's studio," he recalled, a thrilling adventure for the sheltered boy and the beginning of a lifetime of solitary, intensely personal walks.[18]

✧ *Descend the hill toward the small white building,*
the Andrew Wyeth Studio.

We walk the much-trodden woods path between the two studios, the lower section of Andrew's customary walk to Archie's Corner

Alone with nature. Andrew Wyeth sought intense privacy in his studio, just outside Chadds Ford village and thickly screened by trees.

(from here, he went through the orchard and forest and then out into fields by the Andress House). Here ran his **"back way to Kuerner's"** (shown in *Back Way*, 1982), at any time a ready route for a "walk up over the hill" toward Bullock Road. This Jeep trail, now lost in overgrown thickets, played a crucial role in the surreptitious Helga period, allowing him to elude Betsy on his way to

his Prussian companion: "I'd drive up the back way—in secret—to Kuerner's and paint her." He was never a careful motorist, a neighbor recalled: he would drive a new Ford Explorer or Jeep Wagoneer "up through the woods, and it wouldn't fit between the trees, and he would make it fit. It would come back all crunched up."[19]

On the left is the stone **Margaret I. Handy House** (1949) that belonged to a pioneering female pediatrician from Wilmington drawn to live here by her dear friends Andrew and Betsy. Everyone knew Dr. Handy for her fiery red hair and ubiquitous black medical bag (immortalized in *Children's Doctor*, 1949). She twice posed for portraits by Andrew and invested all her savings in a dozen of his paintings, including the important *Marsh Hawk* (1964) and *Snow Flurries* (1953)—wishing he would remove the intrusive fence posts from the latter. Upon her death in 1977, this site became the home of the director of the Brandywine River Museum of Art. The influence of the Wyeths is strong upon it: the design copies a colonial house up the Brandywine near Marshallton, and the artist apparently insisted that it follow his favored, spare aesthetic: no fencing or even landscaping ("We don't permit any fences around here," he told a visitor, and when friends gave him bushes to plant around his home at the Mill, he rejoiced when a flood washed them away). Andrew was a frequent visitor who stored his snowmobiles behind Dr. Handy's house and kept eggs for tempera painting in her fridge.[20]

Birthplace of Masterworks: The Studio of Andrew Wyeth

The museum offers tours of **Andrew Wyeth's Studio**, a National Historic Landmark and a must-see for any lover of American art. "My father's studio is the nearest one can get to physically entering into his world," Jamie has said. By the miracle of art, one man working alone in a small and surprisingly dilapidated-looking room here produced works known by millions the world over. Docents report that visitors from across the globe frequently seem rapt, as if on a pilgrimage.

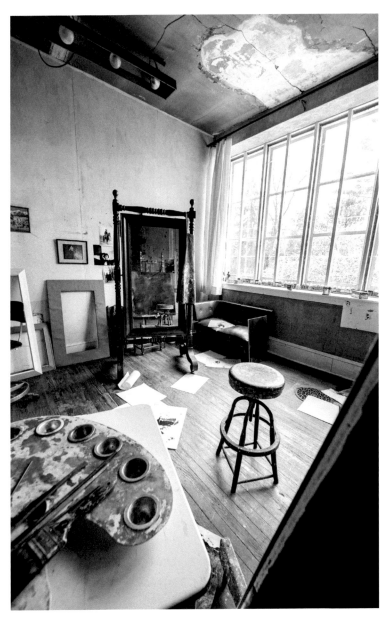

Workspace of genius. Now preserved as a museum, Andrew Wyeth's Studio has hardly changed since 1940. The mirror allowed the artist to see his half-finished paintings in a fresh way; the aluminum palette was specially made for his tempera colors.

The little white building consists of three parts. At the east stands a stuccoed section constructed in 1875 as **Birmingham Township School No. 2**, which N. C. purchased two years after it closed in 1925. He renovated it as an art studio for his daughter Henriette, installing a "north light" window where the front door had been. Henriette married the artist Peter Hurd, one of several contemporary revivalists of the tempera medium and a key influence on the young Andrew, of whom Hurd was very fond. At that time (1936), N. C. added the **central section** of frame for the Hurds to live in. Andrew and Betsy took occupancy after they in turn were married, with the Hurds having moved to the Southwest; a snapshot shows the newlyweds sitting and laughing on the north-facing **stone porch**.

In October 1940, Andrew began painting in the schoolhouse section. His **studio**, usually kept very private, was at the northeast corner, almost bare of appurtenances except a mirror in which he gauged his works-in-progress. He ignored all suggestions that he repair the battered grayish walls, occasionally using them as evocative backdrops for portraiture. A turning point in his career was the laudatory spread in LIFE magazine (May 1948) that showed the young artist perched on a stool here in front of *Karl* with a fencing sword insouciantly stabbed into the floorboards. This studio, the reporter noted, was no aesthete's den but "as white and antiseptic-looking as an operating room" (a reference not to cleanliness but to its spartan lack of "artistic" décor). Often, he slipped outside: drive by and "you may see Andy sketching, dressed in a turtleneck sweater and a pair of dungarees," a newspaper reporter observed in 1949.[21]

As a young bride, Betsy felt oppressed by the larger-than-life N. C., who lived nearby in the "Big House," brought their mail daily, criticized her choice of décor, and treated Andrew like a child in need of artistic guidance. He wandered in a cloud of wartime gloom, constantly harping on bygone "golden days." In an explosive scene in 1942, Betsy slammed a door so hard that plaster fell from the ceiling, when N. C. was taking the liberty of touching up one of Andrew's pictures. Their bedroom and bath faced north;

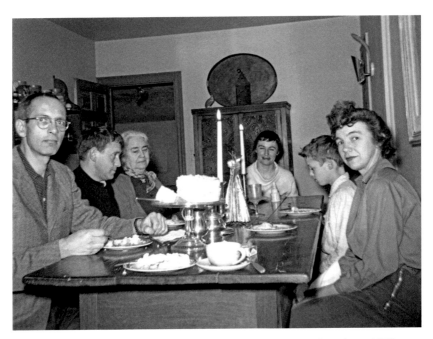

The family in the fifties. In the dining room at the Studio, about 1955, Betsy presides at the head of the table, with Andrew at left between the artist John McCoy and Mrs. N. C. Wyeth. At right are Nicholas Wyeth and Andrew's sister Ann Wyeth McCoy. (Photo courtesy of the Christian C. Sanderson Museum, Chadds Ford, PA © 2020.)

upstairs were bedrooms for their two sons, Jamie having the one on the south side and Nicky the north. Jamie's art career began with seven years of work in the studio here, plugging his ears with wax to avoid having to hear the classical music booming from his father's Victrola. One visitor of 1963 remembered the two artists gulping down TV dinners, too busy to prepare a meal, and how Andrew predicted that his precocious teenage son's fame would someday eclipse his own.[22]

About 1952, the Wyeths added the modest **kitchen wing** in the colonial-revival style they would later develop on a grander scale at Brinton's Mill, to which they moved in 1961. Andrew's refusal to move his studio to the new home he would share with Betsy produced strains in the marriage—well before the Helga crisis. There-

after, this building was taken over entirely by Andrew as his studio, with the model Willard Snowden serving as its caretaker for fifteen years. Andrew spoke to TIME magazine about this "wine-loving Negro drifter": "He gave me a chance to paint something timeless, ageless, endless. He's all of the Brandywine Valley. Its dankness and brooding power." That troubled soul found immortality of sorts in the penetrating portraits of him by Wyeth (*Grape Wine*, 1966) and the album *Willard* by Kingston Trio songwriter John Stewart, who turned to art for inspiration: it was in a room lined with prints by Andrew and Jamie that Stewart wrote the 1967 Monkees hit "Daydream Believer."[23]

After Snowden moved on, Helga made herself at home as helper and female companion amid mounting clutter, briskly screening telephone calls and trying to make herself invisible when guests arrived (one recalls spotting her feet incongruously sticking out below a curtain). For decades, Andrew had what he jokingly called "two wives," Testorf at his side by day and Betsy waiting for him at the Mill each night. To this reader of his authorized biography, he resembles the British poet laureate John Betjeman: both were national treasures of boundless middlebrow appeal, staunchly anti-modern, and dismissed by critics. Betjeman in these years had a constant "beloved other wife," an attractive companion two decades his junior who, although shy, was more fun-loving than his hard-boiled spouse. With both Wyeth and Betjeman, all parties understood that there would be no divorce and remarriage (as Andrew warned Helga early on); the pair of "wives" eyed each other fiercely; and the legal spouse suffered bitterness that did not diminish with time. As both great men eventually suffered ill health and grew gloomily fixated on death, the "other wives" attained dominance, becoming tireless nurses who were tight-lipped whenever the media began to pry. As for Wyeth, he was finally bedridden here at the studio—with Helga faithfully attending him—almost to the day he died in January 2009.[24]

Returning to the studio each morning, Wyeth created countless memorable paintings—his much-cherished privacy was protected by overgrown bushes (he called one painting of the studio *The Jungle*,

and vines eventually grew into his studio room between the walls and ceiling!). A cautionary sign still hangs on the door: *"I am working so please do not disturb. I do not sign autographs."* It took him a long time to answer a knock: first, he would scamper upstairs and then peer down from the window to see who was bothering him. At age thirteen, the budding artist A. N. Wyeth rapped on this door in 1961, having been sent down the path from Carolyn's studio to fetch a flintlock pistol to draw. He has never forgotten his astonishment at seeing his hardworking uncle's faraway look: "He was really in his own world, as if I had just woken him up." Inside the door (in the former dining room), a long table held Andrew's watercolor brushes and paper block, always at the ready for an excursion into the countryside. Unsuccessful drawings were incinerated in metal drums outside, recalling the rusted barrel of *Roasted Chestnuts*. "He was hugely insecure about his art and constantly said he was no good," one witness recalls. "He shoveled so many drawings into the fire."[25]

This studio building that he used for sixty-eight years appears in numerous works, starting with a youthful pen-and-ink sketch in 1932. When Betsy left her clothes basket propped against the south wall, he painted the scene as the light-filled *Monday Morning* (1955). Years later, a bit insensitively, Testorf's hat rested in the same place, for *Straw Hat* (1992). The locale appears in winter with long icicles in *Schoolhouse* (1994). A 1966 watercolor, *The Studio*, became part of the Vincent Price Collection of artwork that one could buy from Sears (Price was one of Andrew's earliest fans); its theft from a Chicago display window a year later remained unsolved until it reappeared at a New York auction house more than thirty years on, still in its original driftwood frame. *The Studio* shows shutters tightly closed, but many paintings emphasize the building's oversized windows, light-through-glass being one of the artist's favorite themes (the subject of an entire show at the National Gallery of Art in 2014). A year after Andrew's death, Betsy donated the historic place—parts threatening to collapse, owing to her husband's absent-minded indifference to upkeep—to the Brandywine Conservancy, which restored it and opened it to the public in 2012.

On a visit today, one is impressed by the feeling of remoteness in this tiny building girdled by bushes and trees, "a perfect misanthropist's heaven" for a Heathcliff: inside, it feels as secluded as Thoreau's cabin, and truly the modern world of twentieth-century art must have seemed forever away. No wonder his paintings remained so doggedly insular and self-referential. Without question, this is how he wanted his narrow-horizons life to be: as he pointedly declared to the New York art crowd in 1943 upon first showing at the Museum of Modern Art, in his Chadds Ford youth, "the life of the towns and cities was remote and almost unknown to us." Later, he would say that the artist must be "ingrown" to avoid being swayed by critics and commentators: "People only make you swerve." But there could be moments of drama in this lonely studio: one evening just before dinner, he daringly threw a bowl of ocher and sienna paint across the seemingly finished tempera *Brown Swiss* (1957). A friend recalled visiting here as a boy, noting the toy soldiers on every windowsill and *Karl* (1948) freshly painted on the easel: "Things were scattered all over the place—but that's just being an artist." Again and again, the "ingrown" painter looked no further for subject matter than *the studio itself*, painting numerous pictures of it both outside and in.[26]

From the front door, Wyeth's forays into nature began. "I am an outdoors painter," he explained to a TIME reporter in 1963 before summoning his dogs and striding off. The journalist marveled at his "ratty" and "ragged" clothes under the sheepskin coat and noted, "When he finds what he wants, he plunks right down in the slush and goes to work with a fury, often until his fingers turn blue"—freezing of the watercolors was a problem, but an admixture of whisky helped. One dog dug a hole nearby, spraying the paper with dirt; then, it knocked over his watercolor pan. (Modern conservators have been able to date Wyeth works by the size of various pets' pawprints left on the pictures.) As the artist rose to go, the journalist noted with surprise the long streak of paint on his lower lip, from his wiping the brush there. This account agrees with many others: he enjoyed a kind of wild freedom outdoors. "Andy just lives outside while he's making sketches or watercolors," Carolyn

explained. "He sits on logs and stones or even in a mud puddle and attacks his paper furiously with his brushes." "He looks like he's in a battle," Hurd said. "He stabs at the work as if with a stiletto, dabbing with a bit of Kleenex, slashing with a razor blade." Other observers saw him licking his brushes, getting paint on his nose, wiping a brush across a brand-new jacket Betsy had just given to him—lost in the world of art making.[27]

One rainy day not long ago, the artist Beth Bathe set up her easel to paint the studio and its wintery surroundings. A retiree, Bathe has forged a second career as "a professional plein air artist" who competes in up to twenty outdoor-painting competitions every year. It is deeply moving to paint here, she says: "At every competition, somebody compares my work to his. He has been a huge influence on me. I like my paintings to look like sepia-toned photos, and I decided not to put modern cars in them, for a vintage, timeless look. I want to evoke a sense of nostalgia." She participates in what *PleinAir Magazine* calls "the largest movement in the history of art": older Americans now taking up outdoor painting—surely a legacy of Wyeth himself, whose books adorned so many suburban coffee tables during baby boomer childhoods. His art taught Bathe the importance of immersing oneself in the local scene and telling a heartfelt story through paint. When working outdoors, she constantly asks herself, "What would Andy do?"[28]

Andrew Wyeth at the Studio: Truth to Nature Means "Self-Effacement"

At the studio, Wyeth submitted to an interview for Selden Rodman's 1957 book, *Conversations with Artists*. It offers penetrating insight into his art philosophy as his career rocketed skyward.

He had Rodman stay at the Chadds Ford Hotel and dined alone with him there; Rodman thought it strange that he was never invited to eat at the guarded Wyeths' dining table. Nonetheless, "we talked all afternoon and late into the night at his home," plus Andrew took him around Chadds Ford to see the locations of those famous pictures *Karl* and *Pennsylvania Landscape*. Rodman was

awed by the sight of N. C.'s painting of *Blind Pew* from *Treasure Island*, which so many American boys had rapturously pored over, hanging over the fireplace in the Wyeth home. But otherwise, the "prosy" works by various artists that decorated the place horrified Rodman, a champion of realism: "They raised in my mind disturbing questions not only about the virility of the realistic tradition itself, but about Wyeth's own taste, which apparently is limited in its appreciation to this tradition."

Wyeth voiced to Rodman an extremely spare philosophy of art—"perhaps it's my Puritan background"—that limited the practitioner to a single approach (accurately realistic painting) and forced upon him the stringencies of *self-effacement*: the subject matter comes from nature, which rules all; the artist's job is to render nature truthfully without, if possible, any manipulation. The artist's eye is a conduit for nature, and his hand is a tool whereby nature can be replicated on canvas. As hyperrealistic as we may find Wyeth's style, to him, his efforts were never quite enough—he had failed to fulfill his own stern mandate: "I've never painted *anything* that looked enough like the real thing, with all its pungency."

Not artistic self-expression so much as *truth to nature* was his fundamental aim: "I believe as I did as a child—in truth. My only rule is: does the picture fit the truth as I feel it? We've gotten too complex. The thing is to describe the object we have gotten to know, with a depth of penetration achieved through feeling." He extolled the work of Thomas Eakins: "There's a Yankee tenacity of truth there." He further asserted that actual "danger" developed if the artist allowed himself too much creativity, lest the truth be lost. Creative excess had ruined the careers of Winslow Homer and John Singer Sargent along with every New York artist: "'Look what *I* can do!' is what the modern painter seems to be saying." He added, "There is a tendency for the imagination to deteriorate the truth. . . . A realist is only safe if he remains close to life"—safe from evils that he considered really unspeakable, such as making "carved images out of pigment . . . grandiose in style and application of paint," smacking of "the glamorous life."

His dislike of "Frenchy" impressionism, his hostility toward New York sophisticates, and his Thoreauvian nature worship had coalesced into a definite and stern philosophy. He considered modern artists "awfully brutal and crass" for showing off their painterly abilities;

instead, they should have "great humility" and "self-effacement," disappearing before the subject matter in nature. (In painting *Nicholas*, "I lost myself so completely" that he could think only of the subject, and "I even forgot to sign it.") Any other approach to art was flamboyant, sickly sweet, oversophisticated, unmanly, and even un-American: "Let's forget art and think of America!"

Critics may argue that this stringent philosophy cut Andrew off from many happy avenues of artistic expression, constraining him in countless ways and undervaluing the human role of the artist in favor of the supremacy of Ruskinian nature. He himself quoted to Rodman a detractor who had said, "Wasn't it a pity that I was so limited and painted such dull subjects?" He knew how isolated he was from the art world: among fellow artists, "most of them dislike my work." Yet he himself frequently dismissed the work of other practitioners, not only the abstract expressionists but fellow realists, including Ben Shahn, whom Rodman had interviewed as well. Shahn's own philosophy of art was the opposite of Wyeth's, and unfearful: he found value in "every movement in the last hundred years. . . . The great artist will not be engulfed by any tendency but will make it a contribution to his own personality and understanding. . . . I'll avail myself of every mode of expression around me." Shahn's view of the Chadds Ford artist was harsh: he would sooner study the much-ridiculed French academic William-Adolphe Bouguereau than this purveyor of a "brilliantly contrived imitation of nature. . . . I admire Wyeth's craft, but I'm not moved by his pictures."[29]

Along Murphy Road

⇢ *Walk past the studio toward the intersection of Creek and Murphy Roads.*

West of the studio stands the stucco-and-frame **McVey's House**. The lanky farmer John McVey owned the thirty-one acres west of the N. C. Wyeth Homestead, and his house and now-vanished **barn** appear frequently in N. C.'s paintings as a kind of ideal agricultural landscape; *John McVey* (ca. 1928) also shows the schoolhouse. One of Andrew's first exhibited works was a watercolor of the barn (1933); later, he painted its intricate interior (1948). Even

in the 1930s, tourists came to Chadds Ford to gawk at the Wyeths, and McVey appointed himself as a guide. Peter Hurd laughed as he recalled how he and Henriette were painting in what later became the Andrew Wyeth Studio when McVey arrived with a group of rubberneckers. Diving into the basement, they heard McVey's booming pronouncements as he arranged their paintings against the wall: "These are *hers*, and those over there are *his'n*. . . . This one here is *his'n*, and it's the worst one." On the morning that N. C. died in 1945, that family patriarch pulled his car to the **foot of Murphy Road** to pick up his toddler grandson Newell, the child of Nat and Caroline Wyeth, who lived at the former McVey place. A color home movie shows N. C.'s maroon, wood-sided Ford station wagon stopped at this intersection on a similar occasion months earlier. Hauntingly, the scene is little changed today.[30]

The stately **white pine** is surely one of those that the Wyeths brought back as a seedling from their beloved New England—the mere smell of white pine needles was enough to engulf N. C. in sobs of nostalgia. The stretch of Creek Road (**Route 100** to longtime residents) west of McVey's was home to several of Andrew's friends, including the painter Rea Redifer and those frequent artistic models the Lynch family, part of a quirky Chadds Ford coterie that wobbled like moths around the master's flame. Redifer was one of several young, would-be painters from across the country who showed up hoping to learn from the legendary man, who (while kind and encouraging) invariably pointed them to Carolyn's studio for instruction—Andy never took on students himself, determined to avoid any of the tedious obligations to others that he thought had fatally dissipated N. C.'s creative genius by the end. The subject of the famous Jamie Wyeth painting *Draft Age* (1965), the free-spirited Jimmy Lynch would tear around the sharp corner here in his pickup at breakneck speed.

⇢ *Walk east along the graveled Murphy Road.*

In the 1960s, Andrew worried that the **meadow** at left, so near his studio, would be developed for industry: "If the Brandywine Con-

servancy doesn't buy it, I'll move to Maine!" Happily, they managed to save it. A large, although dying, **oak tree** to the left of the road survives from a pair depicted by N. C. in *Road to McVey's* (ca. 1912). Along with the view back to the village, the gravel drive is hardly altered, and even some of the fence posts look to date to N. C.'s time. The house on the right was built by the local service station owner and former railroad engineer Horace Kipe in 1922 as **Stony Knoll** (to the humorous N. C., it was "Knobby Knoll"). Kipe would pass Andrew's studio, carrying straw for his mule and wearing a jacket that the artist later painted as a posthumous portrait of a kind (*Blue Coat*, 1956). Beyond are N. C.'s brick **gateposts** and plane trees that he planted, at the foot of his winding drive. "We have to fairly close the gate on them," said Mrs. N. C. Wyeth of tourist crowds seeking access to the Homestead in 1972 as her son Andrew was at the height of fame.[31]

The artist Eo Omwake spent his 1950s childhood living in the former Kipe House. His family moved in about 1953: "My first day there I ran into Jamie Wyeth down by the white fence that bordered our properties and we became fast friends." Omwake would spend many hours in the Andrew Wyeth home, playing with toy soldiers outside the door of the studio and gathering with the family in the little kitchen to admire the painter's latest work, with *Trodden Weed* hanging on the wall above. Especially memorable were Sunday strolls down Murphy Road: "It was Andy, Betsy, Jamie, and I. This was a time when you could just walk anywhere, across people's properties—we didn't always end up at Kuerner's or on the hill overlooking it, but somewhere just as magical, as Chadds Ford was in those days. As I think back, I can see that these walks were times when Andy was out scouting for things to paint." The artist was delightful company: "I remember well his way of walking with his turned-out foot, his jodhpur shoes—and his wonderful laugh, throwing his head back with an open mouth."[32]

Brandywine River Trail to the John Chads House

PROBABLY NO OTHER AMERICAN RIVER of such intimate scale is as famous as the Brandywine. Although little—its entire drainage area is the size of New York City—it is unusually varied: going upstream from its mouth, one passes the abandoned, red-brick factories of Wilmington, the wooded ravine at Hagley Museum, swamps teeming with bullfrogs here at Chadds Ford, breathtakingly beautiful horse country near Embreeville, a roaring steel mill at Coatesville, and eventually Amish farms, where cattle cool themselves in the creek in a scene that looks straight from the nineteenth century.

This walk goes up the Brandywine through riparian woods and marshes and traverses the scene of intense fighting in the 1777 battle, offering up-close views of riverbanks of the kind that Andrew Wyeth loved to paint. An artist friend recalled once seeing how he "grew frustrated with his touch and color mixing" beside the Brandywine "and just reached over and grabbed a handful of mud and smeared it across the watercolor," finding that an effective solution, to his companion's undying astonishment. Wyeth told a visitor in 2006, "I never work at an easel outdoors because I prefer to hold the paper in my lap, and I just toss one painting aside when I want to work on another. Sometimes I step on them, scratch them, or watch them blow into

the river. Quite often it helps to have them washed by the river water." He liked to tell the story of how the Marquis de Lafayette, in France, had been buried in a coffin along with Brandywine mud. In 2008, as he faced his own mortality, Wyeth said that he deliberately added traces of this mystical mud to his tempera of a bird, *Goose Step.*[1]

The Artist Who Never Stopped

Goose Step typically sold for a fortune and is admirable proof of Andrew Wyeth's total commitment to art: it was completed when he was more than ninety years old. Compare him to a famous contemporary, the writer J. D. Salinger—both shot to fame with a work involving the alienated individual, *Catcher in the Rye* (parts serialized 1945–46) and *Christina's World* (1948), the two even sharing a field-of-grain motif. Both men landed on the cover of TIME magazine as American icons in the John F. Kennedy years. Both became renowned for reclusive mystery, shrinking from the press in out-of-the-way hamlets; both filled many hours watching films; in the early 1970s, both took up with younger female protégés, a matter of subsequent controversy; both lived into their nineties. But Wyeth alone stayed in the tough fight of making and then marketing his creative work: Salinger gave up and published nothing past 1965. Whatever one thinks of him as a painter, his tough fortitude cannot be denied. That he did so in the face of such critical abuse—not to mention health scares and waning eyesight—is all the more remarkable. Meeting President George W. Bush at the White House to receive the National Medal of Arts in 2007, he remarked with a smile that the two men shared something in common: being so virulently disliked. Then he went back to Chadds Ford and picked up his paintbrushes once again.

The Banks of the Brandywine

⤳ *The trail begins by the creek at the Brandywine River Museum of Art.*

Founded in 1971 and famous for its collection of Wyeth family paintings, the largest in the world, the **museum** occupies brick-

and-stone **Hoffman's Mill** (1864), a local center for the production of flour, for which Chadds Ford was renowned. To the south is the abandoned **Penn Central Railroad Bridge** (original version 1859), linking to **Chadds Ford Junction** west across the **Trestle**, which young Jamie Wyeth walked on his way to explore **Mattie Ball's Farm**, the scene of some of his earliest farm landscapes and loving depictions of pigs. The Ball house subsequently burned.

Where Fairville Road crosses the tracks at the Junction (likewise west of the creek) stands a blue dwelling, the **Tom Clark House**—always fond of old buildings, Andrew Wyeth was upset when it eventually got remodeled. Here, he painted his celebrated series showing the elderly black model Tom Clark: *That Gentleman*, 1960, a high-profile purchase for $58,000 by the Dallas Museum as he became widely famous, and the superb *Garret Room*, 1962—surely he was at the height of his powers in these years. Near the Trestle was **Chads's Lower Ford**, where British soldiers were cut down while wading across, staining the waters red within sight of Andrew's future childhood home—a historical scene drawn by the young artist as *Fight at Rocky Hill Ford* (1940).

In 1966, the property where the museum **parking lot** stands was a lumberyard slated to become an industrial site, which might have begun a deluge of ugly development along busy U.S. 1. The preservation-minded Wyeth helped launch a vocal opposition: "I've been a gentleman about this long enough," he told a reporter. "I'm going to fight." He worked with his wealthy du Pont artist friend, George "Frolic" Weymouth, who founded the Brandywine Conservancy, toward defeating the development plans. Given an early boost by Earth Day and growing seventies ecological consciousness, the conservancy today has proudly helped protect sixty-two thousand threatened acres of field and forest in Delaware and Pennsylvania.[2]

The Brandywine here drains 287 square miles, and floods have reached 17 feet. In August 1904, N. C. Wyeth and fellow Pyle student Stanley Arthurs paddled from Wilmington to Chadds Ford during high water and then back, shooting over dams and rapids; once, the canoe overturned, and Arthurs nearly drowned. The following summer, N. C. courted shy, dark-eyed Carolyn Bockius by

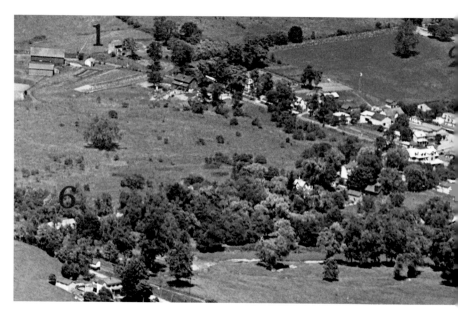

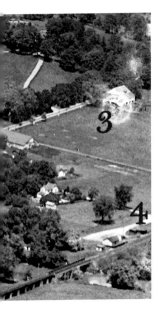

Left: Rural Chadds Ford on the Brandywine, looking northeast, July 12, 1925.
1: John Chads House and barn. 2: Harvey Homestead carriage house, former studio of N. C. Wyeth. 3: Pyle's Barn in Eli Harvey meadow. 4: Railroad station and trestle over Brandywine. 5: Future site of art museum. 6: Highway bridge.

Facing page, bottom: Frolic's Dream.
Hoffman's Mill (1864) undergoing transformation into the Brandywine River Museum of Art, a virtual shrine to Wyeth art, about 1969.

taking her on trips in his birch-bark canoe each weekend, sometimes from Chadds Ford clear down to Wilmington. By then, the valley had captivated him utterly, and in later life, he would sometimes throw out his arms and exclaim nostalgically, "Those glorious days!"[3]

The **Big Buttonwood**, a leaning sycamore that somehow keeps its grip on the riverbank, has been a local landmark since the nineteenth century. N. C. recorded his pride in his son's *Summer Freshet* (1942): "A stunning and vivid thing it is too, a very intimate glimpse of a fragment of a Brandywine bank: a leaning tree trunk, great fronds of leaves hanging over the water. . . . For two weeks Andy has been perched on a tall stool in the middle of the stream." A year earlier, Andrew had researched the river extensively before illustrating Henry Seidel Canby's book *The Brandywine* in the landmark *Rivers of America* series (1941).[4]

> ⇢ *Two trails go under the highway bridge;*
> *the one on the right is less rough.*

Visible across the creek is the **Wilmington and Northern Railroad** (1869), which offered Pyle's students easy access to town. The busy **highway bridge** replaces a long series of earlier bridges, the oldest

Picturesque dilapidation. Still in business today, Fred Taylor's Garage stands by the train tracks just west of Brandywine Creek. "Retread Fred" was a friend of Andrew Wyeth, who painted a view from this position in 1982—"absolutely accurate" as usual.

from 1828—covered spans that stood some yards downstream (see the background of N. C.'s *The Fence Builders*, 1915, and his 1940 self-portrait). Under the highway bridge is preserved part of the stone dam for **Hoffman's millrace** and efforts of Brandywine School painters of another variety: teenagers who lurk beneath the reverberating overpass and daub unflattering encomiums to their classmates. In midwinter, the view north is bleak: low, wet, featureless, a mire of silky dogwood and black willow; flood-flattened grasses flaxen in color drape over the black mud. The river surges by, eats its banks away, and scours potholes.

A crucial river crossing since the Great Road of colonial times, Baltimore Pike or U.S. 1 became (1917) part of the first paved Maine-to-Florida route. Just beyond the bridge, a deteriorating stone dam marks the approximate site of colonial Chads's Ford, the scene of fierce fighting in 1777. The concrete motorway (widened in 1937 and again in 1981) destroyed much of the "remoteness"

that N. C. cherished in this valley, bringing tourists to his door and encouraging the development of estates. West of the bridge, Andrew patronized his friend **Fred Taylor's auto-repair shop** (*Retread Fred's*, 1982), which occupies the former Darlington's Creamery of ca. 1890. Fred's son Dave remembers Andrew's asking him to rearrange the stacks of tires into a more pleasing pattern before he sat at an easel beside the train tracks and began to paint.

Brandywine Meadows and Hoffman's Slough

⇢ *The trail runs a short distance up the powerline right-of-way.*

Here, N. C. took a "grand walk" in October 1908, up the riverbank toward **Brinton's Meadow**, carrying his child Henriette, who chattered all the way—a walk the artist wished would go on forever. Jump ahead sixty years: Henriette's grandson, the artist Peter de la Fuente, bounced along the riverbank in Andrew's Jeep Wagoneer. The impetuous driver ran it right into the creek, attempting a crossing, but got stuck half-way. "I was about seven, and I was yelling and scared to death," de la Fuente recalled. "I had heard about the Brandywine snapping turtles. Finally some people in canoes rescued us." Even in the midst of peril, the great man's artistic eye was working: "He had *seen* something while we were out there, so when we got back to the house, he just vanished"—off to create another painting.[5]

In the 1890s, the inveterate cyclist Howard Pyle rode over to the Brandywine meadows from Chadds Ford in the mornings to check on his students: "He would pedal up along the bank and give us criticism," Frank Schoonover recalled, adding that he once had to quickly smear paint across his palette at Brinton's Mill to give his teacher the impression he hadn't overslept. Pyle sent the students here on Saturday afternoons to bathe in the river, among the pollarded willows. Blocks of ice are strewn across the land here after winter floods, as in *Breakup* (1994), which alludes to N. C.'s story of a local man drowning. It includes a depiction of Andrew

Vanishing emblem of the colonial countryside. Old-timey "worm
fences" were becoming rare, attracting the eye of Frank Schoonover
and the other Brandywine illustrators, who cherished disappearing
rural folkways—as Andrew Wyeth would later do. (Frank E. Schoonover
[1877–1972], *Worm Fence (Hoffman's Meadow)*, 1899, oil on canvas, 13 × 20".
Brandywine River Museum of Art, Gift of Mr. and Mrs. Andrew Wyeth, 1970.)

Wyeth's hands (painted from bronze casts), recalling similar hand
studies by Albrecht Dürer. Betsy Wyeth's title suggests not only
the movement of ice but also her ongoing unhappiness, never to
dissipate, following the Helga crisis.[6]

The **power line** from which pigeons go clap-clapping in flight,
wheeling and settling again, was put through over the artist's stren-
uous objections—with slightly less grotesque towers than originally
planned. Opposition to them galvanized the historic preservation
movement locally and led to the first Chadds Ford Day in 1958.
Wyeth averted his eyes from them, as from all machinery, TIME
magazine noted in 1966: "He even leaves out of his works the gi-
ant high-tension towers that march behind his rural house." They
cannot entirely spoil the beauty of the river valley, through which
Hollywood star Eva Marie Saint was taken on a memorable buggy
ride one Christmas, not long after she filmed Alfred Hitchcock's
North by Northwest. "It was so cold, I had a robe over my legs," she

tells me. "Andy drove me along the Brandywine. I felt like I was in a Christmas card! He was such fun and very playful—I never saw him quiet. He wanted me to pose for him in his studio, but I said, 'I'm an actress, I'm too busy.' I guess I passed up my chance to be Helga!"[7]

◇ *Take the boardwalk to the right.*

The Brandywine Conservancy installed the **boardwalk** after 1976 to provide access to the Chads House, which then lacked toilet facilities or a parking lot. Alive with birds and turtles, **Hoffman's Swamp** was the "morass" of 1777 accounts of the bloody battle. It was treeless when N. C. knew it as Sellers Hoffman's Meadow; he painted *Brandywine Meadows* (ca. 1918) just north. Skunk cabbages push out in springtime in the brooding *Frog Hunters* (1941), a marsh scene that helped make Andrew Wyeth well-known when shown at the Museum of Modern Art's *Magic Realists* show in 1943, curated by Alfred Barr and representing the mainstreaming of surrealism.

A favorite skating place when Andrew was a boy, **Hoffman's Slough** appears in the malevolent *Night Mare* (1973), its horse-bones theme apparently taken from Hieronymus Bosch. He had shown this vicinity from the air in the quasi-abstract and haunting *Hoffman's Slough* (1947), exhibited at the prestigious Whitney Museum's annual show and seen by millions in LIFE magazine in May 1948—a good example of his more "essentialized" landscapes of the 1940s, since the whole village is omitted in the distance, along with many trees shown in an aerial photograph of that period (and in his preliminary study). "It's one of his most prophetic paintings," the Southwest artist Woody Gwyn told me, "done years before Minimalism." Its stripped aesthetic has tremendous power, Gwyn explained. "I once showed him one of my own works," he recalled of his teenage sojourn in Chadds Ford in 1963, "and it had a kind of niggling quality. I've never forgotten what he told me: 'Whatever you do, *do it like a man.*'"[8]

Recently a neighbor smiled while recalling the suddenly wealthy Wyeth painting west of the Brandywine, where he had stood for *Hoffman's Slough*: "He had this new, fancy Lincoln Continental Mark

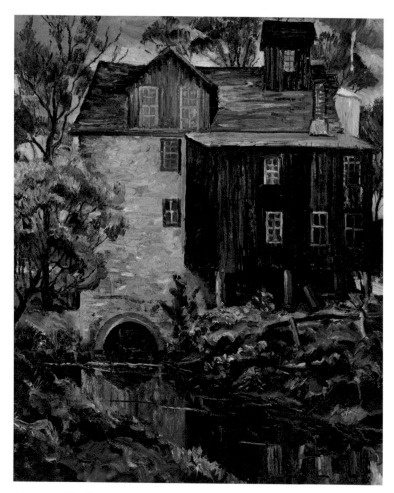

Classic mill of the Brandywine. Brinton's Mill looked workaday three decades before Andrew and Betsy Wyeth returned it to an eighteenth-century appearance. Artist Peter Hurd, who painted this canvas in his studio above the millwright's shop in the village, had married Andrew's sister Henriette the year before. (Peter Hurd [1904–1984], *Brinton's Mill*, June 1930, oil on canvas, 30⅛ × 25⅟₁₆". Brandywine River Museum of Art, Bequest of Carolyn Wyeth, 1996. © artist's estate.)

II, dark blue—a top luxury car. But it was stuffed with his art paraphernalia and looked like he was living in it!" That 1956 automobile was the most expensive then made in the United States, a plaything of Elvis Presley and Frank Sinatra, but a friend recalled that "Andy just parked it under that maple tree by the studio—no garage!"[9]

Farther upstream—beyond Brinton's Bridge, looking west toward Pocopson Road—Andrew once more stood in the Brandywine floodplain to show a twisted old sycamore tree in *Dil Huey Farm* (1941), an important picture as he simplified his approach to portraying landscape. This area west of the creek and upstream from Brinton's Bridge also included **Woodward Farm**, seen in *Slight Breeze* (1968) and in the distance beyond the dam in *Night Sleeper*, the ever-popular dog painting (1979; Wyeth *painted stripes on an actual bag* before proceeding). It seems to have been overlooked, but *Night Sleeper* is a reworking of Howard Pyle's *Awakening of Brunhild*.

Andrew and Betsy Wyeth at the Mill

On strictly private land to the north stands the site of **Brinton's Bridge** (1854, burned in 1957), a heavily guarded ford during the battle, with the colonial **Brinton Mill** complex nearby (a **miller's house** built by Amos Brinton ca. 1778, plus a **gristmill** and **granary**). The Quaker Brintons were prominent in colonial times, having come from Birmingham, England, in 1686. The British army careened through the property after fording the creek on the afternoon of September 11, 1777; Andrew reimagined this lively scene in a watercolor, *Plundered* (1996). Pyle's students played baseball in the meadow here. Later, N. C. took his family to Brinton's Bridge for ice cream under the trees, and they swam below the dam or picked strawberries while he fished. He depicted the mill dam in *Brinton's Falls* (ca. 1905) and the lovely *Barn on the Brandywine* (ca. 1919).

In 1958, Wyeth sketched neglected hunting dogs chained up by the derelict mill, the basis of the much-admired picture *Raccoon*. It seems to have gone unnoticed that the dogs are a reworking of those in Dürer's *St. Eustace*, that touchstone of Pyle. Whenever exhibited or published, *Raccoon* was accompanied by a caption that gave the name of the chief dog (Jack, a "sad, damp-eyed hound") and its piteous fate (shot by the owner "in a drunken rage")—the kind of anecdotal overlay that made art critics cringe. While Andrew was working on *Raccoon*, he and Betsy were delighted to learn that the Brinton's Mill property was for sale. Following an elaborate

Hunting dogs from Dürer. To create his famous painting *Raccoon* (1958) of hounds beside the Mill, it is apparent that Andrew Wyeth turned to this Northern Renaissance print, *St. Eustace* (ca. 1501). Detail.

1958–61 restoration by Betsy that returned the place to its Revolutionary War–era appearance, plus modern amenities, the Wyeths lived at the Mill for decades: first in the granary, which became a studio after the miller's house was completed and was the scene of an audacious art heist in 1982. I have never been there, but I am told that this was an idyllic world, to dwell amid priceless antiques in a colonial mansion and step outdoors into a fertile floodplain rich with wildlife, with kingfishers darting over the water as Betsy thumbed through her trusty bird guide. But one regular visitor was struck by the insularity: "The staff would hang up his new paintings, and Andy would expound on them at length in front of the fireplace, and everyone would gush with enthusiasm. This was the world of 'Wyeths,' closed and self-affirming."[10]

Many a disciple wandered down the ungated driveway seeking their hero. After a pet goose was shot by a stranger in 1974, a sturdy palisade fence went up around the property, but lacking a permit, it

was quickly removed. Aficionados were innumerable: it was at the Mill that Andrew was interviewed for his TIME magazine cover story in 1963 as he rose to dizzying summits of fame. Kennedy honored him with the Presidential Medal of Freedom, the country's highest civilian honor; no artist had ever received it before. The Chadds Ford painter was said to command the highest prices of any artist on the planet, except for Pablo Picasso.

How to explain his meteoric ascent? For one thing, the generation of successful Americans who began patronizing "the Rich Man's Norman Rockwell" in droves had, like his admirer President Dwight Eisenhower, typically grown up in a rural United States, only to see it buried under interstate highways and housing tracts; Wyeth brought back the vanished world of their youth. Nostalgia for bygone days proved a powerful force in the modernizing, superpower America of the 1950s—especially when it paid homage to the Revolutionary War era, even as the United States nobly sought to export democracy. Andrew, who had never traveled abroad, felt a high calling as a leading exponent of American culture, sitting in front of his blazing colonial fireplace at the Mill with a reporter in 1963 and exclaiming, "This country has the greatest opportunity it has ever had to achieve a dominant position in the arts."[11]

Living here for more than forty years, he painted and drew an enormous body of work in and around the Mill and beside its **dam** (rebuilt in 1967 as part of his assistant George Heebner's project of returning the gristmill to colonial working order) and flooded **raceway**. At considerable cost, Brinton's Mill provided an opportunity for a tangible restoration of the colonial era. Showing profound reverence for bygone days, Andrew and Betsy went all out, rebuilding whole dams on the Brandywine, hauling fifteen truckloads of tires out of the millrace, reconstructing the sluice gate, and then making the milling apparatus work again—despite never expecting to make a dime at grinding grain.

Assistants re-created the undershot **waterwheel** from scratch—lovingly joining it without a single nail—and spent four hundred hours on the shaft alone, carved from the trunk of a 260-year-old white oak tree. Rather than replaster crumbling walls inside the

home, imprinted with an early owner's signature and cat footprints, the Wyeths applied a DuPont chemical fixative to keep them up. Andrew compared notes with his friend Richard Widmark, the Hollywood actor whose Connecticut estate included a 1790 mill. By the 1980s, after decades of exhaustive and painstaking work, the Wyeths' property struck a visiting academic as an elaborate pastiche assembled from fragments of the past. The **garage**, for example, was a replica of an old Quaker meetinghouse horse shed; inside the home was a new room imitating one at George Washington's Headquarters in Chadds Ford—"This makes the room a copy of a copy," the visitor sniffed, since the headquarters had been re-created as a public museum following its 1931 fire.[12]

A reporter in 1964 had found the artist to be "Wyeth alone—walking by the Brandywine Creek where the British defeated General Washington on their way to Philadelphia; lying on his belly to sketch tiny flowers along the waterway that once powered his ruined old mill" (*May Day*, 1960). At the Mill, he produced many famous pictures: *Marsh Hawk* (1964, which seventeen years later became the most expensive painting by a living American ever sold at auction), *Battleground* (1981)—we even look down on it from the wealthy Wilmington patron Charles Cawley's private jet en route to Maine in the highly atypical *Otherworld* (2002). Hollywood legend Charlton Heston bought *Flood Plain* (1986), which reminded him of his rural childhood in Michigan; the real artist and the actor who had played Michelangelo in a movie would become close friends. When an assistant came to work for the Wyeths in 1979, she was perplexed that the artist seemed to do little else but depict this tiny locale. "I would come to work in the morning and he would be out painting the Mill . . . every day, and I kept thinking, how could he find [so much] inspiration in that? *Every day*." When age decreased his mobility, he painted here even more often, for example posing a nude model in the hollow of a riverside **pin oak tree** struck by lightning in *Dryad* (2000); on second thought, he painted the model out of the picture, typical of his late, redoubled interest in "vacancy." On a visit, his famous Norwegian artist admirer Odd Nerdrum asked to climb inside this tree.[13]

Witness beside Creek Road. A survivor of the Battle of the Brandywine, the historic John Chads House is seen as Howard Pyle's students knew it, circa 1898. The white pine at right still stands today.

As detailed in the authorized biography, the tireless Betsy managed her husband's booming career in a private complex of buildings across Route 100 from the Mill. A house called (after Winslow Homer's) the **Ark** offered a flood-time retreat above the deluged valley. Betsy was proud of her restoration of the red-brick **Schoolhouse**, which housed her innovative computerized catalogue of artworks plus wall-to-wall ring-binders. Accompanied by a faithful nurse, Andrew Wyeth died early in the morning in the gray, ranchstyle **Long House**—on January 16, 2009—during that frigid season he called "my time of year." In his often-vexatious later years, he had preferred the fun, spontaneous sociability of Chadds Ford, whereas his wife wished to summon him to Maine, where she spent the warmer months on her three private islands out in the surging Atlantic, an ironclad retreat. And so it was in Maine that he came

to be buried, beside the field where he painted *Christina's World*, under a black granite headstone hand-carved in old-fashioned style.

The John Chads House

The boardwalk leads to the **Chadds Ford Historical Society**. Since 1971, it has operated a museum in the **John Chads House** (ca. 1725), narrowly rescued from collapse. The stone building was home to the man who operated the colonial ferry over the Brandywine that gave its name to the town. Today, it is a picturesque house museum, with creaking floors that slope like a ship at sea. Much Revolutionary War lore surrounds the Chads House and its adjacent **springhouse** (painted by N. C. in 1903 and 1907 and likewise rescued from demolition; it had served as a creamery and later a schoolhouse). A corner of the springhouse was damaged by a cannonball during the battle. The **white pine** near the house was already large when the Revolutionary War historian Benson Lossing visited in the 1840s.

N. C. stood beside the rivulet downhill from the springhouse to sketch the delightful complex in June 1910 in preparation for a large oil study. He also painted the house and former barn (Hoffman's Lower Dairy) from along Creek Road to the north in *February* (ca. 1911). The Chads House and its pine tree appear in several paintings by Andrew Wyeth, including *The Home of John Chads* (1943) and—with elements rearranged for purposes of a magazine-cover illustration—*Autumn Cornfield* (1950), an example of the artist at his most "Regionalist Painter." Although deeply involved with the founding of the historical society and related archival research into the Chads House, Betsy was upset by construction of the society headquarters on the site of the original barn, thinking it a modern intrusion in the ancient landscape.

In the early 1970s, Terry Newitt lived with fellow twenty-something artists in the house just north: "Andy would show up while I was out sketching the Brandywine—he was like a little pixie. Once he sat in his Jeep on Route 100 and did a watercolor that sold for $40,000. He'd come down and party with us all the time, even though his wife disapproved. At my *Great Gatsby* party in May

1974, two thousand people showed up. He got so mobbed, we had to put him up on the roof." Like many local painters, Newitt came under the spell of the master—"You had maybe the world's greatest artist living in your town! I'd copy an Andrew Wyeth ten times to get it right"—before eventually breaking free to forge his own style. Others took a different approach, he noted: "Let's copy Wyeth and make money." Like many people I interviewed, Newitt is nostalgic for the seventies, when a painter could still become a household name in America, when "to sit and paint was a spiritual experience" unspoiled by seductive screen technology, and before his childhood village became "all commercialized, all rich people now."[14]

Quirky Antiquarian: The Sanderson Museum

Just south on Creek Road from the historical society (no trail access) is the **Sanderson Museum**, created in 1967 in the home of the Wyeths' late friend Christian "Sandy" Sanderson, who amassed curious antiquarian collections relating to the area and had great influence on the historical awareness of both painters, who adored this loveable if curmudgeonly eccentric. In the little museum (which Andrew helped keep going with repeated financial infusions) are many items related to the Wyeths, including Andrew's early *Portrait of Chris* (1937). On frequent visits, the artist (incognito) enjoyed the joke of badmouthing his own pictures to unsuspecting visitors. He depicted the Victorian house that the museum occupies (*Back Apartment*, 1961, with one window left out, and *The Bachelor*, spring 1964) and Sanderson's dying mother in the magic realist *Christmas Morning* (1944). The quirky Chris staged a photograph that reenacted Andrew painting *The Bachelor*, with young disciple Rea Redifer portraying his master. Showing a shirt messily hung on a line on the porch, Wyeth's rather minimalist watercolor recently sold at auction in 2018 for a quarter-million dollars—that is, $380 per square inch.

A born packrat who eventually lived in near squalor, Sanderson saved many of his friend's very early pencil sketches for magazine il-

Poignant colonial tableau. Christian Sanderson's history-loving mother in death, December 25, 1943, the scene that inspired Andrew Wyeth's surrealist *Christmas Morning*. (Photo courtesy of the Christian C. Sanderson Museum, Chadds Ford, PA © 2020.)

lustrations. Filled with mementoes of the Revolutionary War battle and much else, the museum occupies one of a row of modest houses, mostly of the nineteenth century, between the Chads House and the village center. Around Chadds Ford, anecdotes of Sanderson still abound—breathlessly narrating the battle with a map quickly drawn on a bedsheet, endlessly hitching rides from neighbors (sometimes not bothering to ask their names), his puritanical mortification when the ribald Andrew and Betsy told racy jokes just to shock him.

A historian stopped by several years ago:

FEBRUARY 22, 2004. Andrew Wyeth chose Tommy Thompson to be curator of the Sanderson Museum. He is a bald little man in glasses and red bow tie who at first told me the museum is closed in February but then let in a stream of people, more than one of whom knew Sanderson, a local celebrity for his fiddle ensemble. His eyes mist over in telling how

Sanderson, for the first time ever, shook his hand from his hospital bed as he was dying in 1966. Thompson hauled out two truckloads of refuse but kept all 4,000 handwritten notes on torn grocery bags (one apologizing for the house being a mess), the postcards Sanderson mailed to himself on his birthday, numberless glassine envelopes stuffed with brown crumbled fragments such as "VALUABLE—Matchstick I used to light a candle such-and-such a time." His mother heard of Lincoln's death as she lay on the sofa; Sanderson had her drape her withered self across the same battered sofa for a reenactment. After 84 years she got electricity in a house; he photographed her pulling the overhead cord, her head immersed in a glow of exaltation. Later she lay dead on a cot beside the window, head wrapped in gauze, Old Glory over her knees, and Sanderson at her feet snapped a shutter for a foreshortened, icy portrait. This so moved Andrew Wyeth, he painted *Christmas Morning*. Thus a woman who had donned colonial costume for Brandywine illustrators at the turn of the century posed one last time.

Hazarding a porch that bowed under the weight of rotting newspapers, Andrew brought celebrity visitors from the movie star Robert Montgomery to the photographer Henri Cartier-Bresson to meet Sanderson, that American original. He even broke a lifelong rule of not joining groups to become a member of the museum board, insisting, somewhat to their consternation, that the displays never deviate from the original plan: "You've got to leave it just this way. Nothing can change."[15]

The Cannon of Procter's Battery

The vicinity of the Sanderson Museum played a crucial role on September 11, 1777. The smaller of the two British forces sent to attack the American center was commanded by Lieutenant General Wilhelm von Knyphausen, a Prussian officer with a livid saber scar from eye to chin (he appears in Wyeth's watercolor *General*

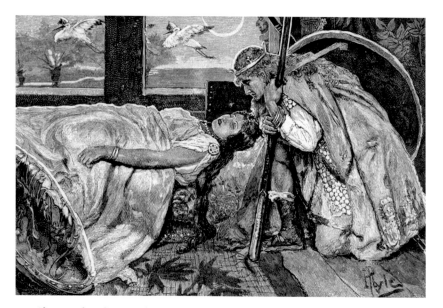

Sleeper by the window. It seems that Howard Pyle's *Awakening of Brunhild* (1882) made a powerful impression on Andrew Wyeth, its echoes felt in his pictures of dreaming and death, *Christmas Morning* and *Night Sleeper*.

Knyphausen at Brandywine, 1944). The first shots of the battle rang out as his troops reached **Kennett Meeting** on today's U.S. 1. George Washington supposed that the British would cross the Brandywine directly in front of him, facing cannon fire from Colonel Thomas Procter's artillery on the **knoll** behind today's Sanderson Museum. But Knyphausen pushed only briefly across the ford and then fell back as Americans retook the west bank under the command of Captains Charles Porterfield and Andrew Waggoner and then General William Maxwell. Again, only the British knew that their assault was merely a feint.[16]

Procter's artillery consisted of four brass cannons pulled up behind a hastily built breastwork of earth and logs in front of an orchard (visible to battlefield tourists long into the nineteenth century). It looked across blooming fields of buckwheat toward the creek—labeled as "Meadow Ground" on General George Weedon's map, drawn that day and the only American cartography that shows the battlefield. This battery fired all day at Knyphausen in one of the really spirited artillery duels of the war (see Andrew's *Knyphausen's Artillery*, 1945). The cannonading could be heard like

distant thunder as far away as Philadelphia—by Congress, then meeting at Independence Hall, and by Thomas Paine, who wrote to Benjamin Franklin in Paris, "I was preparing dispatches for you when the report of cannon at Brandywine interrupted my proceeding."

At noon, Washington rode up and down the American line, stopping off at the Chads House. James Parker, a Loyalist from Virginia, was secretly observing him from a British battery on the far heights, across the Brandywine. He watched as the general left the house, accompanied by officers and two white flags, climbing the hill behind it to view the battlefield with a spyglass. Wyeth imagined a quite similar scene in the 1954 sketch *General Washington at the Battle of Brandywine.* Parker had the British fire their cannons, and "my prayers went with the ball that it might finish Washington & the Rebellion together." As the shells whistled down, Washington said calmly to some civilians who were tagging along, "Gentlemen, you perceive that we are attracting the notice of the enemy. I think you had better retire." Thus did he narrowly escape being killed, which might have changed the whole future history of the North American continent—and the world.[17]

Up Creek Road

Other interesting locales lie within a short drive. On Wylie Road just east of Creek Road was **John Wylie's Farm**—149 acres for a breed of milking cattle, and more picturesque than Kuerner's— where N. C. and his son ordered firewood and where Andrew occasionally painted over a period of decades (*Cistern*, 1988). On one visit, he peeked inside a colonial outbuilding, which he then recorded as the famous *Cooling Shed* (1953). "We called it the cooling shed, but it was actually a water trough," a granddaughter of the farmer remembers. "Water came from uphill at the cistern and came through the water trough in the shed area, then into the kitchen. It was the best-tasting water, although I noticed there was moss around the wooden trough. I really hated to see that farm go out of the family." Her parents were friends with the Wyeths, "but later Andy went into a different crowd, those who had a little more money."[18]

Roundelay, the George Brinton House (ca. 1830, 1479 Creek Road, on a bluff north of Masters Way)—its driveway appears in *Bonfire* (1992)—was the scene of glittering parties given by the series of wealthy socialites and horse breeders who owned it. Under the aegis of Admiral Delmar Fahrney, Sir John Thouron, and finally the John Deere heiress Patricia Hewitt, Roundelay outdid itself in splendor: David Rockefeller's helicopter settling on the lawn, Jackie Kennedy dropping by. These were playful plutocrats: Thouron once pranked Weymouth by having a pizza delivered to his estate every hour; Hewitt dressed as a witch at a party populated by witch-themed mannequins, frightening the guests when she suddenly moved. Andrew's circle, we must recall, contained as many grandees as it did humble tenant farmers, this being the strange mix in this far-outer-suburb of Philadelphia, then the fourth-largest city in the world's wealthiest nation. "I love parties and social life," he told a reporter in 1968; if he didn't limit the invitations, "I'd never get any work done. I'd spend all my time talking." He loathed how his father had gotten caught up in Roaring Twenties boozefests lasting until 3:00 A.M., sapping his creative energies.[19]

Famous visitors from Hollywood and the New York smart set notwithstanding, many observers noted how little the Wyeths socialized and how much Betsy preferred staying at home amidst the austere colonial environment she had so meticulously created at the Mill. Here, she wrote a children's book, *The Stray* (1979), with illustrations by her son Jamie, 158 pages of inside jokes about local characters, including the nearby well-heeled who live in "palaces." Hand-drawn maps show actual Chadds Ford locales, including Roundelay transformed into a majestic landlocked galleon; art and text make winking reference to such Andrew Wyeth paintings as *Winter 1946*, *Soaring*, and *The German*. An intricate (if occasionally claustrophobic) Wyeth Country mythology is developed, one later extended in the authorized biography in which the puckish artist, like his beloved character the Scarlet Pimpernel, pops up "here, there, everywhere" around Chadds Ford in the company of du Pont executives and garage mechanics alike.[20]

"The Most Famous Farm in the World"

Andrew Wyeth at Kuerner's

T HIS DRIVE FOLLOWS RING ROAD through territory fundamental to Andrew Wyeth and passes Kuerner Farm, which can be visited on a tour from the Brandywine River Museum of Art.

Millions of people believe that they know this place through Betsy Wyeth's tireless promotion of her husband's watercolors—the book *Wyeth at Kuerners* (1976) once lay heavy on countless coffee tables; Wyeth dorm-room posters were de rigueur; framed prints appeared on the walls of TV's *That Girl* and *The Partridge Family*; and even Snoopy's doghouse in *Peanuts* boasted a priceless original. "His reproductions sell by the thousands in the vast network of superstores across the continent," an observer wrote in 1970, confronting the consumer "as you buy a vacuum cleaner or a set of dishes."[1]

But Kuerner Farm's artistic history went back much further than the 1970s: on boyhood walks as early as the 1920s, Andrew recalled, he felt a strange desire to become a painter and depict this place, which lay next door to his childhood home, just over the hilltop. His first ambitious oil painting was done here in the spring of 1933. Not until his father's death at the adjacent railroad cross-

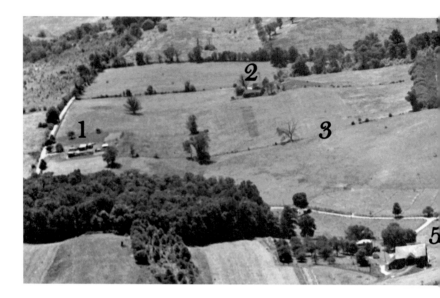

ing, however, did he feel a kind of compulsion to make it a constant theme—or so he explained in a statement that has been endlessly repeated. But we must recall that he had already been painting Kuerner Farm for a dozen years.

He may have made it "the most famous farm in the world," but Kuerner's is ordinary, one of tens of thousands of farms that once blanketed southeast Pennsylvania as far as the eye could see. If it had particular artistic interest, perhaps it lay in the sculpturelike visibility of what he termed "that square house" from all sides at the foot of steep hills in a nearly treeless terrain—"a lonely outpost in the sweeping landscape," Betsy called it. One of his great artistic breakthroughs was made here: to take ordinary winter landscapes and give them a sublime feeling of bigness, an almost Arctic-tundra barrenness, "a vast wilderness of the North," as he said. His paintings "feel" so big that he stopped taking his art patrons to see the actual locations—they were often disappointed at the humdrum smallness. Still, many celebrities visited Kuerner's, including President Dwight Eisenhower, Henry and Jane Fonda, and Charlton Heston (who paid for a new roof on the famous barn).[2]

Kuerner Farm, July 1939.
Revealing aerial view looking
west, six years after Andrew
Wyeth began painting here.
1: Adam Johnson's House,
Bullock Road above.
2: Andress House.
3: Fenceline of *Winter 1946*.
4: Summit of Kuerner's Hill,
with Atwater Orchard above.
5: Kuerner barn, with house
to left.
6: Ring Road at N. C. Wyeth's
fatal railroad crossing.

Approaching Kuerner Farm

⟶ *Drive south on Ring Road from its
intersection with U.S. 1.*

This is historic ground: **Ring Road** was the main route from Wilmington to Chadds Ford in colonial days and was named for the farmer whose house served as George Washington's Headquarters (Tour 1). At the top of a rise, the road crosses what little remains of the **Penn Central Railroad** (abandoned in 1971), which had fond associations for young Andrew as the route his mother took him for Christmas shopping in Philadelphia to buy his toy soldiers. Tragically, at this spot, N. C. Wyeth was later killed (see Tour 2). As Kuerner Farm became famous, the now-overgrown **railroad causeway** to your left became, a bit incongruously, the setting for an iconic sunset photograph of Eric Clapton and the rock band Cream, visiting Philadelphia from England in the spring of 1968.

Just past the hilltop is the forty-six-acre, National Historic Landmark Kuerner Farm (before suburbanization, it was much larger). A fundamental point: in a region known for breathtaking farmsteads

and exceptionally picturesque colonial houses and outbuildings, Kuerner Farm ranks only middling in attractiveness. Why the microregionalist found this prosaic spot eternally inspiring remains a mystery that goes to the heart of who he was as an artist—returning again and again to the familiar within walking distance of his own backyard. "I didn't think it was a picturesque place," he confirmed, and photographs show it to have been thoroughly utilitarian in his day, a most improbable locus for artistic activity for a month, much less a lifetime. This puzzle led Betsy to publish *Wyeth at Kuerners*, digging up 459 works that Andrew had produced at the farm over forty-four years. When a much younger artist—Karl Kuerner's grand-

Fatal railroad crossing. Looking west, October 19, 1945, the day that N. C. Wyeth died here, with police on the scene investigating. Kuerner's Hill at left, beyond Ring Road crossing. Car is the white dot right of the tall semaphore signal.

son—began painting there and fretted that the locale was too limited to nurture both himself and Wyeth, the master replied decisively, "Oh, no. *We have not even touched the tip of this place yet.*"[3]

Searching for an explanation for the almost inexplicable—one of the most talented artists America has produced came here willingly not once but *innumerable times*, year after year—we can only say that he painted it out of love: he had adored since childhood the busy working farmstead, an easy half-mile trot from home, and its stern German-immigrant farmer, whom he shyly approached in his best clothes at age thirteen to ask permission to paint this place. As he often said, here he perfected the making of art out of seemingly un-aesthetic subjects, the opposite approach to the usual sentimental painting of rural landscapes (as typified by the New Hope school of Pennsylvania impressionist artists so influential on N. C.). And at Kuerner's, he was left entirely alone by the industrious Karl and his silent wife, Anna, who had suffered a mental breakdown. Here, Andrew said, "I don't exist as a person. That's important for my creative process." Fundamentally, he picked Kuerner Farm because it was "a world of its own," a micro-environment within the already tiny environment of Chadds Ford: truly Wyeth, in pursuit of the "ingrown," could never have his horizons narrow enough.[4]

Microworld of an artist. Often shown in Andrew Wyeth paintings, the entrance drive leads past the springhouse (left) to the barn and Kuerner home.

Kuerner's stands on historic ground: the 1777 battle was fought nearby, grapeshot have been plowed up here, and a cannonball was once found embedded in an old pear tree. From colonial times to 1898, this land was farmed by the Ring family; the wealthy Atwater-Cleveland family acquired it in 1908 and rented out the farmhouse. Karl and Anna became tenant farmers in 1926, renting from Dr. Arthur Cleveland, and finally managed, through terrifically hard work, to buy the farm in 1943. Karl awed the young Andrew with bloody stories of World War I battlefields, told in vigorous broken English. The toughness of the former machine gunner, who ran the farm with military precision, found visual expression in the colorless and uncompromising style of painting that Andrew developed here—as if the artist found something of a second mentor, after the death of N. C., in Karl. Henceforth, he would show the Brandywine region unsentimentally, as "this tough place"—I think a deliberate repudiation of his Victorian-born father, who gushed endlessly about the valley's romantic charms. He omitted most signs of modernity, making the farm seem timeless; it was actually quite up to date, as Kuerner was eventually able to afford "the most advanced tractors American technology had to offer" (as a visiting farmer marveled), one of the first tractor-powered hydraulic lifts ever marketed, and efficient mechanical milkers—but to my knowledge, none of this equipment ever appears in a painting, so that the truism "Andrew

Wyeth painted his world" needs to be qualified with the words "very selectively."[5]

As the art historian Henry Adams points out, Wyeth was an avid watcher of movies—he projected them in his studio—and at Kuerner Farm, he perfected an approach to painting in which Kuerner became an ominous, movielike character ("undoubtedly the most brutal man I've ever known"), the rather bleak farmhouse a brooding cinematic backdrop, and views of Kuerner's Hill akin to what Adams calls "the opening shot in a movie, when you don't know what's going to happen yet, but it fills you with apprehension." Specifically, the hill in *Winter 1946* resembles one in Andrew's fa-

vorite film, the World War I epic *The Big Parade*, which he screened
constantly in his studio.[6]

Karl Kuerner eventually suffered from leukemia, as meditated
upon in *Spring* (1978), his emaciated body emerging from a snow-
drift at the foot of Kuerner's Hill in an eerie, surrealist picture that
possibly recalls Hieronymus Bosch's *St. Jerome at Prayer* (ca. 1490)
and made the farmer's grieving family uncomfortable—"But maybe
the painting is *supposed* to be horrible," one daughter mused. The
prominent tire-track alludes to the artist himself, who was infa-
mous for leaving such scars: "That's Andy," Kuerner's son laughed.
"I tell him he should stay over this way where the ground is solider,
but, see, he has his mind on something else. He doesn't pay atten-

Andrew Wyeth's walk to Kuerner's.
Looking down the famous hill toward the barn and house. He often strolled this way from his studio.

tion to anything except the painting." Karl died the following year, and Andrew said, rather strangely, "We distributed his bones on that hill," scattering ashes. With Kuerner gone, he visited the farm less regularly—although Chadds Ford residents recall the familiar sight of him perched on the paint-splattered hood of his Jeep, watercolor pad on his knees. "The back would be filled with torn-up pieces of paper, all the drawings he had been working on," a friend recalled.[7]

Frolic Weymouth was eager to preserve the place, although the now elderly and fatalistic artist was less keen, despite having once offered to buy it himself. Karl's son and grandchildren generously made possible the sale of the property to the Brandywine Conservancy in 1999. By that time, farming was totally uneconomical hereabouts: "I guess we keep the farm going as a sort of national monument not only of a rural culture that is dying," Karl's grandson explained, "but to preserve the place as much like Andy painted it as we can." Although reduced in acreage and with fence lines growing scruffy—how Karl would have frowned!—it remains surprisingly unchanged from its appearance when the artist first saw it, nearly a century ago. Today, it is one of a few legendary Wyeth Country places that attract a consistent stream of plein-air painters seeking to emulate the great master.[8]

One disciple was Peter Nielsen, who stumbled upon a book about the artist in faraway Denmark. As his interest swelled, he sought to discover "if Andrew Wyeth's world is present today."

Kuerner's Hill became an object of fascination, until, in 1997, "*I decided to go to the United States to paint a watercolor of this hill.*" No Danish tourist agency had ever heard of "Chadds Ford," but Nielsen looked it up on the Internet. Craning his neck out of a rental car, he eventually found the famous hilltop. Many changes struck him: only a single old pine remained at the top, nearby Mother Archie's Church was in ruins, and subdivisions had replaced farm fields for miles around.[9]

Around Kuerner Farm

⇢ *Crossing the former railroad, the Kuerner farmhouse and barn are on the left.*

Out front, the tar-covered **entrance drive** with its dwindling rows of **pines** is featured often in Andrew's paintings, such as *Pine Baron* (1976), a good example of his "flash impression" approach: pulling into the driveway, he slammed on the brakes upon seeing an old World War I helmet of Kuerner's stuffed with pine cones, the perfect subject for a picture. By the surrealist technique of "automatic painting," drips of ink form the pine-tree trunks in *The German* (1975). George Thorpe was a young newcomer to Chadds Ford when he approached a plein-air painter in the driveway, sitting beside a Jeep: "He had a paintbrush in his mouth, paint on his cheeks. I thought, 'Oh, a crazy artist!' I asked him if by any chance he was Andrew Wyeth. And Wyeth said, 'No, but I know him well.'"[10]

Green-stone **gateposts** are serpentine from a local quarry that Kuerner removed from the Victorian home Windtryst (above Washington's Headquarters; see Tour 1) long after it burned in 1914; young N. C. had lived there in 1907, and Andrew loved to visit the romantic ruins as a child. A strange **chimney** (or "chimley") on the Kuerner House is likewise serpentine, Karl being proud of its twelve-foot-deep foundations; much stonework of sturdy Old-World specifications was done on the property by German and Italian prisoners of war after he bought the farm during World War II, amid wild rumors that this crusty foreigner must be a Nazi

sympathizer. "Wyeth didn't like painting anything modern," to-day's Kuerner Farm docent aptly says—but the **television antenna** appears often in his paintings of the place, including *Oil Drum* (1957). It makes a sprightly cameo in the famous *Young Bull* (1960) and shows up again in the watercolor *Heavy Snow* (1967), which sold in 2017 for nearly $400,000, a reminder that a single plein-air Wyeth can earn more than most struggling artists, no matter how talented, make in a lifetime.

The severely plain, stuccoed **Kuerner farmhouse** dates to the era of Caleb Ring, around 1814, with the third floor added about 1850 (although Kuerner always thought that the place was colonial and told visitors that Washington prayed here before the battle, Lafayette strategized, and wounded soldiers left bloodstains). For all its real-life drabness, it stars in countless Andrew Wyeth paintings in museums worldwide; the micro-regionalist returned to it over and over for decades, finding creative sustenance in a place that most of us would have found hopelessly workaday as a subject. He often omitted a few windows to escape a static appearance; a friend recalled the twenty-five-year-old Andrew telling him, "It's not what you put in a picture, it's what you leave out of the picture—let the *eye* complete it." Sometimes it is reflected in the **cattle pond**—dammed up by Karl—where the Wyeths skated, as in the semi-abstract *Brown Swiss* (1957), which the artist proudly called "one of my best things." Purposely or not, the perspective is "off"—his drawing skills, sometimes flawless, occasionally faltered. In 1967, a critic called him "sharp in focus, objective as a photograph, and painstaking, if surprisingly awkward technically." Andrew likely agreed: "I consider myself a lousy draftsman. I have to struggle at it." *Brown Swiss* is one of those Wyeth pictures sometimes held up as proof of his modernist credentials, but his decorous efforts in this regard often show, to my eye, the influence of his early training in book jackets and magazine spreads: not so much modern art of the museums as modern art as filtered through stylish midcentury illustration layouts.[11]

One of his best-known drawings is *Rope and Chains, Study for Brown Swiss* (1956). Here, there was no sign of struggle! The sculp-

tor J. Kim Sessums recalled the impact this tour-de-force drawing had on him as a teenager "growing up on a gravel dirt road in Mississippi. I had so little exposure to the outside world." Then someone showed him *Wyeth at Kuerners*: "When I saw what you could do with a pencil, it set my hair on end. I couldn't sleep. I lived on *Rope and Chains* for five years—how did he get the texture on that paper . . . ?" For millions of twentieth-century Americans who lived far from museums, *Wyeth at Kuerners* was a priceless gateway to the entire world of visual art.[12]

I have heard several such stories. David Hastings grew up on a remote farm in North Carolina, searching for arrowheads in lonely fields. A glimpse of the gorgeous book *Andrew Wyeth* (1968) as the staff first put it on display in a college library changed his life: "I wrote him a letter—no zip code. He wrote back in his Mont Blanc pen. It was the start of forty years of letters." Hastings visited the artist, who drove him around Kuerner Farm in a battered Wagoneer, faux woodwork flapping off its sides. "I haven't traveled far, but I've tried to travel deep," Andrew told the young admirer, paraphrasing Henry David Thoreau. He described the profound visual effect that the sight of a rabbit in the snowy landscape once had on him: slapping the back of his head, he cried to Hastings, "*My God, look at that!*" He seemed unconcerned by the development that was creeping over the hills, since his work was largely about what Hastings called "the fleeting nature of the things you love." Once he wistfully remarked, "Maybe the landscape will die for Jamie, too." Hastings concluded that he "is really an illustrator of his own novel," a William Faulkner of the brush, not unaware of the fact that "stories sell paintings." Going for lunch at the Chadds Ford Inn, the artist left his truck unlocked, although the back was mounded with watercolors and drawings. Shouldn't he lock it? Hastings asked. Sometimes pictures got stolen, Wyeth explained—but eventually the culprit would come to him, seeking a signature. Then, the wily artist would tell him that this work was a pitiful forgery.[13]

Andy had a key to the Kuerner farmhouse and was free to come and go. He often painted views out of the windows, as in the magnificent *Groundhog Day* (1959, named rather prosaically for the

View that inspired a masterpiece. A glimpse from the Kuerners' kitchen window, sixty years after Andrew Wyeth stood here and envisioned *Groundhog Day.*

day it was finished) at the Philadelphia Museum of Art, looking from the **kitchen** at the hillside to the south, where a felled gum-tree log lay. The "ragged, chopped, sharp sliver part of the log," as the artist called it, surely is meant to rival the verisimilitude of the cannon-splintered column in Howard Pyle's Revolutionary War picture *Attack upon the Chew House* (1898). He was explicit that the cup, plate, and knife are a kind of portrait of Kuerner (who spurned the use of an effete fork); in surrealist terms, each is a "significant object" not unlike the mysterious, fur-covered teacup and spoon that the Museum of Modern Art had bought in 1946 as a major example of surrealism in European art. *Groundhog Day*'s then-colossal price tag of $35,000 brought media attention to Wyeth's newfound wealth and inspired, from establishment artists and critics, a cascade of resentment and disdain that he would endure for the rest

Artist's hideout. Now famous for those hooks, this third-floor room in the Kuerners' farmhouse afforded complete privacy as a studio-retreat when Andrew Wyeth sought to be alone with his model Helga Testorf.

of his life. (He was quite bitter that the Philadelphia Museum held no show of his paintings for another forty-seven years.) To this day, however, the museum-going public adores *Groundhog Day* for its evocation of rural life and a simpler time, tinged with loss and melancholy amid the quietness of an afternoon (and some pick up on the surrealist sense of menace). Sixty drawings were undertaken for the painting; he may have been aware that Thomas Hart

Benton sometimes made hundreds. Kuerner later regretted having swept so many half-finished sketches off the kitchen floor and into the fireplace.[14]

The artist frequently used the **third-floor room** on the south as his studio. Its ceiling has the famous **hooks** for hanging blood sausages that he depicted in the celebrated *Karl* (1948). Betsy suggested the somewhat disorienting surrealist composition, the viewer "right smack down low"; the picture may owe something to a stern-looking 1944 addition to the Museum of Modern Art collection, *André Derain* (1936) by Balthus. As a teenager, the artist Woody Gwyn knocked on the Kuerners' door in 1963, explaining that he was from Texas and that "I love Andrew Wyeth." He found no brutal machine gunner of myth: "Karl couldn't have been nicer. He took me up the tiny stairway to see where *Karl* had been painted. There were the same cracks in the ceiling!" Perhaps beguiled by Wyeth's mythmaking, biographers have portrayed Karl as almost monstrous, a view that his granddaughter emphatically rejects. The man she knew had persevered through grinding poverty, keeping his family intact even when it was suggested that the children ought to go into foster care—early on, they were too poor to afford bread for sandwiches and so took little pancakes to school. In spite of many hardships, "He was so much fun, he smiled a lot and loved to laugh. The night he died, he held my hand and tried to smile."[15]

Andrew Paints Helga

Starting in 1971, Wyeth's secretive series of paintings of Helga Testorf were done, in part, in the third-floor rooms at Kuerner's, using as his model a German-born housekeeper and freelance nurse who lived directly across Ring Road—in reality a much warmer, livelier person than she appears in her melancholy portraits, where one never sees her radiant smile. He was fifty-four; she was thirty-two and a married mother who had moved to the area when her husband got a greenhouse job at Longwood Gardens. When pulled from somewhat mildewed storage and revealed to the world in 1986, the 240 Helga pictures triggered a journalistic furor, complete with a helicopter circling over the Brandywine treetops.

Wyeth became the first cultural figure to land, simultaneously, on the covers of TIME and *Newsweek*.

"Betsy knew nothing"—was that true, or did she herself orchestrate a media stunt? Certainly the sharp-eyed wife and her efficient staff of assistants would have been difficult to elude in a tiny village for *fifteen years*, where, it must be said, there had been whispers about sightings of a warmly affectionate couple in cornfields or woods. Yet with the collusion of Karl Kuerner (whose farm Betsy avoided, although she had written that famous book about it) and the indulgent Carolyn Wyeth over at the Homestead—plus loyal Frolic Weymouth, who hid the evidence—the ever-furtive artist seemingly managed it. "No, I don't think she knew," a former friend of Betsy's assured me. "He was *very* clever."

Testorf was not his first choice—he had wanted her young daughters to pose instead, much as the virginal Siri Erickson was doing in Maine—and I have learned that he was, around this same time, rebuffed in his efforts to secure a different model farther south on Ring Road: after seeing a man's wife mowing the grass while wearing only a bikini bottom, the artist asked him whether he could paint her in the nude. The answer in that case was definitely no. As for Helga, living isolated among the Kuerner cow pastures, the soulful immigrant came alive in the presence of the great man and became deeply interested in the spiritual qualities of his art, about which she could eventually expound at length, with something of the cheerful eloquence of the younger disciples of the guru Timothy Leary—perhaps the closest analogue for their unconventional seventies relationship.

Her friendly husband demanded in vain that the nude sessions stop, then refused to speak to Wyeth for years. There was a certain maternal dimension: Andy visited his own mother daily, but she would die in 1973—a mother who, by the way, had been expected to give her husband, N. C., plenty of manly leeway, unquestioningly. Hapless in most tasks not involving a paintbrush, Andy came to rely on Helga as a studio assistant plus gatekeeper against the prying public and, in old age, as a nurse-companion who accompanied him on outings and excursions, a thing the increasingly reclusive (and confessedly unmaternal) Betsy refused to do. Ten years after Andrew's death, Helga opened up on camera to mutual friend Bo Bartlett. They had been "both in love" and reveling in a return to a care-

free rural childhood without responsibilities, alone amid forest trees and the blossoms of the orchard: "How many people get to live their childhood twice?" She did not mention the price that others had paid—Betsy never got over the pain of betrayal—but emphasized instead how her beloved Andy needed freedom above all.[16]

Barn and Outbuildings

After a spark from a locomotive burned the original **barn** in the 1870s, the railroad company supplied the prefabricated "double-decker" one still standing today. (The farm was known as Red Barns when visited by N. C. on a rainy countryside walk in 1910.) Andrew made a point of emphasizing that he seldom portrayed the barn—seeking to avoid a "cornball" cliché of rural art—but it is prominent in his pioneering effort at painting, the oil *Spring Landscape at Kuerner's* (1933) with the hired man plowing, showing it from the hill behind, a favorite tobogganing locale. He gave this painting to Kuerner, who, to Andrew's dismay, years later sold it for a song to buy farm equipment. The family recalls that it was a dump truck, but usually one reads that it was a tractor, with Karl saying memorably, "I can't plow with a picture."[17]

This painting mesmerized Gene Logsdon, who interviewed Karl for *Wyeth People*, a 1969 book of interviews with Andrew Wyeth's models. A young *Farm Journal* editor down from Philadelphia, he was rapturous when Karl showed him *Spring Landscape* and described it so sensitively—"See the way the sunlight is slanting off the sweaty backs of the horses. . . . *Andy saw it*, even though he was just a kid." In a flash, Logsdon realized that Wyeth could peer into his own Midwestern heart: he had been raised on a farm but was now stuck in the city, where "the soft luxury of upper class life and the sappy affectations of the established art world" could only revolt the truthful Wyeth, who "has clung to his unerring vision of human nature's earthy roots." Logsdon resolved to discover "the secret of artistic creativity" that sprang from unsullied agrarian "wellsprings," making this his "Holy Grail," although he had never paid the slightest

attention to art before—so great was Wyeth's transformative power over people's lives. Sitting in Kuerner's kitchen, the disciple marveled, "I am the luckiest person in the world to be here."

Alas, the magical mystery tour ended sadly for this well-meaning man. Longing for nothing more than a brief interview, "I was not allowed near Andy" by a gimlet-eyed gatekeeper who had, four years earlier, even attempted "to kill the story" in LIFE magazine that ultimately supercharged Andrew's fame. Betsy "scolded" him on the telephone for having been so thoughtless as to pry into Andy's sacred artist-model relationships and scuttled his chapter on Peter Hurd even though it was completely finished. "I was tired of the whole tense effort anyway," Logsdon said wearily, and so this remarkably empathetic disciple did no further research into Wyeth's "wellsprings." With time, *Wyeth People* has become a much-cited resource. Moving to a farm in Ohio where he wrote books on agrarianism, Logsdon was finally granted his cherished interview . . . thirty-five years later. The lunch took place in 2004 at Chadds Ford Inn, he and his wife face-to-face at last with the genius he thought as epochal a figure as Leonardo. But "Andy was not very forthcoming," Gene's widow recalls.[18]

The view from the barn to Kuerner's Hill appears in the much-reproduced *Young Bull* and *Spring Fed* (1967), which also show the **courtyard** where cows' feet sounded sharply on the concrete and which the stooped Anna kept scrupulously clean. One of the most famous American paintings, *Spring Fed* depicts the **horse trough** deep inside the barn that was used for cooling milk, fed since the nineteenth century by a continuous, never-freezing flow of water by gravity from a spring across the road, on the hill. Here, the Kuerners would dunk themselves to wash off the chaff after a hot day mowing in the hay fields. Given Wyeth's interest in late-medieval Northern art, is it merely accidental that *Spring Fed* has affinities with Nativity scenes: the stone-cut manger, the view of distant cattle seen through a rickety shed? Or might aspects be derived from John Everett Millais's *Christ in the House of His Parents* (1849–50), one of those Pre-Raphaelite artists so influential on Pyle? (*Christina's World* is arguably a reworking of Pyle's very favorite Millais painting, *The Blind Girl* of

Mobile studio. Andrew Wyeth with the Land Rover that he drove so often to Kuerner Farm in the 1960s. Here he is at Sanderson's House, carrying his dog under his arm. (Photo courtesy of the Christian C. Sanderson Museum, Chadds Ford, PA © 2020.)

1856.) None of these possibilities occurred to Carolyn Wyeth, who said her brother, vociferously dismissive of religion, was merely alluding to the finality of death: "That trough is like a casket."[19]

In front of the barn lies the low, two-hundred-year-old **springhouse**, where Andrew refreshed himself from barrels of Kuerner's hard cider, avoiding the pig carcasses dangling from hooks. Milk from the twelve cows was cooled in large pans here, a frog sometimes hopping in. The springhouse is prominent in the moonlit, springtime *Evening at Kuerner's* (1970), made familiar through numerous posters and ample evidence of his stature as the greatest American portraitist of trees. The idea of the single lit window indicating Kuerner's being ill derives from N. C.'s near-final picture *Nightfall* (1945), wherein, LIFE magazine explained, a farmer's wife lies sick. During the making of *Evening at Kuerner's*, Andrew first fatefully glimpsed Helga dragging her vacuum cleaner down the drive. Little did she know that she would someday become

Glimpse of Kuerner's Hill. As seen from the barn, the drive winds its way past the old springhouse. The famous *Young Bull* and *Spring Fed* were painted nearby. The plein-air painting tradition continues today, nearly ninety years after Andrew Wyeth first depicted the place.

legendary as "the last person ever made famous by a painting" (Logsdon worshipped her as a modern-day Mona Lisa, "the only difference being that Mona Lisa had clothes on.") In painting an ultraprivate series of pictures of her, Wyeth sought a return to the anonymity of his youth, out of the glare of expectations and Betsy's insistence on moneymaking: "We were running away from notoriety," Helga later explained. He was known everywhere now, and this was the same year that he became the first living artist to have an exhibition at the White House. He endured the discomfort of being feted before a posh crowd in the East Room by President Richard Nixon, who said, "As I ask you to drink to his health tonight, I think we can truly say that Andrew Wyeth, in his paintings, has caught the heart of America, and certainly tonight, the heart of America belongs to him."[20]

Behind Kuerner's house are other outbuildings, including the **woodshed** that appears in a painting of that title with dead crows dangling against its wall (1944) as well as in *Working Farm* (1988). Anna tirelessly chopped kindling in another woodshed attached to the rear of the house, seen in the acclaimed watercolor *Wolf Moon* (1975)—an ominous moon was a frequent motif in the illustrations of Pyle—which began as pencil sketches after midnight and was completed before dawn in the studio. In 1942, *American Artist* magazine marveled at Andrew's speed: he dashed off a picture in a half hour, not the typical two or three hours of many watercolorists. But then again, he was also capable of proceeding very slowly indeed: "Andy would work all day in the same location on a drawing," the

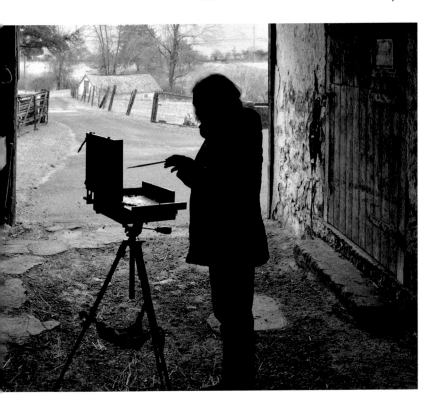

artist Bo Bartlett told me. "I'd pass by in the morning to see him seated and drawing, and I'd pass back by late in the day and he'd still be in the same place working on the same drawing."[21]

As is legendary, Wyeth roamed the farm freely. The Kuerner children saw him sitting shirtless on the grass out front, painting or "striding around in clothes full of holes, real distracted-looking sometimes as he sizes up something—heck it might be nothing more than a little spider—totally oblivious to everything except what he's sketching." Anna frowned when he disappeared up to the third floor with his model, Helga. Mentally troubled and virtually mute—and famously menaced by Karl's rifle in *The Kuerners* (1971)—Anna proved an intriguing figure to many visitors: flitting around the farmyard "like a night moth," cutting the grass with a sickle as if it were the Middle Ages, addressing her cats in German, and frugally building the evening fire by piling discarded

Andrew Wyeth pencil drawings onto the grate. Her delicious cooking kept the peripatetic artist fed, which, along with Karl's cider, was part of the magnetic attraction of this locale (although Betsy chided about the tippling). Without Anna's sustenance, her son recalled, America's beloved painter might be seen to "carve off a bite of cheese from a chunk his dog's been gnawing."[22]

The View to Kuerner's Hill

⇢ *Kuerner's Hill rises on the right side of Ring Road.*

This surprisingly steep hilltop (thirteen acres preserved, labeled **"Snow Hill"** on the map in this book) will forever be synonymous with Wyeth, but it was a tall local landmark well before his day: an 1863 military map of the Brandywine Valley marks it as Washington's Hill and indicates that the general surveyed the battlefield from its northwestern slope. An earlier map of 1848 shows that cannons had been mounted in 1777 on the hilltop as well as near

today's Kuerner Barn, facing south, guarding Ring Road from any British flanking attack.

Around 1910, N. C. enjoyed the view from what he called Cleveland's Hill, a favorite place for tobogganing—he often sat here to contemplate the glories of nature, and one of his home movies shows a splendid, unbroken rural panorama from the village all the way to Kuerner's farmhouse. When walking eastward from his childhood home on almost daily outings, young Andrew would have constantly crossed over the hill on his way to Kuerner's—an excursion he repeated all his life. "I've walked that hill a hundred times, a thousand times, ever since I was a small child," he recalled, and it appears in innumerable drawings and paintings as one of his great leitmotifs. The very early *Chestnut Tree* (1933), of a stately tree killed by blight, shows the view of the farm buildings from the hillside, a view also captured by a home movie of the Wyeth clan out strolling amid a vast, windswept agricultural terrain. A **drive-way** was cut up the pastures of the hill about 1950 when Kuerner

subdivided his property (this became an easy route of access for Andrew), and houses now occupy the hill's northern slope. Such subdividing seemed desperately necessary as farming became unprofitable with the new influx of population: land values soared even as competition with national agribusiness drove farm incomes down; instead of mowing hay, there came to be more profit in mowing rich people's lawns; suburbanites' dislike of hunting meant an

Kuerner's Hill from the north.
Rare early view taken from Washington's Headquarters, about 1910. Harvey Run Valley is in the foreground, out beyond unpaved Baltimore Pike. This is the rural Chadds Ford that Howard Pyle's students loved. (Photo courtesy of the Christian C. Sanderson Museum, Chadds Ford, PA © 2020.)

explosion of hungry deer and raccoons, so that "you can hardly raise corn around here anymore," Karl's son grumbled. Logsdon thought the subdivisions only heightened the fascination of Kuerner Farm for Wyeth, making it a priceless survival of "a tightfisted farm that has only partly emerged from the nineteenth century."[23]

Virtually a sacred site, the hilltop offered Andrew a fine view as he sat amid the buttercups each spring. The **pine trees** at the top were planted by Kuerner as shade for his Brown Swiss cattle—he said that all the pines on his farm came from the Black Forest— and appear in innumerable artworks, including the Helga painting *Farm Road* (1979) and *Snow Birds* (1970), recently the subject of a forgery. Always fond of nature's sounds, he liked to sit under them and listen to the wind in their branches. *Groundhog Day* began, in part, with pencil sketches derived from this vista.

The pines are replaced by a maypole in his fanciful depiction of his artistic models all cavorting together, *Snow Hill* (1989), a theatrical picture by a man who spent much of his childhood playing in borrowed costumes amid the pastures above the Homestead. The maypole is similar to one in Pieter Bruegel the Younger's *Dance Around the Maypole* (ca. 1625), and we may also detect Bosch's *Ship of Fools* (ca. 1490) and Albrecht Dürer's *Peasant Couple Dancing* (1514)—although it is often difficult to prove whether a Wyeth work alludes to anything beyond his own private imagination. "To whom do you feel closest among the Old Masters?" a reporter asked him at a press conference in 1967 (at which the reluctant celebrity looked so stricken that one observer said he resembled "an 18-year-old suffering from his first hangover"). He tellingly replied, "I don't feel terribly close to any of them." Living near him in the early nineties, Bo Bartlett discovered that he "had a vast knowledge of art, all art," but I see curiously little evidence of this in his own paintings, beyond the occasional nod to the Northern Renaissance. When asked in later years to name the historical figures he'd most like to query for advice, his unhesitating answer was, "My father." Another artist who visited in the 1990s came away astounded at the legendary painter's lack of knowledge about art history: "He had no clue about copperplate etching, no clue about lost-wax cast-

Snow Hill. Karl Kuerner planted the iconic pines from the Black Forest at the very top of this steep local landmark where the Wyeths often went sledding. Seen here in October 2019, just weeks before the last of the original trees died.

ing!" Yes, to interviewers, he would mention in passing the work of other painters, but often it was to dismiss them with surprising forcefulness, a curmudgeonly harshness akin to Benton's. Take the immortal Paul Cézanne and Wyeth's fellow Museum of Modern Art American realist Ben Shahn: he had no use for either, although we may see echoes of Shahn in his own work: *Pacific Landscape* (1945) in *Christina's World* and *Liberation* (1945) in *Snow Hill*. Many contemporaries produced "junk" or were "godawful," he growled, and he once told *Newsweek* that "Matisse is a lot of crap."[24]

The Scene of *Winter 1946*

Continuing along Ring Road, on the left are the recently stabilized ruins of a **tenant house**. Farther on stood the huge **white oak** of *Walking Stick* (2002), seeming to grasp a still-extant telephone

pole, a type of modern intrusion that Wyeth rarely showed. Such poles have long lined Ring Road and the driveway up Kuerner's Hill (see the 1957 photograph of Andy walking up the latter, reproduced in the authorized biography), but the artist always omits them.

The Novelist and the Artist

"That ominous child," the novelist Joseph Hergesheimer called the rather peculiar young Andy during his frequent visits to the Homestead. The two men turned out to be kindred spirits, a generation apart. Published when Andrew was eight, Hergesheimer's book about his colonial home in West Chester, six miles north, constantly refers to a primitivistic attachment to the local soil: to "the mood, the earth, of the Dower House," that bulwark against "all the inroads of the doubtful present, and the positively threatening future," with its "stone foundations set so deeply in the earth"; his role as homeowner makes him "a proprietor in the earth of Pennsylvania." Walking up a hill, "I stamped a foot into the earth," he writes in *From an Old House*—and instantly discovers a profound connection with "my own place. This slope, the weeds, the earth, were mine; it was my ground."

Andrew often heard the celebrated writer reading his manuscripts aloud to N. C. in sessions that lasted all night. With his brown palette, he would come to share the preoccupation with the color of bare earth and almost seems to illustrate Hergesheimer in his painting *Trodden Weed* (1951), in which the artist himself strides across a brown Chadds Ford slope, wearing old costume boots of Pyle's (the sliver of distant Sugar Loaf landscape confined to upper right is a trick from Dürer's *Adam and Eve*, 1504; the literary Betsy got the title from John Keats). Andrew later explained that the picture was about very close observation of one's local habitat and stressed how sacred the earth beneath his feet felt to him. At the time one of the most famous writers in the nation, steeped in the contemporary Americana movement, the now-forgotten Hergesheimer proved an unacknowledged influence on young Andy.[25]

Across the road rises the **south flank of Kuerner's Hill**, which the local boy Allan Lynch runs down in the iconic *Winter 1946* (the north-south **fencerow** seen in this and other pictures still exists). Few legends are so well-known in American art as the fact that the picture is a symbolic portrait of N. C., who died in the car accident just over the hilltop—Andrew's father seemingly alive and breathing beneath "the bulges of that hill." Indeed, the grieving son did his preparatory pencil drawing, given to N. C.'s friend the novelist Joseph Hergesheimer, just a month after the crash, to which Lynch had been early on the scene. It has recently been ingeniously suggested that he derived the picture from a supposed Pieter Bruegel in the Philadelphia Museum of Art (a shepherd running headlong down a bleak hillside scarred with tracks), a place where he spent much time in the late 1930s studying the Johnson Collection of tempera paintings on wood panels, trying to master the ancient technique. The boy wears an Army jacket, and the picture has an unnoticed relationship to Howard Pyle's painting of a doomed Civil War charge through mud and corn stubble, *The Battle of Nashville* (1906)—Wyeth said that he often brooded on the plight of soldiers in battle and that Kuerner Farm had a military feel. The big buttons and clumsy gait of the central figure in Pyle's *Fight on Lexington Common* (1898) also recur. Surrealism comes into play as well, when we recall the jacket-clad man casting a shadow on the sand in Salvador Dalí's *Paranoiac-astral Image* (1934). Wyeth had painted this locale before: in *Black Hunter* (1938), the shotgun-wielding David "Doo Doo" Lawrence is shown on the hillside with Archie's Corner behind. Late in his career, he depicted the hillside again in *Little Africa* (1984).[26]

Winter 1946 was the fateful turning point for Andrew Wyeth. At nearly thirty, most young men might have sought a broader professional horizon in a bustling postwar world—his own brother, working for DuPont, would transform commerce by inventing the plastic soda bottle—but Andy retreated, determined to double-down on micro-regionalism by investigating this tiny locale over and over, as he would do for decades to come. Starting now, as we pondered earlier, he *never went anywhere*.

Kuerner's Hill of the imagination. In a late picture of winter 1944–45, N. C. Wyeth reconfigured the Chadds Ford landscape, looking down from his favorite hilltop to a rearranged Pyle's Barn and Washington's Headquarters. *Nightfall* helped inspire Andrew Wyeth's *Christina's World*. (N. C. Wyeth [1882–1945], *Nightfall*, 1945, tempera on hardboard, 32 1/16 × 40 1/16". Brandywine River Museum of Art, Bequest of Helen and John Kenefick, 2019.)

Archie's Corner to the Brandywine

TODAY, ONE WOULD HARDLY GUESS that little-noticed Archie's Corner, south of Kuerner Farm, was one of the most crucial places for the artistic development of young Andrew Wyeth—indeed, largely the spot where he formed his identity as a painter independent of his father, N. C. The quiet locale preserves only a hint of rural flavor, as suburbia surrounds it, just beyond the hilltops. Film footage from just thirty years ago, when Andrew Wyeth paid one of his nostalgic visits, shows a terrain far more open and windswept than today: every year brings more suburban houses and an explosive increase in invasive shrubs, forming wildly overgrown, semi-tropical thickets that are profoundly changing the look and feel of Wyeth Country.

⇢ *At the intersection of Ring and Bullock Roads, park in the lot at Mother Archie's Church ruins.*

To the east is a **forest** that is at least a couple of centuries old, prominent in *Blackberry Picker* (1943), one of Andrew's last "green" landscapes before his palette turned sepia. Nestled among the trees is the **Allen Mickel House**, begun in 1954 as a do-it-yourself project that took years to complete; the land was bought from Kuerner.

Robert Mickel grew up here, playing across the road in the cemetery ("You could hide in the sunken graves!") and delighting in the company of Adam Johnson, who tended the grounds lovingly. Winters brought sledding on Snow Hill, avoiding the "curmudgeonly and grouchy old farmer" Kuerner; but in all the years he lived here, he never once spotted the elusive Andrew out painting.[1]

A Free Black Enclave

The Wyeths knew this intersection as **Archie's Corner**, sometimes calling it **Little Africa** after the black residents who made it their hardscrabble home in this "colored section" at the edge of the village—a situation that N. C. would have found strikingly similar to Henry David Thoreau's description of the black "Former Inhabitants" near Walden Pond, whom he romanticized in *Walden*. Chadds Ford lies at the extreme southeastern edge of Pennsylvania; from Little Africa, it is less than two miles to the "circular border" of Delaware, which remained a slave state for eighty-five years after Pennsylvania began to abolish the practice in 1780.

No wonder free black people made their home here and throughout the valley. Another encouraging factor was the presence of the big dairy, Lafayette Farms; the Turners were ardent abolitionists, and into the early twentieth century, most of their labor force was black. But as in *Walden*, the black community on the outskirts of town eventually faded away: only 1 percent of residents in today's gentrified Chadds Ford Township is black. "These were our close friends and we miss them," Betsy Wyeth once wrote. "Chadds Ford is not the same without them."[2]

Only deteriorating stone ruins with faint traces of white stucco inside and out survive of **Mother Archie's Church**, built as **Bullock Octagonal School** in 1838 on the main road from Chadds Ford to Wilmington but converted to a church for a black congregation by the preacher Lydia Archer in 1891 ("Auntie Archer" at the turn of the century, known for lustily singing hymns while doing household chores; later, she would be called "Sister Archie" by the Wyeths). The church was abandoned in 1945; Andrew's early *Fall at Archie's*

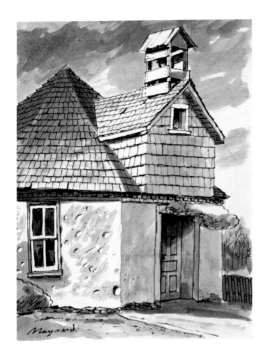

Converted schoolhouse. Mother Archie's Church at the time that it housed a little African American religious community. Starting in the 1930s, young Andrew Wyeth painted a breakthrough series of pictures here.

(1937) shows the **walnut tree** that apparently still stands west of the building, with the Loper House and roadcut beyond. His black model, the housekeeper Evelyn Smith, posed in the **frame house** beside the church (its foundations remain) for *Spring Evening* in 1948—N. C. had been driving over to pick her up the morning he was killed. (How the impoverished Smith would have been amazed to know that this watercolor would sell in 2011 for $458,000!) In taking black people as his subjects, Andy followed the example of fellow regionalist Thomas Hart Benton, perhaps America's most famous artist in the Depression era.

By 1954, the church was a ruin, and surrounding hills were being developed. Aware of this coming fate, and frustrated in his efforts to buy the place so that Smith would not lose her home, Wyeth recorded the assortment of buildings for posterity in *The Corner* (1953)—he "fixed them there against all change," his authorized biographer wrote. Surely an important element of his art was an emotional attempt to turn back the clock in Chadds Ford, which

experienced such explosive growth beginning in the 1950s: in N. C.'s words, the Wyeth artists suffered from "a keen and impossible longing for the past" and fought back against "the terrible fact that the past is gone, gone forever."[3]

At the second **window** to the left of the front door, he posed another model, Vivian Kinslow, the family's young black maid—barefoot and wearing a yellow dress—for *Afternoon* (1946), recorded in a series of photographs (the painting appeared in LIFE magazine in 1948 as the artist became famous). The same window is featured in the brooding *Night Lamp* (1950). The adjacent **stone wall**, with walnut tree, appears in the much-later *Ring Road* (1985), as an older Andrew returned to this rich artistic theme of Little Africa. Behind the church lies a small **graveyard** with crude headstones

Octagonal ruins. Little remains of Mother Archie's Church today, seen here with Archie's Corner in the distance. We look toward *Snow Flurries* Hill, now subdivided.

dating from the 1890s to 1910, including one for a Loper. At the very beginning of his career, a teenage Andrew depicted the place, not with literal accuracy, in the moody oil painting *Burial at Archie's* (1933), which takes a cue from N. C.'s Barbizon master, Jean-François Millet.

The Roadcut and *Snow Flurries*

⋄ *Look south from Mother Archie's.*

Aiming toward Delaware, Ring Road (still dirt when Andy was a child) climbs a hill through a **roadcut**, along which he would race in winter on skis or toboggan as a boy. This territory is ancient: lots here were deeded in 1695, and the little-altered road was laid out in 1707. Ring Road heads toward the new **First State National Historical Park**, which preserves **Beaver Valley**, a favorite bicycling destination of Howard Pyle and his art students in the 1890s and today a better-preserved rural landscape than Wyeth Country itself. Beside the roadcut to the west stands the stone **Benjamin Ring House** (1750s)—not the same, of course, as Washington's Headquarters—which appears in the background of such famous works as *Pennsylvania Landscape* and *Snow Hill*. The artist climbed to its third floor to look toward Kuerner's Hill in the 1980s, finding it concealed by recent growths of trees: "I used to be able to see it." Thereafter, he often could be spotted sketching from his car across the street or wandering over the lawn. Once, he brought the owners a file of historical research that Betsy had compiled about the house, charming them with a big smile and kind compliments about the wife's amateur paintings.[4]

Illustrators afield. Howard Pyle School of Art bicycling excursion to sketch the picturesque beauties of Beaver Valley, Delaware, in today's First State National Historical Park, circa summer 1898. Frank Schoonover is at left, with Pyle at right.

This little-noticed roadcut was vitally important to the art-ist—"It's the entrance to my valley." He depicted it in *Road Cut* (1939), suffused with delicious warm color of the kind he later mostly purged from his art. An ink study of the sides of the cut (1940), inspired by Pyle's technique, is phenomenally detailed and suggests Thoreau's minute observation of the rather similar Deep Cut of the railroad by Walden Pond. In *Soaring* (1942–50), with its buzzard's-eye view, one senses that his private world ends at the roadcut, with only rolling featureless tundra beyond. Decades later, he revisited this childhood place in *Ring Road* (1985); one local recalled seeing the artist sitting in his Jeep for days, presumably working on this picture—unconcernedly blocking one lane of the busy thoroughfare with his vehicle.[5]

Only the trace of a cellar hole survives of **Bill Loper's House** and blacksmith shop at the southwest corner of the Mother Ar-

chie's intersection. N. C. liked this rural locale and painted the Loper House at least once. As a child, Andrew was fascinated by Bill's missing hand, replaced by a metal hook after he got tangled up in a silage chopper. So poor that he "ate polecats if he had no other food," Loper became his first black model, although N. C. would not allow his son to depict the grotesque appendage: "Too finicky with detail," he declared, and smeared it out. Photographs show young Andrew painting here in 1934 as Loper sawed up a big fallen tree. Decades later, he revisited this place in the nostalgic *Little Africa* (1984) and *Field Hand* (1985), daring at last to show the metal hook. Now the terrain is that of his memory, stripped of modern suburban sprawl that had impinged on all sides and that Andrew professed "not to see."[6]

The whole region east of Loper's house was enormous rolling fields, now developed as suburban **Hilloch Lane** (as late as 1970, Chadds Ford was home to only 1,000 people, but its population had reached 3,100 by 1990). Here is the rise we ought to call **Snow Flurries Hill**. From the hillside above Mother Archie's, he sketched the sweeping view in January 1953 as *Archie's Corner*, with the stone ruins of the Loper House in the foreground. This view was further explored as *Flock of Crows* and finally, with the authentic foreground details bled away and replaced with grass, as the stern and powerful landscape tempera *Snow Flurries* (1953) at the National Gallery of Art. "It's just a hill where I walked a great deal," he later explained. In 1968, his biographer noted that "in the heart of the *Snow Flurries* hill sits a house with a tar driveway," and low-density development has subsequently continued to blur away these iconic Chadds Ford landscapes.[7]

The Artist at Adam Johnson's

⟶ *Drive west on Bullock Road.*

Just uphill to the west from Mother Archie's, the **Adam Johnson House** and claptrap outbuildings formed one of Andrew's most important early subjects, in which he emphasized the ancient but

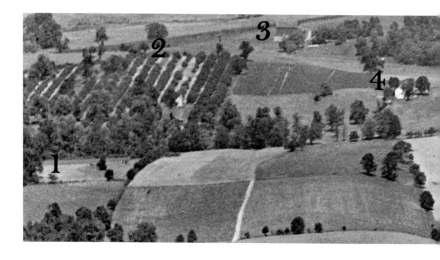

vanishing ways of pre-industrial farm life (as in *Adam and His Wagon*, 1940). N. C. loved such a theme too, but his son took it in a new direction, not quaintly picturesque but sober, even bleak.

A large number of 1930s watercolors and sketches suggest that this vicinity is where Andrew truly learned to paint landscapes. For the sequestered boy, it was thrilling freedom to leave his father's Homestead and walk up here. It was a "long ridge—like a spine—all open farm country. I've walked it all my life, wandering this little territory perfectly to myself, very much alone," he recalled. Especially powerful were the sensations he felt here in gloomy winter: "There was the feeling of life beginning to stir, the gleam of lights in the houses of the Negroes that lived along the ridge, the sound of Adam Johnson's pigs as I passed some outer sheds of his farm." No wonder his earliest artistic efforts were focused on this deeply meaningful place of personal escape into the ethos of early America.[8]

During his childhood years, this dwelling was home to John Lawrence, whose son David (aka "Doo Doo," a friendly nickname) was his favorite playmate. Later, Johnson bought the house and inexplicably lowered the roof on the log section, as in *Woodchopper* (1940). As shown in *Hog Pen* (1944), views were extensive

The hills where Andrew Wyeth walked.
Vicinity of *Soaring*, looking east, July
12, 1925, on the artist's eighth birthday.
Bullock Road at right. 1: Field uphill from
N. C. Wyeth Studio. 2: Atwater Orchard
and top of future "Kuerner's" Hill.
3: Red Barn, later Kuerner's, with railroad
embankment behind. 4: Andress House.
5: Archie's Corner, with Mother Archie's
Church and Adam Johnson House.

from this knoll, including to the east,
toward the bare hills of *Snow Flurries*.
Like everyone locally, Andrew was fond
of Johnson, who recalled the fourteen-
year-old ("Little Ol' Andy") approaching him to say that "he was
going to make his living doing this and could he draw me some-
time." Johnson might greet the peripatetic artist with a shout, "You
out sighting, are ya?" Andrew gave him an early tempera and was
amused when Johnson cut it down to fit a frame that he had found
in the local dump.[9]

The artist delighted in the ramshackle **sheds** for hogs and chick-
ens in the barnyard behind the house, showing them in virtuoso
drawings and in the masterful *Adam* (1963), with its friezelike, al-
most classical serenity in contrast to the humble subject matter—
grackles whirling past a pig pen. He described the process of paint-
ing a picture here "above Archie's" in LIFE magazine in 1965. His
friendships with Johnson and other African American neighbors
have attracted attention ever since seventy-four of his pictures of
the black community were exhibited at the Mississippi Museum of
Art in 2001—with some praising his refreshingly broadminded soci-
etal outlook (although he was far from being a political progressive)
and others wondering whether he patronized or somehow took ad-
vantage of his poor, illiterate models. Wyeth considered himself a
misfit youth isolated from the village, one who felt closest to these
black companions: "I paint them because they are my friends."[10]

Andress House and *Soaring*

✧ *Continue west on Bullock Road.*

Almost inconceivably, this whole area was once wide-open fields, now heavily wooded and suburbanized. To the right down Old Orchard Road (a private lane), one can glimpse the historic stone **Andress House** (ca. 1790, enlarged in 1823). It was the closest eighteenth-century dwelling to Andrew's childhood home, and, as a boy, he had been fascinated by its coarse female tenant, bald and cussing. The farmhouse became the subject of several 1940s depictions, which show the then-derelict place covered in white stucco and with a **windmill** and red 1840 **barn** nearby (a blade of the long-vanished windmill was recently found with a metal detector). *Winter Corn Fields* (1942), showing the house, was bought by a du Pont patron in Delaware and fell out of public view until it sold in 2015 for $1.1 million.[11]

Winter Fields (1942, of a dead crow), recently interpreted as a World War II allegory, likewise shows the Andress place. Wyeth had been avidly studying the watercolors of Albrecht Dürer, including *Deer Head Pierced by an Arrow* (1504), as well as that northern master's fastidious portrayals of grass. The influence of Pisanello's late-medieval bird studies is apparent too. *Winter Fields* became a crucial prelude to *Christina's World*. A curator has commented that, "like most of Wyeth's paintings," it is "not an exact copy of any one scene, but rather a compilation." This repeats a common misconception about the artist's approach: it is really an almost maplike portrayal of the actual facts of the local landscape, as can be said of nearly all of Wyeth's Brandywine work. *Winter Fields* was one of the first of his paintings to come in for critical abuse, with the modernist Clement Greenberg dismissing it in 1945 as "a dead bird in the grass executed with meretricious and astounding precision."[12]

The memorable picture *Soaring* (1942–50) shows the Andress vicinity too: an aerial view of bleak Chadds Ford countryside, with turkey vultures in flight. Begun during World War II (he was dis-

Artist of the absolutely accurate. Andrew Wyeth in his studio, 1942, the year he turned twenty-five and painted the hyperrealistic *Soaring*. (Photo courtesy of the Christian C. Sanderson Museum, Chadds Ford, PA © 2020.)

qualified from service by crooked hip joints) and perhaps in dialogue with Peter Hurd's stirring LIFE magazine illustrations of Allied bombers over Germany, it embodied his Thoreau-like determination to study nature minutely: Kuerner even captured a buzzard so that the artist could sketch this somewhat revolting creature for days. A fast-decomposing fowl was eventually sprawled in his studio, to his family's alarm. "Andy studies nature more meticulously than a scientist," a visiting newspaper writer reported with fascination. He had intended only to sketch the bird's head, the artist explained, but then could not help drawing everything else too, having to paste bits of cardboard together to make a four-foot expanse.[13]

Soaring: Every Feather Shown

The hyperrealistic feathers in *Soaring* recall Dürer's famous bird-wing studies (*Wing of a Blue Roller*, 1512). With, once again, his trademark fidelity to the facts of Chadds Ford, Wyeth didn't *fabricate* a rural backdrop, as he easily could have done, but instead imagined the *actual* view eastward from above the Andress House (an initial sketch shows the Loper House instead)—recalling childhood daydreams, lying in the fields, of being able to fly.

The buzzard portrait became a point of contention between N. C. and his son, with the older artist warning the younger that his bleak and colorless style of painting was a dead end. Andrew accordingly hid the picture in his cellar for six years, where it became a support for a toy electric railroad. Later, it emerged and helped establish his early fame—still with evidence of the tracks on its rear surface! Rather than reconfigure his driveway, as he considered doing, the current owner of the Andress House has deliberately kept it exactly as seen in *Soaring*. Late in life, Wyeth revisited the place to paint *Ice Queen* (1994), showing a sleigh that he remembered having been in the barn when he was a child.

Soaring is a critical work in the development of Wyeth's art. As one of his "essentialized" landscapes of the 1940s, it helped teach him how to strip away certain elements that are less important, which subsequently became a hallmark of his temperas. It is distinctly similar in color, mood, and architectural subject to the eventual *Christina's World*. And here, he could revel in his propensity for the microscopic as he perfected his tempera technique. "You see every little detail of the feathers, in the most realistic way possible," said Katie Wood Kirchhoff, the curator of the Shelburne Museum in Vermont, which owns the celebrated picture. "Tempera is his perfect medium." In the background, "he has cut away everything that's not absolutely necessary. The public connects on a personal level with this painting, because there is so much room for projection."[14]

All-American beech. Only fragmentary forests survived in agricultural Chadds Ford when Andrew Wyeth was young. Here, I believe, is the rediscovered giant of *Corner of the Woods*, sixty-six winters after he painted it.

Behind the Andress House to the north and abutting the N. C. Wyeth Homestead once stood the enormous **Atwater orchard**, now a wooded subdivision (begun in 1949) on Old Orchard Lane. Until the late 1950s, Wyeth could walk to Little Africa or Kuerner Farm through cornfields and pastures, meeting nobody. Thereafter, suburban homes and "no trespassing" signs forced him to zigzag, and he was constantly running into nosy gawkers. "People spot me wandering around in the fields and think I'm loafing," he complained in 1968. "Those walks are as important to me as my brush."[15]

Part of his **"path in the woods"** to Archie's Corner can be traced today, just north of the bend in suburban **Ardmoor Lane**, cut through Tulloch family farmland in 1986 to the distress of the reclusive Carolyn Wyeth, living just downhill at the Homestead. Here, I believe, one can still find the truly **giant beech** of *Corner of the Woods* (1954), on what Wyeth called "the path leading to Adam Johnson's." That picture began with pencil and watercolor studies in October 1953. Betsy posed outdoors numerous times, finally sweltering in her winter coat as spring came. Unusually, he

had brought his tempera panel into the woods and completed the picture away from the studio.

This forest was familiar to all of N. C.'s family, who would shout, "Let's take a walk up in the woods!" (*Up in the Woods* became the name of an Andrew Wyeth watercolor of a tree stump in 1960.) Later in life, driving in his Jeep, the artist was less mindful of paths, weaving between trees and even cutting right through manicured yards on Ardmoor Lane and Bullock Road, to homeowners' disbelief. To this day, they talk of how he roared right under their clotheslines or repeatedly got stuck in the mud. As we saw, Wyeth was rough on his trucks, often getting hung up on rocks in fields. One local summarized his approach to off-road difficulties: "When in doubt, *gun the engine*. That pretty much describes his attitude towards life generally."[16]

West to the Brandywine

⇢ *Proceed to the T intersection of Bullock and Creek Roads.*

This section long had a rural flavor: the westernmost stretch of Bullock Road remained gravel into the 1970s. The **row of maples** along Creek Road, adjacent to **Pyle's Meadow**, dates back nearly a century, to the time when those wealthy du Ponts, flush with wartime profits, were buying up small farms and fashioning huge Brandywine estates. N. C. deplored their "*fancy* farming" and how "this dear old valley is suffering slow torture . . . in the hands of the moneyed people. . . . Damn *money*, damn the people who slop it around like hogwash!" He especially lamented the dynamiting of the old Barney house and barn just east of Twin Bridges (shown in an interesting sketch in a letter from May 1918).[17]

Left at the intersection, the bulky 1925 concrete bridge over the Brandywine replaced the covered **Twin Bridges** of 1855. Just over the bridge is the Haskell Estate, called **Hill Girt Farm**, once 1,500 acres and famous for Guernsey cattle. Andrew's politician friend Harry Haskell Jr. lived here—owner of *Raccoon* and *Roasted Chestnuts*. As boys, the two had skated on the estate pond. Later,

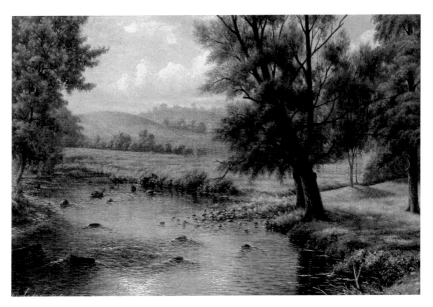

Pyle's Ford. Just downstream from Twin Bridges, south of Chadds Ford, this historic crossing of the Brandywine attracted artists in the nineteenth century. (George Cope [1855–1929], *Pyle's Ford*, 1896, oil on canvas, 8 × 12". Brandywine River Museum of Art, Gift of Mr. and Mrs. Andrew Wyeth, 1970.)

Haskell worked in the Dwight Eisenhower administration and often heard from the president how much he admired Wyeth art: "He wanted Andy to come teach him how to paint. So they smuggled him into the White House a lot of times." Haskell had bought three works in 1950–52 at steadily escalating prices. He recalled, "Andy asked me if I would loan *Roasted Chestnuts* to the president to hang in the Oval Office. We smuggled that in, too. I heard that at a big meeting, the president was standing looking at that painting, and he said, 'How in the hell does he do it, anyway?'" Wyeth painted the president's portrait for the cover of TIME magazine, visiting Ike's Gettysburg farm in August 1959; President Richard Nixon later hung the original in his California office. Wyeth also did a watercolor of the Eisenhower house as seen beyond a sycamore tree, *At Home*—a rare view of a Pennsylvania scene that was not Chadds Ford.[18]

Hal Haskell helped found the Brandywine Conservancy, and in 1969 his estate was one of the first along the river to be protected by a conservation easement. In 2003, a Hollywood production was filmed here, M. Night Shyamalan's "period horror" movie *The Village*, with sets and ambiance directly inspired by Wyeth's moody paintings. Life and art converged as the elderly artist—whose 1940s pictures had owed something to his avid film-viewing—visited the set. Unfortunately, it was a critical flop, as was the dog-themed weeper *Marley & Me* five years later, filmed at a picturesque 1830 farmhouse along the Brandywine just upstream from the Wyeths' estate (at the foot of Meetinghouse Road).

Creek Road (Route 100) is the **road to Wilmington** by which Pyle and his students bicycled to the city, ten miles away, for lemonade at Ainscow's Restaurant and Oyster House, at 802 Market Street. It was along this road that N. C. recalled walking to Chadds Ford the first time, in October 1902, the morning after the twenty-year-old had arrived by train from New England. The landlady at his boardinghouse at Tenth and Adams fixed him a sandwich, which he ate at **Adams Dam** (part of the Winterthur estate). He had brought a trout line in his pocket and fished a while before strolling to Chadds Ford and, on the fateful following day, beginning to study with Pyle. Decades later, N. C. could recall every detail of that life-changing walk down the sandy roads beside the Brandywine.[19]

The Wyeths and Wilmington

N. C. Wyeth long preserved close connections to Wilmington, marrying a young local and buying his canvases and frames at the cluttered, old-timey **Hardcastle Gallery** that stood at 417 Shipley Street downtown. That establishment was frequented by Pyle as well, having been founded by a Yorkshire cabinetmaker as George Hardcastle & Son in 1890. In the 1960s, Andrew Wyeth regularly brought a basket of apples for his trustworthy framer there, Francis Coll, and earned a secret nickname from the staff, "0–85," for his inevitable purchase of Burnt Umber among the Winsor & Newton watercolors. It is said that he would buy teensy Winsor

& Newton sable brushes (Series 7 No. 1) "by the fistful." A stash of rare Whatman watercolor paper was stored here just for him. A few blocks away, N. C. perused the titles at **Greenwood Book Shop** in the Delaware Trust Building. The late Dr. William H. Duncan told me how N. C. would pull up a chair and regale him with stories while he, as a boy, unpacked deliveries.[20]

When Andrew was fifteen, his art was first seen by the public at an exhibition at the downtown **Wilmington Public Library**, in November 1932. He was a regular in exhibitions at the **Delaware Art Museum**. Several of his early patrons were du Ponts, some of whose portraits he painted. He made a series of visits to the **Winterthur** estate to paint Henry Francis du Pont in 1964, the magnate who bought *Groundhog Day* (1959) for the Philadelphia Museum of Art and whose premier collection of antiques has long confirmed the Brandywine Valley as a center for the study of early American culture. Du Pont helped found the local art museum to enshrine the memory of Pyle, whom he knew in his youth.

Andrew's son Jamie Wyeth married a du Pont and created a sprawling estate at **Point Lookout**, on the Brandywine south of here, adjacent to the **Great Bend**, once the site of an Indian town in a horseshoe curve of the creek. Here was the "Big Bend" estate of Frolic Weymouth, an artist and the founder of the Brandywine Conservancy. (Brandywine fishermen gawped in disbelief one spring day when Weymouth's carriage came by with the singer Michael Jackson beside him, waggling his silver glove.) Jamie's *New Years Calling* (1985) depicts a du Pont family tradition at **Granogue**, the spectacular Irénée du Pont estate that lies just south of his own. At ninety-eight, Irénée told me how Andy had learned to swim in the pond at Granogue when they were boys together. In the cold spring of 1991, the artist shivered while painting the view from the lofty cupola of the mansion.

The du Ponts were not Wyeth's only Wilmington patrons: at **Guyencourt**, the wealthy importer William E. Phelps, a dear friend of N. C., was crucial in Andrew's early years (53 Guyencourt Road; Andrew did a mural over the fireplace of buzzards in flight), just as the Wilmington banker Charles Cawley was in his later ones. Oddly enough, his last Brandywine Valley painting features not Chadds Ford but Wilmington, where he experienced one of his "flash impressions" while coming home from the eye doctor: the

gate posts and traffic lights at **Nemours/Alfred I. duPont Hospital for Children** appear—accurately rendered as usual—behind the motorcyclist in *Stop* (2008). As he did so often, he blocked traffic when he pulled his truck to the side of the road to paint. A police officer who responded was astonished to find the famous artist and his companion, Helga Testorf, both sitting nonchalantly in folding chairs beside the busy street.

✦ At Creek Road (Route 100), turn right to return to Chadds Ford village.

The road is hazardous as it approaches the bend, yet Andrew Wyeth was once seen perched on a stool *partly on the pavement,* painting a landscape. A local stopped and warned him that he might get struck: "He looked like a sack of old clothes piled up there!" Farther on, the steep slope to the right is **Rocky Hill**, defended by American troops in 1777 as the British waded across the river at **Chads's Lower Ford**, just upstream—depicted by Andrew as *Fight at Rocky Hill Ford* (1940). The conflict was so brisk that the Brandywine waters were tinged with blood.[21]

The road hugs the Brandywine, and probably this is the scene of that legendary incident when an inebriated Zelda Fitzgerald drove her car into the river after a party at N. C. Wyeth's. Andrew never forgot the thrill of F. Scott Fitzgerald visiting his father's home, wearing a big straw hat and driving a touring car, during the period that the famous author and his unpredictable wife lived at Ellerslie mansion in Wilmington (1927–29): "The *Great Gatsby* right here!" But Scott, Carolyn thought, pointed her father "downhill."[22]

At a left bend, one passes the Andrew Wyeth Studio (Tour 3) and gravel Murphy Road, which leads to the N. C. Wyeth Homestead. The unaltered houses on the left belonged to the Armor and Seal families. Crossing Harvey Run, we return to Chadds Ford, that little Pennsylvania town made so famous by a family of artists who transformed their ordinary rural world into an extraordinary place of memory and imagination—Wyeth Country.

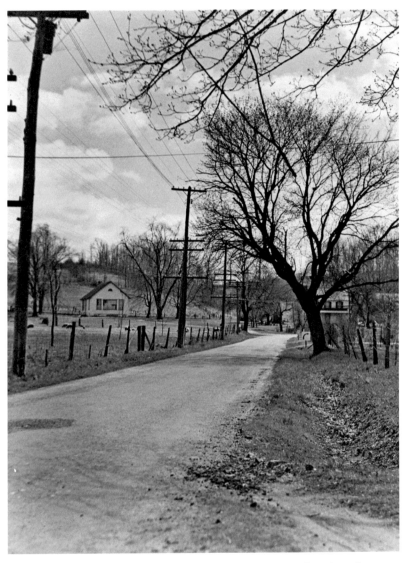

The future Andrew Wyeth Studio. Seen at the foot of Rocky Hill about 1930, the former schoolhouse had been bought by N. C. Wyeth, who installed the north-light windows for his artist-daughter Henriette. Later enlarged to include bedrooms and a kitchen, in fall 1940 it became home to newlyweds Andy and Betsy Wyeth. View from Creek Road, McVey House at right.

Acknowledgments

RESEARCHED IN 2018–20, this book expands upon the art historical discussion in my previous *The Brandywine: An Intimate Portrait* (2015). Neither of these books was authorized by any institution or family—I have written them entirely on my own. In trying to understand Andrew Wyeth, at times I felt like the biographer of Vladimir Nabokov, who grappled with records under lock and key and an elusive subject who wove mythologies of self that stand like barricades against deeper inquiry. Even Wyeth's battered metal paint box was ruled off-limits. I persisted because we have long needed a guidebook to the major artists of the Brandywine—now more than ever, as the new First State National Historical Park extends its boundaries farther into Chadds Ford, so that it is now only two miles from Wyeth Country. The whole nation is recognizing the importance of the Brandywine Valley.

Another reason to write this book was to interview people from all walks of life with living memories of the artists of Chadds Ford. Typical of this eclectic area, they ranged from surgeons to arborists, tycoons to automobile mechanics. A few vividly remembered N. C. Wyeth, although he has been dead for more than seventy years. Many are seniors—Andrew Wyeth would be over one hundred now—and, to my constant surprise, most had never been inter-

viewed before. I am grateful to everyone who agreed to talk. A few asked to remain anonymous.

Following a lot of sleuthing, this book contains many images never reproduced before, including the aerial photographs, which I hope will give a good sense of the agricultural landscape of bygone days. The talented cartographer Nat Case designed the maps.

In Chadds Ford and vicinity, I wish to thank Rodney Arment, Andy Bell, Abner Cloud, Peggy Day, Jerry Dowling, Karen Heebner, Andy Johnson, Rob and Katharine King, Jim Leader, Lloyd Lisk, William Mahoney, David McGinley, Kathy Meaney, Barbara Moore, Susan and David Poston, Bruce Prabel, Debbie Reardon, Gary Sharp, Helen and George Sipala, Geoff Snelling, Roger Steward, Dave Taylor, and George Thorpe. Elsewhere in Pennsylvania, I thank Jim Bostelle, John Chambless, Karen Delaney, Catherine Faust, Kathleen Foster of the Philadelphia Museum of Art, Dale Frens, Heather Ramsey, Sarah Stuhlmuller, and Christa Vanderbilt. Catherine Quillman and Damon Sinclair were extremely generous with their time. Jason Greenplate and the staff of Chadds Ford Historical Society and Charles Ulmann at the Sanderson Museum were likewise very helpful. At the Brandywine Conservancy and the Brandywine River Museum of Art, thanks go to Virginia A. Logan and Thomas Padon; and also to Sheila Fleming, Christine Podmaniczky, David Shields, Gail Stanislow, and especially Amanda Shields.

In Delaware, I thank Don Altmaier; Randy Barton; David Berndt and Mike Brock of Hardcastle Gallery; Howard Pyle's descendants Roberts and Allison Brokaw, Tom and Margaretta Brokaw, and Maggie Brokaw; Wade Catts; Nick Cerchio; the late Dr. William H. Duncan; Andrew Dinsmore in the office of Senator Chris Coons; Brad du Pont; Nancy Greenewalt Frederick; Jim Graham; the late André Harvey; Daniel Jackson; Nan Jackson; E. Jean Lanyon; James McGlynn; Terry Newitt; E. O. Omwake; Mary Alice Peeling; Walter and Beverly Rowland; and Marion Silliman. Irénée du Pont offered many insights. The very kind Peg Laird and Bobbie Harvey offered much-needed advice and encouragement. At Winterthur Museum, thanks go to Catherine Matsen

and Joyce Hill Stoner, and at the Delaware Art Museum, Margaretta Frederick and the librarian, my former student Rachael DiEleuterio. I wish to acknowledge the kindness of the late Howard Pyle Brokaw, the grandson of the artist. At Longwood Gardens, thanks go to my coworkers Jackie Miller, Heidi Benson, Katherine Limbaugh, and Joanne Tilles, and also to Scott Wade. My mother, Isabel Maynard, offered generous support, not to mention having purchased the summer reading list book *King Arthur* that first introduced me to Howard Pyle at Sea Island, Georgia, in 1977.

Across the United States, I thank Bo Bartlett, Robert Daniel Bohné, Casey Cleveland, Peter de la Fuente, Steve Doherty of *American Artist*, Jane Farrow, Jim Grieves, Woody Gwyn, David Hastings, Nancy Hoving, Katie Wood Kirchhoff of the Shelburne Museum, Les Linton, Carol Logsdon, Steve Lopez of the *Los Angeles Times*, Anna B. McCoy, John McPhee, Virginia Mecklenburg of the Smithsonian American Art Museum, Jon Redmond with whom I explored Wyeth's world in Maine, Dr. J. Kim Sessums, Jonathan Shahn, Annalyn Swan, A. N. Wyeth, Michael Taylor of the Virginia Museum of Fine Arts, and Stephen Triplett. The art historians Henry Adams and David Cateforis offered truly invaluable support and advice to this unauthorized biographer. Ian Shoenherr generously shared his deep knowledge of Howard Pyle. I am grateful for the kindness of the late Tomie dePaola, whom Ben Shahn once taught to draw using ink and a tree branch. A very warm thank you goes to Eva Marie Saint. The initial suggestion to brush myself off amid discouragement and write another book—this one—came from George Will.

At Temple University Press, Aaron Javsicas did an extraordinary job with the editing and stood by this project, for which I am very grateful. Two anonymous outside reviewers examined the manuscript not once but twice, following the emergency revision of the pictorial program, and I am grateful for their support. Thanks to Carlos Alejandro and Fred Weyman for their fine photography. A conversation with Blaine T. Phillips Jr. of the Conservation Fund, who has done so much to preserve the Brandywine, helped inspire me to write this guidebook.

My three small children were patient throughout countless walks in Chadds Ford, even when they floundered in stinging nettle, fell into streams, or finally in exasperation begged their father *never again* to mention a certain very famous artist. As with my previous books, my greatest debt by far is to my wife, Susan Maynard, whom I met in an art history class.

Notes

ABBREVIATIONS

CCHS: Chester County Historical Society
CFHS: Chadds Ford Historical Society
WPL: Wilmington Public Library

PREFACE

1. *Journal Every Evening* [Wilmington], March 6, 1935; "267 Pyle Paintings in Public Library," *Boston Evening Transcript*, clippings file, WPL. "*Christina's World* owes a lot" to Pyle, Wyeth said; Rodman, *Conversations*, 213. It resembles Thomas Eakins's *An Arcadian* (1883), painted not far from Chadds Ford at Avondale, Pennsylvania; Woody Gwyn, pers. comm., July 8, 2019.
2. Debbie Reardon, pers. comm., March 8, 2019.
3. Meryman, "Andrew Wyeth: An Interview," npn; Rodman, *Conversations*, 213.
4. Venn and Weinberg, *Unknown Terrain*, 47.

CHAPTER 1

1. Howard Pyle to Eric Pape (May 26, 1898), courtesy of Ian Schoenherr.
2. Pitz, *Pyle*; N. C. Wyeth, *The Wyeths*, 46–47.
3. Coyle, *Pyle*, 160.
4. "Pyle Took Pride in Accuracy," *Journal Every Evening* [Wilmington] (May 5, 1937), clippings file, WPL; May and May, *Pyle*, 98; Maynard, *Brandywine*, 187.
5. May and May, *Pyle*, 108; Pitz, *Pyle*.
6. Miller and Barr, *American Realists*, 58.
7. A. Wyeth, *Autobiography*, 122.

8. Schoonover, "Pyle."

9. Maynard, *Buildings of Delaware*, 74.

10. N. C. Wyeth, *The Wyeths*, 309.

11. Maynard, "Thoreau Manuscript"; Warner and White, *World of Andrew Wyeth*.

12. Duff, *American Vision*, 84.

13. Corn, *Art of Andrew Wyeth*, 130; Meryman, *Spoken Self-Portrait*, 99. N. C. called *Nightfall* "my 'John McGinley'" picture, but John's brother Hugh claimed that he had posed himself, telling his grandson, "Your Aunt Sis and I are famous." John's own daughter, who died recently age 105, was certain that the picture shows the taciturn Hugh, who rented a farm on Brinton's Bridge Road; John lived at 480 Ring Road. Red-headed Sis (Elizabeth) is shown younger than her actual age. Peggy Day and David McGinley, pers. comm., June 22 and 24, 2020.

CHAPTER 2

1. Kimmelman, "Imperfect American Idol."

2. Meryman, "Wyeth: An Interview," 93.

3. Hunter, "Inflated."

4. Steve Doherty, pers. comm., June 13, 2019; *New York Times*, February 28, 1971.

5. Rodman, *Conversations*, 211; Greene, interview.

6. "Wyeth's World." Wyeth's last visit to Winterthur was on May 28, 2008; Joyce Hill Stoner, pers. comm., July 25, 2020.

7. *Two Worlds*, 6; A. Wyeth, *Autobiography*, 19.

8. Duff, *American Vision*, 84; *Andrew Wyeth: Dry Brush*, npn; Pitz, *Pyle*.

9. "Parade of Youth," February 9, 1936, clippings file, Sanderson Museum, Chadds Ford; Venn and Weinberg, *Unknown Terrain*, 45; Grigson, *Romantics*, 327; Andrew Wyeth to William Phelps, February 2, 1944, Phelps Papers.

10. Duff, *American Vision*, 86; B. Wyeth, *Wyeth at Kuerners*, viii.

11. John Milner, interview, CFHS, May 22, 2017.

12. Les Linton, pers. comm., March 9, 2020. Linton is an artist of Tracy City, Tennessee. In later years, Andrew Wyeth preferred the paper Fabriano Artistico 300 lb. Extra White.

13. A. Wyeth, *Autobiography*, 52.

14. Meryman, "Wyeth: An Interview"; Meryman, *Spoken Self-Portrait*, 86; Schoonover, "Pyle"; "Philosophy of Schoonover."

15. Andrew Wyeth to William and Mary Phelps, January 27, 1957, Delaware Art Museum; Sweet and McCord, *Wyeth*, 85; A. Wyeth, *Autobiography*, 46.

16. Andrew Wyeth to William and Mary Phelps, February 23, 1961, Delaware Art Museum; A. Wyeth, *Autobiography*, 150.

CHAPTER 3

1. *New York Times*, February 3, 1987; Meryman, "Wyeth: An Interview"; A. Wyeth, *Autobiography*, 12; N. C. Wyeth, *The Wyeths*, 205; bobartlett.com; Bartlett, *Andrew Wyeth Self-Portrait*.

2. *Two Worlds*, 10, 48; A. Wyeth, *Autobiography*, 13; Weekly and Lewis, *Exalted Nature*, 56; "Brain Full of Lore."

3. Hunter, "Inflated"; Porter, *Art in Its Own Terms*, 80; Porter, "Interview." What I call a "broomstick" in *Adam* could be a mop or tool handle.

4. Corn, *Art of Andrew Wyeth*, 150.

5. Monument: Bartlett, *Andrew Wyeth Self-Portrait*.

6. B. Wyeth, *Wyeth at Kuerners*, 148; Plimpton and Stewart, "Wyeth," 101.

7. Chipp, *Theories*, 60. My view of Andrew Wyeth as beholden to literal fact is contradicted by Kathleen Foster of the Philadelphia Museum of Art, who reached the opposite conclusion when she researched the artist for his retrospective: "He has a reputation for being like a camera, but no, it's about his process of distillation and manipulating things. People overestimate the realism and the description and underestimate the amount of choice and selection. I was surprised how much he made up, how much he composed"; pers. comm., November 13, 2018. She notes that his temperas are more composed and his landscape watercolors more factual.

8. Miller and Barr, *American Realists*, 5, 23, 58.

9. Corn, *Art of Andrew Wyeth*, 119.

10. Meryman, *Andrew Wyeth* (1968), 4, 38. Clouds: Bartlett, *Andrew Wyeth Self-Portrait*.

11. Plimpton and Stewart, "Wyeth," 99, 101; Rodman, *Conversations*, 219.

12. David Hastings, pers. comm., August 23, 2019.

13. *Kennett News and Advertiser*, January 4, 1957, clippings file, CCHS.

14. A. Wyeth, *Autobiography*, 150, 23.

15. *Ladies Home Journal*, March 1910, in Schoenherr, Pyle Blog; Corn, *Art of Andrew Wyeth*, 77.

16. Wilmerding and Knutson, *Memory*, 42; Duff, *American Vision*, 80. Surrealist approaches to landscape painting found a worldwide audience: it has gone unnoticed, but 1930s pictures by Eric Ravilious in England bear a close resemblance to early Andrew Wyeth. Graham Sutherland said, "I go for walks with no particular pre-conceived ideas. I have a very small notebook and I look right and left as I am walking, and suddenly I see something that interests me. . . . The moment of seeing is often fleeting. . . . It is the element of the accident and the accidental encounter which is important"; Hammer, *Sutherland*, 14.

17. Secrest, "Painter."

18. Bartlett, *Andrew Wyeth Self-Portrait*.

19. Sweet and McCord, *Wyeth*, 70; Logsdon, "The Farm That Inspires."

20. A. Wyeth, *Autobiography*, 52; Wilmerding and Knutson, *Memory*, 93.

21. Meryman, "Wyeth: An Interview," 110.

22. "Andrew Wyeth," LIFE, 102.

TOUR 1

1. McGuire, *Battlefield Park*.

2. *Biography: Andrew Wyeth*.

3. Irving, *Washington* 3:249; Trevelyan, *American Revolution* 4:227.

4. McGuire, *Philadelphia Campaign*, 203.

5. *Journal Every Evening* [Wilmington], December 3, 1927.

6. Schoenherr, Pyle Blog.

7. Sweet and McCord, *Wyeth*, 59; A. Wyeth, *Autobiography*, 27; Hammer, *Sutherland*, 20.

8. Casey Cleveland, pers. comm, October 18, 2018, and June 10, 2019.

9. Pitz, *Pyle*, 157; N. C. Wyeth, *The Wyeths*, 811.

10. Brinckle, "Interview."

11. Pitz, *Pyle*, 154; Ian Schoenherr provided various details about Pyle's school of art.

12. Helen and George Sipala, interview, CFHS, February 2, 2018, and pers. comm., October 1, 2018; Quillman, "Posing."

13. Roger Steward, pers. comm., July 28, 2020.

14. Maynard, *Brandywine*, 198.

15. Duff, *American Vision*, 81.

16. Jim Graham, pers. comm., March 31, 2020; *Woman's Day*, August 1963, clippings file, CCHS.

17. Mildred M. Ketchum to Andrew Wyeth, December 5, 1961, Phelps Papers.

18. "Preservationist."

TOUR 2

1. *New York Times*, June 22, 1970, clippings file, CCHS.

2. "Summer Art Schools."

3. Schoonover, "Interview"; Pitz, *Pyle*.

4. N. C. Wyeth, *The Wyeths*, 807.

5. Ibid., 210.

6. Duff, *American Vision*, 87; N. C. Wyeth, *The Wyeths*, 837–838.

7. Grubin and McCullough, *The Wyeths*; Altmaier, pers. comm., October 3, 2018. More about the crash: N. C. had largely gone deaf, a condition congenital in the family; Anna B. McCoy, pers. comm., December 6, 2018. A visit to the wreck site sixty years to the hour after it happened suggested that sun glare was a factor, as locals assumed. One drives through shadowy trees and then suddenly ascends to the tracks, the sun bright and just to the left. According to one account, the engineer saw N. C. fling himself over the child's seat in a desperate attempt to save his much-loved namesake; but then again, the driver was found crushed between the seat and the steering wheel, as if he had been immobilized by a heart attack. Accounts say that the car was pushed nearly 150 feet down the tracks, but it was probably half that; photographs show it lying about where today's rusted semaphore signal stands (eyewitness to the disaster, that tower has evidently been moved westward and shortened).

8. Echelmeyer, "Chadds Ford's Andy Wyeth"; Bartlett, *Andrew Wyeth Self-Portrait*.

9. "The Wyeth Who Doesn't Paint."

10. Schoonover, "Interview."

11. Schoonover, "Pyle"; Allen and Allen, *N. C. Wyeth*, 174.

12. N. C. Wyeth, *The Wyeths*, 811.

13. *Philadelphia Inquirer*, May 11, 1966, clippings file, CCHS.

14. N. C. Wyeth, *The Wyeths*, 595.

15. B. Wyeth and A. Wyeth, *Close Friends*, 13; Meryman, *Andrew Wyeth* (1968).

16. Peixotto, *Pilgrimage*, 218–219.

17. Bobbie Harvey, pers. comm., July 1, 2019; Woody Gwyn, pers. comm., July 8, 2019; Terry Newitt, pers. comm., April 10, 2020.

18. Eddieflotte.com.

19. Casey Cleveland, pers. comm., June 10, 2019.

20. Jim Grieves, pers. comm., June 10, 2019; Logsdon, "The Farm That Inspires."

TOUR 3

1. Sarah Stuhlmuller, pers. comm., August 10, 2020.

2. Maynard, *Brandywine*, 179–180; fragmentary newspaper article, June 30, 1898, clippings file, CCHS; "Wyeth's World."

3. Meryman, *Spoken Self-Portrait*, 99; Bo Bartlett, pers. comm., June 6, 2018.

4. Meryman, "Andrew Wyeth: An Interview."

5. Sweet and McCord, *Wyeth*, 54.

6. Weekly and Lewis, *Exalted Nature*, 56.

7. Duff, *American Vision*, 87; Meryman, *Secret Life*, 49.

8. *The Fence Builders* in Podmaniczky, *Catalogue Raisonné*.

9. Meryman, "Andrew Wyeth: An Interview."

10. Woody Gwyn, pers. comm., July 8, 2019; Talorico, "Look."

11. Anna B. McCoy, pers. comm., December 6, 2018.

12. Meryman, *Secret Life*, 90; Adams, "Interview"; also "Andy, why don't you really free yourself?" in Duff, *American Vision*, 85. Wyeth told Helga that the tree he first painted as a boy was a V-shaped one at the east end of the orchard, perhaps shown in *Jacklight* (1980).

13. Harry Haskell Jr., interview, CFHS, June 6, 2017; Ruskin, *Elements*, 48–49; Cook, *Ruskin* 2:83.

14. N. C. Wyeth, *The Wyeths*, 384, 376; Podmaniczky, *Wyeth* 1:40; Podmaniczky, *The Wyeths*, 10.

15. A. Wyeth, *Autobiography*, 92.

16. Talorico, "Look."

17. *Sunday Bulletin Magazine* [Philadelphia], October 10, 1965, clippings file, CCHS.

18. Meryman, *Spoken Self-Portrait*, 86.

19. A. Wyeth, *Autobiography*, 103; Andy Bell, interview, CFHS, July 19, 2016.

20. Rodman, *Conversations*, 212; Donald Tulloch, interview, CFHS, April 28, 2014.

21. "Wyeth: An American Realist," 102; Echelmeyer, "Chadds Ford's Andy Wyeth."

22. Meryman, *Secret Life*, 180; Woody Gwyn, pers. comm., July 8, 2019.

23. "Preservationist"; Johnstewartdocumentary.wordpress.com.

24. Geddes, "Betjeman."

25. A. N. Wyeth, pers. comm., October 17, 2018.

26. Miller and Barr, *American Realists*, 58; Bartlett, *Andrew Wyeth Self-Portrait*; Meryman, "Wyeth: An Interview"; Altmaier, pers. comm., October 3, 2018.

27. TIME, December 27, 1963; *Sunday Bulletin Magazine* [Philadelphia], October 10, 1965, clippings file, CCHS. Pawprints: Stoner, *Wyeth Legacy*.

28. Beth Bathe, pers. comm., February 20, 2020.

29. Rodman, *Conversations*, 211–229. Ben Shahn's son confirms that his father admired Andrew Wyeth's craft; Jonathan Shahn, pers. comm., 2018.

30. Logsdon, *Mother*, 47–49.

31. Andy Johnson, pers. comm., May 30, 2019; *Lancaster News*, May 12, 1972, clippings file, CCHS.

32. Eo Omwake, pers. comm., September 12, 2019.

TOUR 4

1. The artist who saw Wyeth rub mud was Rea Redifer; Bo Bartlett, pers. comm., June 6, 2018. Conservator Joyce Hill Stoner has not seen evidence of mud; Stoner, pers. comm., November 14, 2018. Doherty, "Visit"; Cateforis, *Rethinking*, 96.

2. Frank, "Second Battle."

3. N. C. Wyeth, *The Wyeths*, 86, 135; Pitz, *Brandywine Tradition*, 113.

4. N. C. Wyeth, *The Wyeths*, 813.

5. Peter de la Fuente, pers. comm., May 21, 2019.

6. Schoonover, "Interview."

7. "Preservationist"; Eva Marie Saint, pers. comm., November 14, 2018.

8. Woody Gwyn, pers. comm., July 8, 2019.

9. Don Altmaier, pers. comm., October 3, 2018; Casey Cleveland, pers. comm., June 10, 2019. The sycamore in *Night Mare* is presumably the solitary one still visible in the slough behind Hank's restaurant, also in *Pennsylvania Winter* (1947).

10. Sweet and McCord, *Wyeth*, 88; *Andrew Wyeth: Dry Brush*, 42.

11. *Woman's Day*, August 1963, clippings file, CCHS.

12. *Evening Journal* [Wilmington], January 11, 1969; Dorst, *Written Suburb*, 54.

13. Benjamin, "Perfectionism"; Mary Landa, *Radio Times* interview, WHYY Philadelphia, September 5, 2018.

14. Terry Newitt, pers. comm., April 10, 2020.

15. Charles Ullman, pers. comm., January 30, 2020.

16. McGuire, *Philadelphia Campaign*, 173. The site of Procter's battery (knoll above Sanderson's) was still visible at the time of the Bache Map military survey of the Brandywine Valley in 1863.

17. Ibid., 170; Conway, *Life of Thomas Paine*, 104.

18. Jane Farrow, pers. comm., July 13, 2019.

19. Andy Bell, interview, CFHS, July 19, 2016; "The World of Wyeth," *National Observer*, September 9, 1968, clippings file, CCHS. "Roundelay" is sometimes spelled "Rondelay."

20. Junker and Lewis, *Retrospect*, 203.

TOUR 5

1. Sweet and McCord, *Wyeth*, 20.

2. Logsdon and Kuerner, *All in a Day's Work*; A. Wyeth, *Autobiography*, 90; B. Wyeth, *Wyeth at Kuerners*, 185; Meryman, "Wyeth: An Interview."

3. Logsdon, "The Farm That Inspires."

4. Duff, *American Vision*, 120; *Two Worlds*, 40; Bartlett, *Andrew Wyeth Self-Portrait*.

5. A. Wyeth, *Autobiography*, 153; Meryman, *Spoken Self-Portrait*, 92; Logsdon, *Mother*, 19.

6. Henry Adams, pers. comm., October 2, 2018.

7. Logsdon, "The Farm That Inspires"; Meryman, *Spoken Self-Portrait*, 103; Nancy Hoving, pers. comm., May 23, 2019.

8. Logsdon, "The Farm That Inspires."

9. Peter Vilhelm Nielsen, https://www.petervnielsen.dk/.

10. A. Wyeth, *Autobiography*, 110; George Thorpe, pers. comm., October 19, 2018.

11. Streeter, *Frozen Lives*, 41; Hunter, "Inflated"; Plimpton and Stewart, "Wyeth," 97; Don Altmaier, pers. comm., October 3, 2018.

12. Dr. J. Kim Sessums, pers. comm., November 7, 2018.

13. David Hastings, pers. comm., August 23, 2019.

14. Wilmerding and Knutson, *Memory*, 95.

15. Bartlett, *Andrew Wyeth Self-Portrait*; Woody Gwyn, pers. comm., July 8, 2019; Catherine Faust, pers. comm., July 30, 2020.

16. Bartlett and Brass, *Helga*.

17. Streeter, *Frozen Lives*, 109.

18. This account is based on Logsdon, "The Farm That Inspires," and *Mother*; also Carol Logsdon, pers. comm., August 3, 2020. Kill the story: Meryman, *Spoken Self-Portrait* audio.

19. Logsdon, "The Farm That Inspires"; Corn, *Art of Andrew Wyeth*, 152; Brinckle, "Interview."

20. Logsdon, *Mother*, 59–60; Bartlett and Brass, *Helga*; Nixon, "Toasts."

21. Bo Bartlett, pers. comm., June 6, 2018.

22. Logsdon, "The Farm That Inspires."

23. *Two Worlds*; Logsdon, "The Farm That Inspires." Later in life, Andrew said that the hill he walked "a thousand times" was that of *Snow Flurries*, but the description makes even more sense for Kuerner's Hill; A. Wyeth, *Autobiography*, 37.

24. Canaday, "Art"; Plagens, "Misfit"; bobartlett.com. The artist's near-panic in 1967 was repeated at the retrospective show that Philadelphia Museum of Art curator Kathleen Foster put on in 2006: "He was like a kid, so nervous, beside himself and clutching Betsy, wild with anxiety, until he got inside and looked around. Then he turned to me with a look of beatitude and said, 'Oh, the light is so wonderful!'" (pers. comm., November 13, 2018).

25. Meryman, *Secret Life*, 82; Hergesheimer, *Old House*, 35–39; Rodman, *Conversations*, 216.

26. Meryman, *Spoken Self-Portrait*, 99; Wilmerding and Knutson, *Memory*.

TOUR 6

1. Dr. Robert A. Mickel, pers. comm., September 11, 2019.

2. B. Wyeth and A. Wyeth, *Close Friends*, 13.

3. Meryman, *Andrew Wyeth* (1968), 5; Grubin and McCullough, *The Wyeths*.

4. Kathy Meaney, pers. comm., August 9 and September 12, 2019.

5. A. Wyeth, *Autobiography*, 24.

6. Logsdon, "The Farm That Inspires"; Bartlett, *Andrew Wyeth Self-Portrait*.

7. *Washington Post*, March 7, 1977, clippings file, CCHS; Meryman, *Andrew Wyeth* (1968), 5. The distant hill in *Snow Flurries* is not Kuerner's Hill (or "Snow Hill"), although Betsy stated that it was in *Wyeth at Kuerners* in order to end the walk-format book back where it began. Instead, that distant hill is near today's St. Cornelius Church, far southeast of Kuerner's Hill.

8. Meryman, *Spoken Self-Portrait*, 86–89.

9. Ibid., 89.

10. Meryman, *Secret Life*, 190.

11. Ibid., 185; Geoff Snelling, pers. comm., October 5, 2018.

12. Madison Museum of Contemporary Art, www.mmoca.org; *The Nation*, December 15, 1945.

13. Echelmeyer, "Chadds Ford's Andy Wyeth."

14. Katie Wood Kirchhoff, pers. comm., November 14, 2018.

15. "The World of Wyeth," *National Observer*, September 9, 1968, clippings file, CCHS.

16. Sweet and McCord, *Wyeth*, 56, 97. If I am correct, the huge beech of *Corner of the Woods* stands not on the N. C. Wyeth property line, as is sometimes said, but south of there, where the woods once terminated, near today's bend in Ardmoor Road.

17. N. C. Wyeth, *The Wyeths*, 589–590.

18. Harry Haskell Jr., interview, CFHS, June 6, 2017.

19. N. C. Wyeth, *The Wyeths*, 811.

20. E. Jean Lanyon, pers. comm., October 12, 2018; Dr. William H. Duncan, pers. comm., November 11, 2018. George Hardcastle's 1915 obituary says that he founded his art business in 1890.

21. George Thorpe, pers. comm., October 19, 2018.

22. Duff, *American Vision*, 86.

Bibliography

Abbott, Charles D. *Howard Pyle: A Chronicle*. New York: Harper and Brothers, 1925.

Adams, Henry. *Andrew Wyeth: Master Drawings from the Artist's Collection*. Chadds Ford, PA: Brandywine River Museum, 2006.

———. "Interview on the Legacy of Andrew Wyeth." Smithsonian.com (May 31, 2006).

Allen, Douglas, and Douglas Allen, Jr. *N. C. Wyeth*. New York: Bonanza Books, 1984.

Anderson, Nancy K., and Charles Brock. *Andrew Wyeth: Looking Out, Looking In*. Washington, DC: National Gallery of Art, 2014.

"Andrew Wyeth: An American Realist Paints What He Sees." LIFE, May 17, 1948, 102–106.

Andrew Wyeth: Dry Brush and Pencil Drawings. Cambridge: Fogg Art Museum, 1963.

Bartlett, Bo. *Andrew Wyeth Self-Portrait: Snow Hill*. Chip Taylor Communications film, 1995.

Bartlett, Bo, and Jesse Brass. *Helga*. Making Art film, 2019.

Benjamin, Stan. "Andrew Wyeth's Perfectionism." *Bridgeport* [Conn.] *Post*, March 1, 1964.

Biography: Andrew Wyeth. 1980. YouTube; accessed on May 9, 2019.

"A Brain Full of Lore" [Howard Pyle]. *Delaware County Daily Times*, August 7, 1902.

The Brandywine Story, 1777–1952. Brandywine Battlefield Park Commission, 1952.

Brinckle, Gertrude [Secretary to Howard Pyle]. Interview (April 1966). MSS 179 Robert H. Richards Jr., Delaware oral history collection, Special Collections, University of Delaware Library.

Canaday, John. "Art: Andrew Wyeth Talks." *New York Times*, January 14, 1967, clippings file, Chester County Historical Society.

Canby, Henry Seidel. *The Brandywine*. New York: Farrar and Rinehart, 1941.

Cateforis, David, ed. *Rethinking Andrew Wyeth*. Oakland: University of California Press, 2014.

Chipp, Herschel B. *Theories of Modern Art*. Berkeley: University of California Press, 1968.

Conway, Moncure D. *The Life of Thomas Paine*. 1908; reprint, New York: B. Blom, 1969.

Cook, E. T. *The Life of John Ruskin*. 2 vols. 1911; reprint, New York: Haskell House, 1968.

Corn, Wanda M. *The Art of Andrew Wyeth*. Greenwich, CT: New York Graphic Society, 1973.

Coyle, Heather C. *Howard Pyle: American Master Rediscovered*. Wilmington: Delaware Art Museum, 2011.

Doherty, M. Stephen. "A Visit with Andrew Wyeth, March 9, 2006." Artists Network online.

Dorst, John D. *The Written Suburb*. Philadelphia: University of Pennsylvania Press, 1989.

Duff, James H. *An American Vision: Three Generations of Wyeth Art*. Boston: Little, Brown, 1987.

Echelmeyer, Fred. "Chadds Ford's Andy Wyeth Among America's Top Artists." *Chester* [Pa.] *Times*, May 20, 1949.

Frank, William P. "It's the Second Battle of Brandywine." *Wilmington Morning News*, May 12, 1966.

Furst, Karen Smith. *Around Chadds Ford*. Mt. Pleasant, SC: Arcadia, 2005.

Geddes, Andrew. "Being with John Betjeman." *The Spectator*, January 20, 2007.

Greene, Stephen. Interview (June 8, 1968). Archives of American Art.

Grigson, Geoffrey. *The Romantics*. Cleveland: Meridian Books, 1962.

Grubin, David, and David McCullough. *The Wyeths: A Father and His Family*. Smithsonian World film, 1986.

Hammer, Martin. *Graham Sutherland: Landscapes, War Scenes, Portraits 1924–1950*. London: Scala, 2005.

Hergesheimer, Joseph. *From an Old House*. New York: Knopf, 1926.

Holsten, Glenn. *American Masters: Wyeth*. Glenn Films for PBS, 2018.

Howard Pyle: The Artist, the Legacy. Wilmington: Delaware Art Museum, 1987.

Hunter, Sam. "The Inflated Reputation of 'Wyeth the Great.'" *Sunday Bulletin* [Philadelphia], September 3, 1967, clippings file, Chester County Historical Society.

Irving, Washington. *Life of Washington*. 5 vols. Philadelphia: Lippincott, 1871.

Junker, Patricia A., and Audrey M. Lewis. *Andrew Wyeth: In Retrospect*. Seattle: Seattle Art Museum, 2017.

Kimmelman, Michael. "An Imperfect American Idol and His Self-Enclosed Art." *New York Times*, January 17, 1997.

Lafayette at Brandywine. West Chester, PA: West Chester Historical Society, 1896.

Landa, Mary. *Radio Times* interview, WHYY Philadelphia, September 5, 2018.

Lengel, Edward G. *General George Washington: A Military Life*. New York: Random House, 2005.

Logsdon, Gene. "The Farm That Inspires America's Most Famous Artist." MS, ca. 1989.

———. *The Mother of All Arts: Agrarianism and the Creative Impulse*. Lexington: University Press of Kentucky, 2007.

———. *Wyeth People*. 1969; reprint, Dallas: Taylor, 1988.

Logsdon, Gene, and Karl J. Kuerner. *All in a Day's Work . . . From Heritage to Artist*. Wilmington, DE: Cedar Tree Books, 2007.

Lykes, Richard Wayne. "Howard Pyle, Teacher of Illustration." *Pennsylvania Magazine of History and Biography* 80, no. 3 (July 1956): 339–370.

May, Jessica, and Christine Podmaniczky. *N. C. Wyeth: New Perspectives*. New Haven, CT: Yale University Press, 2019.

May, Jill P., and Robert E. May. *Howard Pyle: Imagining an American School of Art*. Champaign: University of Illinois Press, 2011.

Maynard, W. Barksdale. *The Brandywine: An Intimate Portrait*. Philadelphia: University of Pennsylvania Press, 2015.

———. *Buildings of Delaware*. Charlottesville: University of Virginia Press, 2008.

———. "Thoreau Manuscript Leaf Found at N. C. Wyeth Studio." *Thoreau Society Bulletin* 243 (Spring 2003): 3.

———. *Walden Pond: A History*. New York: Oxford University Press, 2004.

McClellan, Richard A. *The Land of Truth and Phantasy*. Dover, DE: McClellan Books, 2005.

McGuire, Thomas J. *Brandywine Battlefield Park*. Mechanicsburg, PA: Stackpole, 2001.

———. *The Philadelphia Campaign. Vol. 1, Brandywine and the Fall of Philadelphia*. Mechanicsburg, PA: Stackpole, 2006.

Meryman, Richard. *Andrew Wyeth*. Boston: Houghton Mifflin, 1968.

———. "Andrew Wyeth: An Interview." LIFE, May 14, 1965, 93–122.

———. *Andrew Wyeth: A Secret Life*. New York: HarperCollins, 1996.

———. *Andrew Wyeth: A Spoken Self-Portrait*. Washington, DC: National Gallery of Art, 2013.

———. *Andrew Wyeth: A Spoken Self-Portrait*. Audio recording of lecture. Washington, DC: National Gallery of Art, 2014.

Michaelis, David. *N. C. Wyeth: A Biography*. New York: Knopf, 1998.

Miller, Dorothy C., and Alfred H. Barr, Jr. *American Realists and Magic Realists*. New York: Museum of Modern Art, 1943.

Mortenson, C. Walter. *The Illustrations of Andrew Wyeth: A Check List*. West Chester, PA: Aralia Press, 1977.

Nixon, Richard. "Toasts of the President and Andrew Wyeth." February 19, 1970. American Presidency Project online.

Peixotto, Ernest. *A Revolutionary Pilgrimage*. New York: Scribner, 1917.

Phelps, William E. Papers. Archives of American Art, microfilm roll 3589.

"The Philosophy of Frank Schoonover." *Evening Journal* [Wilmington], January 23, 1935, clippings file, Wilmington Public Library.

Pitz, Henry C. *The Brandywine Tradition*. Boston: Houghton Mifflin, 1969.

———. *Howard Pyle*. New York: Potter, 1975.

Plagens, Peter. "A Misfit—And a Master." *Newsweek*, November 6, 2005.

Plimpton, George, and Donald Stewart. "Andrew Wyeth." *Horizon* 4, no. 1 (September 1961): 88–101.

Podmaniczky, Christine B. *N. C. Wyeth: Catalogue Raisonné of Paintings*. 2 vols. Chadds Ford, PA: Brandywine River Museum of Art, 2008.

———. *The Wyeths in Chadds Ford: The Early Years*. Chadds Ford, PA: Brandywine River Museum of Art, 1997.

Porter, Fairfield. *Art in Its Own Terms*. New York: Taplinger, 1979.

———. Interview, Archives of American Art (June 6, 1968).

"The Preservationist [Andrew Wyeth]." TIME, October 21, 1966, 106.

"Pyle Took Pride in Accuracy." *Journal Every Evening* [Wilmington], May 5, 1937, clippings file, Wilmington Public Library.

Quillman, Catherine. *100 Artists of the Brandywine Valley*. Atglen, PA: Schiffer, 2010.

———. "Posing for Wyeth." *Philadelphia Inquirer*, July 11, 2006.

Recca, Phyllis. *Chadds Ford Then and Now*. 2 vols. Chadds Ford, PA: Author, 2016.

Rodman, Selden. *Conversations with Artists*. New York: Devin-Adair, 1957.

Ruskin, John. *The Elements of Drawing*. 1857; reprint, New York: Dover Publications, 1971.

Schoenherr, Ian. Howard Pyle Blog. Howardpyle.blogspot.com.

Schoonover, Frank E. "Howard Pyle." *Art and Progress* 6, no. 12 (October 1915).

———. Interview (November 1961). Delaware Art Center Collection, University of Delaware Library.

Secrest, Meryle. "A Painter of Our Time." *Los Angeles Times*, December 1, 1996.

Standring, Timothy J. *Wyeth: Andrew and Jamie in the Studio*. Denver: Denver Art Museum, 2015.

Stoner, Joyce Hill. *The Wyeth Legacy*. Video recording of lecture, Norman Rockwell Museum, Stockbridge, Massachusetts, July 12, 2016.

Streeter, LuLynne. *Frozen Lives: Karl and Anna Kuerner*. Atglen, PA: Schiffer, 2017.

"Summer Art Schools—Where the Artists Paint from Nature Nowadays." *Philadelphia Inquirer*, July 9, 1899.

Sweet, Frederick A., and David McCord. *Andrew Wyeth*. Boston: Museum of Fine Arts, 1970.

Talorico, Patricia. "A Look at N. C. Wyeth's Art through Grandson's Eyes." *Sunday News-Journal* [Wilmington], June 30, 2019.

Thompson, Thomas R. *Chris: A Biography of Christian C. Sanderson*. Philadelphia: Dorrance, 1973.

Trevelyan, Sir George Otto. *The American Revolution*, 1897–1914; reprint, New York: McKay, 1964.

Two Worlds of Andrew Wyeth: Kuerners and Olsons. New York: Metropolitan Museum of Art, 1976.

Venn, Beth, and Adam D. Weinberg. *Unknown Terrain: The Landscapes of Andrew Wyeth*. New York: Whitney Museum of American Art, 1998.

Warner, James A., and Margaret J. White. *The World of Andrew Wyeth: In the Footsteps of the Artist*. 1986; reprint, New York: Galahad Books, 1992.

Weekly, Nancy, and Audrey Lewis. *Exalted Nature: The Real and Fantastic World of Charles E. Burchfield*. Buffalo: Burchfield Penney Art Center, 2014.

Wilmerding, John. *Andrew Wyeth: The Helga Pictures*. New York: Abrams, 1987.

Wilmerding, John, and Anne C. Knutson. *Andrew Wyeth: Memory and Magic*. New York: Rizzoli, 2005.

Wyeth, Andrew. *Andrew Wyeth: Autobiography*. Boston: Little, Brown, 1995.

Wyeth, Betsy James. *The Stray*. New York: Farrar Straus Giroux, 1979.

Wyeth, Betsy James, and Andrew Wyeth. *Andrew Wyeth: Close Friends*. Jackson: Mississippi Museum of Art, 2001.

Wyeth, Jamie. *Farm Work*. Chadds Ford, PA: Brandywine River Museum of Art, 2011.

Wyeth, N. C. *The Wyeths: The Letters of N. C. Wyeth, 1901–1945*. Edited by Betsy James Wyeth. Boston: Gambit, 1971.

"Wyeth's World." *Philadelphia*, July 22, 2008.

"The Wyeth Who Doesn't Paint." *Sunday Bulletin Magazine* [Philadelphia], July 3, 1966.

Illustration Credits

page(s)

14 **Three-hundred-year-old sentinel.** Photo by Fred Weyman.

18 **Map of Andrew Wyeth's Brandywine Valley.** Nat Case, © INCase, LLC.

20–21 **Still-rural Chadds Ford, July 1939.** Courtesy of Hagley Museum & Library.

22 **Avid antiquarians.** Photo courtesy of the Christian C. Sanderson Museum, Chadds Ford, PA © 2020.

28–29 **Patron saint of nature worship.** N. C. Wyeth (1882–1945), *Walden Pond Revisited*, 1932 / 1933, oil on canvas, 58⅛ × 70". Brandywine River Museum of Art, Bequest of Carolyn Wyeth, 1996.

30 **Artistic locus.** Illustration by the author.

31 **Glimpse of the artist at work?** Photo courtesy of the Christian C. Sanderson Museum, Chadds Ford, PA © 2020.

33 **Rainy afternoon along the Brandywine.** Photo by Fred Weyman.

40 **The artist going afield.** Photo courtesy of the Christian C. Sanderson Museum, Chadds Ford, PA © 2020.

43 **Sunlit studio at Rocky Hill.** Photo by the author.

46 **Boots for walking the Brandywine hills.** Photo courtesy of the Christian C. Sanderson Museum, Chadds Ford, PA © 2020.

48 **Surrealist roots of Andrew Wyeth's haunting style.** Salvador Dalí, Spanish, 1904–1989, *Paranoiac-astral Image*, 1934, oil on panel, 6⅛ × 8¹¹⁄₁₆ in. (15.6 × 22.1 cm). Wadsworth Atheneum Museum of Art, Hartford, CT. The Ella Gallup Sumner and Mary Catlin Sumner Collection Fund, 1935.10. Photography credit: Allen Phillips/Wadsworth Atheneum. © 2020 Salvador Dalí, Fundació Gala-Salvador Dalí, Artists Rights Society.

50 **Wyeths on exhibition.** Courtesy of Wilmington Public Library.

52 **Genesis of a sober mood.** N. C. Wyeth (1882–1945), *Dying Winter*, 1934, oil on canvas, 42¼ × 46⅜". Brandywine River Museum of Art, Purchased with Museum funds, 1982.

56–57 **Map of Wyeth Country.** Nat Case, © INCase, LLC.

60–61 **Historic hills above Chadds Ford.** Russell Smith (1812–1896), *Brandywine Battlefield*, 1870, oil on canvas, 36¼ × 54¼ inches (92.1 × 137.8 cm). Delaware Art Museum, Gift of Mr. Charles E. Mather II in loving memory of Gilbert Mather, 1970.

64–65 **Great Road of colonial times.** Courtesy of Ian Shoenherr.

67 **Lafayette slept here.** Photo box 8, Chadds Ford Historical Society, Chadds Ford, Penn.

68 **Lafayette's Headquarters transmogrified.** Courtesy of Ian Shoenherr.

70–71 **Essence of the pastoral Brandywine.** N. C. Wyeth (1882–1945), *The Springhouse*, 1944, egg tempera on hardboard, 36 × 48 inches (91.4 × 121.9 cm). Delaware Art Museum, Special Purchase Fund, 1946.

72 **Pennsylvania landscape.** Photo by the author.

75 **Legendary porch of Painter's Folly.** Photo ca. 1970. Chadds Ford Historical Society, Chadds Ford, Penn.

page(s)

78 **Bloodstained shrine of the Revolutionary War.** Horace Pippin (1888–1946), *Birmingham Meeting House in Summertime*, 1941, oil on fabric board, 16 × 20". Brandywine River Museum of Art, Purchased with the Museum Volunteers' Fund and other funds, 2011.

80 **Artist-preservationist of the colonial past.** Photo courtesy of the Christian C. Sanderson Museum, Chadds Ford, PA © 2020.

81 **Venerable relic.** Photo by the author.

84 **Art students at the ancient mill.** Howard Pyle Manuscript Collection, Delaware Art Museum.

86 **A master washes his brushes.** Frank E. Schoonover Manuscript Collection, Delaware Art Museum.

91 **Favorite artistic subject.** N. C. Wyeth (1882–1945), *Pyle's Barn*, ca. 1917–1921, oil on canvas, 32¼ × 39¼". Brandywine River Museum of Art, Gift of Amanda K. Berls, 1980.

91 **With palette and easel.** Photo courtesy of the Christian C. Sanderson Museum, Chadds Ford, PA © 2020.

94–95 **Afternoon glow.** N. C. Wyeth (1882–1945), *Chadds Ford Landscape—July 1909*, 1909, oil on canvas, 25 × 30¼". Brandywine River Museum of Art, Gift of Mr. and Mrs. Andrew Wyeth, 1970.

98–99 **Haunt of the artists.** Photo courtesy of the Christian C. Sanderson Museum, Chadds Ford, PA © 2020.

101 **Among friends.** Collection of the author.

108 **Artist's cottage on Rocky Hill.** Photo © Carlos Alejandro. All Rights Reserved.

113 **In the orchard.** Chadds Ford Historical Society, Chadds Ford, Penn.

115 **Path to his studio.** Chadds Ford Historical Society, Chadds Ford, Penn.

116–117 **Inner sanctum of the artist.** Photo © Carlos Alejandro. All Rights Reserved.

121 **Alone with nature.** Photo © Carlos Alejandro. All Rights Reserved.

123 **Workspace of genius.** Photo © Carlos Alejandro. All Rights Reserved.

125 **The family in the fifties.** Photo courtesy of the Christian C. Sanderson Museum, Chadds Ford, PA © 2020.

138–139 **Rural Chadds Ford on the Brandywine, looking northeast, July 12, 1925.** Courtesy of Hagley Museum & Library.

138 **Frolic's Dream.** Chadds Ford Historical Society, Chadds Ford, Penn.

140 **Picturesque dilapidation.** Photo by the author.

142 **Vanishing emblem of the colonial countryside.** Frank E. Schoonover (1877–1972), *Worm Fence (Hoffman's Meadow)*, 1899, oil on canvas, 13 × 20". Brandywine River Museum of Art, Gift of Mr. and Mrs. Andrew Wyeth, 1970.

144 **Classic mill of the Brandywine.** Peter Hurd (1904–1984), *Brinton's Mill*, June 1930, oil on canvas, 30⅛ × 25¹/₁₆". Brandywine River Museum of Art, Bequest of Carolyn Wyeth, 1996. © artist's estate.

146 **Hunting dogs from Dürer.** *St. Eustace* (ca. 1501). Detail. Collection of the author.

page(s)

149 **Witness beside Creek Road.** Courtesy of Hagley Museum & Library.

152 **Poignant colonial tableau.** Photo courtesy of the Christian C. Sanderson Museum, Chadds Ford, PA © 2020.

154 **Sleeper by the window.** *Awakening of Brunhild* (1882) by Howard Pyle. Collection of the author.

158–159 **Kuerner Farm, July 1939.** Courtesy of Hagley Museum & Library.

160–161 **Fatal railroad crossing.** Chadds Ford Historical Society, Chadds Ford, Penn.

162–163 **Microworld of an artist.** Photo © Carlos Alejandro. All Rights Reserved.

164–165 **Andrew Wyeth's walk to Kuerner's.** Photo by Alexander Maynard.

169 **View that inspired a masterpiece.** Photo by the author.

170 **Artist's hideout.** Photo © Carlos Alejandro. All Rights Reserved.

175 **Mobile studio.** Photo courtesy of the Christian C. Sanderson Museum, Chadds Ford, PA © 2020.

176–177 **Glimpse of Kuerner's Hill.** Photo by Fred Weyman.

178–179 **Kuerner's Hill from the north.** Photo courtesy of the Christian C. Sanderson Museum, Chadds Ford, PA © 2020.

181 **Snow Hill.** Photo by Alexander Maynard.

184–185 **Kuerner's Hill of the imagination.** N. C. Wyeth (1882–1945), *Nightfall*, 1945, tempera on hardboard, 32¹⁄₁₆ × 40¹⁄₁₆". Brandywine River Museum of Art, Bequest of Helen and John Kenefick, 2019.

189 **Converted schoolhouse.** Illustration by the author.

190–191 **Octagonal ruins.** Photo by Fred Weyman.

192 **Illustrators afield.** Frank E. Schoonover Manuscript Collection, Delaware Art Museum.

194–195 **The hills where Andrew Wyeth walked.** Courtesy of Hagley Museum & Library.

197 **Artist of the absolutely accurate.** Photo courtesy of the Christian C. Sanderson Museum, Chadds Ford, PA © 2020.

199 **All-American beech.** Photo by the author.

201 **Pyle's Ford.** George Cope (1855–1929), *Pyle's Ford*, 1896, oil on canvas, 8 × 12". Brandywine River Museum of Art, Gift of Mr. and Mrs. Andrew Wyeth, 1970.

205 **The future Andrew Wyeth Studio.** Chadds Ford Historical Society, Chadds Ford, Penn.

Index

W. Barksdale Maynard is a professional writer and journalist. He has lectured on art and architecture at Princeton University, Johns Hopkins University, and elsewhere. He is the author of seven books and two coauthored books, including *The Brandywine: An Intimate Portrait*, *Walden Pond: A History*, and *Woodrow Wilson: Princeton to the Presidency*.